ABERRATIONS

An OCTOBER Book

An Essay on the Legend of Forms

A B E R R A T I O N S

JURGIS BALTRUŠAITIS

TRANSLATED BY RICHARD MILLER

THE MIT PRESS
CAMBRIDGE, MASSACHUSETTS
LONDON, ENGLAND

© 1989 Massachusetts Institute of Technology

All rights reserved. No part of this book may be reproduced in any form by any electronic or mechanical means (including photocopying, recording, or information storage and retrieval) without permission in writing from the publisher.

Originally published under the title
Aberrations: Essai sur la légende des formes
by Flammarion, Paris, 1983.

Published with the assistance of the Getty Grant Program.

This book was printed and bound in the United States of America.

Library of Congress Cataloging-in-Publication Data

OCTOBER Books

Joan Copjec, Douglas Crimp, Rosalind Krauss, and
Annette Michelson, editors

Broodthaers
edited by Benjamin H. D. Buchloh

Aids: Cultural Analysis/Cultural Activism
edited by Douglas Crimp

Aberrations
by Jurgis Baltrušaitis

Against Architecture: The Writings of Georges Bataille
by Denis Hollier

Depraved Perspectives

The optical depravations known as **anamorphoses** *and* **aberrations** *(in the astronomical sense), which, by allowing things to be seen other than as they are, have given rise,* vis-à-vis *sight, to legends of forms and,* vis-à-vis *the mind, to the legends of myth. They are all the product of the same logical and poetical mechanism.*

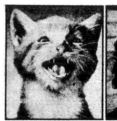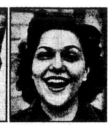

Introduction

Depraved perspectives? A mental view in which sight is dominated by the desire, the passion, to see things in a preconceived manner and in which perspective itself operates with a geometrical logic, constructing a framework of adequate structures according to a precise and immutable viewpoint. Depraved perspectives are an ineluctable part, to varying degrees but always in a positive way, of all attempts to attain knowledge. The history of science, human science, exact science, would be incomplete were we not to take them into account. Its development is even conditioned, to a certain degree, by the multiplicity of areas in which errors and facts rub shoulders. This book brings together four essays devoted to the mechanism for a morphology of legend.

"The truths of metaphysics are the truths of masks."[1] They are also the truths of fables. The illusions and fictions that spring up around forms are reflections of reality, and in turn they engender other forms in which images and legends are projected and materialized as though alive. Some of these fables form the basis of this collection: the fable of the beast nascent in man, the tale of pictorial stones, the romance of the Gothic forest, and the revelations of Paradise and China, of long-ago eras and far-away countries, in a garden. Chosen from a vast repertory—the entire universe has constantly been recreated by poets and logicians—they can be arranged under four broad subjects: the human face, imagery, architecture, the nature-garden, thus giving us some notion of the breadth and diversity of this fascinating field.

Legends grow naturally out of valid concepts and appearances, but when introduced into the speculative domain they unfold with an implacable rigor, transgressing, in certain phases, the limits of reason. We are not talking about an accident of thought. Great men, philosophers, sages, writers and artists of the highest achievement, have often taken up the strangest of notions. It is at that point that the absolute power of fiction becomes clear. Any man can have bestial traits. Minerals depicting living worlds and ruins abound in natural science treatises. Trees create cathedrals. Gardens mirror diverse sites and eras. Everything has an imperturbable logic, one with strict technical analyses and marked by undisputed mythological and historical erudition.

The methods of identifying human and animal bodies, scientific exegeses of the genesis of images in stone, the comparison of Gothic cathedrals to druidic forests, Egyptian pyramids, and Oriental cupolas, the evocation in a closed space of a universal and dramatic phantasmagoria, all are aberrations in both meanings of the word: a deviation, a moral slip, an optical phenomenon in which a (celestial) body is apparently displaced from its true position and viewed as if it were elsewhere. Yet aberrations correspond to a reality of appearances and possess an undeniable faculty for transfiguration. The life of forms depends not only on the site in which they actually exist but also on that in which *they are seen* and recreate themselves.

ABERRATIONS

Animal Physiognomy

In 1950 a Paris weekly newspaper published a page of photographs, juxtaposing the faces of well-known personalities and the heads of wild and domestic animals that bore extraordinary resemblances to them (figs. 1–4).[1] The idea had come from a volume that had appeared that same year in Hachette's *Série gaie*,[2] in which pictures of similar animals, when accompanied by captions describing them as office employees (the tiger: "sales chief"; the fish: "office manager," etc.), suddenly seemed to embody peculiarly human attitudes and expressions. In bringing out these similarities, the two authors intended only to shock and amuse the eye by a juxtaposition of images, unaware that they were actually continuing a very old tradition.

The identification between man and animal goes back to the most distant past. It is responsible for the fables and gods of every ancient civilization. It has played a part in systems of knowledge seeking to judge the moral nature of man through physical appearances.

The human body has always been the subject of scrutiny by seers and philosophers, who have sought to find in it evidences of man's deepest feelings. The shape of the nose, the eyes, the forehead, the composition of each part of the body, and the configuration of the body as a whole reveal, for those who know how to decipher them, man's character and genius. The physiognomist observes the body just as the astrologer observes the heavens in which are inscribed the arrangements and destinies of the world, and he uses both direct deduction and analogy.

The ancient *Physiognomies* of the formulators of the doctrine—Pseudo-Aristotle, Polemon, Adamantios, and Pseudo-Apuleius, all of whom share more or less the same basic notion—set forth two methods.[3] Every feature betokens something. Magnanimity is indicated by thick hair, erect posture, robust frame, the abdomen broad and flat; signs of timidity are soft hair, a rounded body, thin calves, pale face, weak, blinking eyes (Pseudo-Aristotle). Blue eyes and small pupils indicate the wicked, the vile. According to Adamantios, the bluest eyes are the best eyes. Such chains of reasoning, intermingling mind and matter, constantly recur in these dissertations, but they follow the same process when comparing human features and the features of animals whose aptitudes and instincts are supposedly more easily discerned.

Cattle are slow and lazy. They have thick noses and large eyes: slow and lazy men have thick noses and large eyes. Lions are magnanimous and their noses are rounded and flat, their eyes relatively deep-set: the features of magnanimous men share these particularities.
—Pseudo-Aristotle

Those with narrow jaws are treacherous and cruel. Serpents with narrow jaws have every vice.
An unusually wide mouth denotes a voracious, cruel, mad and impious man. The mouths of dogs are similarly wide.
—Adamantios

All these treatises, both Latin and Greek, devote entire chapters to such zoological physiognomy, in which each part of the body is identified with a part of an animal, revealing hidden qualities. The system is set forth in brief, cursory propositions, given without commentary or explanation, but its very concision gives rise to unexpected visions. While the direct physiognomic method is set forth and developed on the basis of concepts of the human proportions and canon,

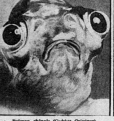
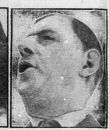
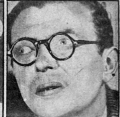

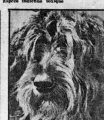
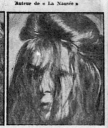
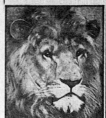
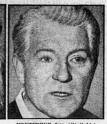
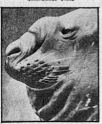

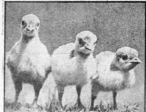
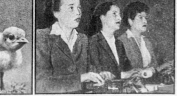

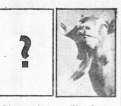

FRANCE-DIMANCHE, "MAN AND ANIMAL," 1950. PHOTO: BIBLIOTHÈQUE NATIONALE.

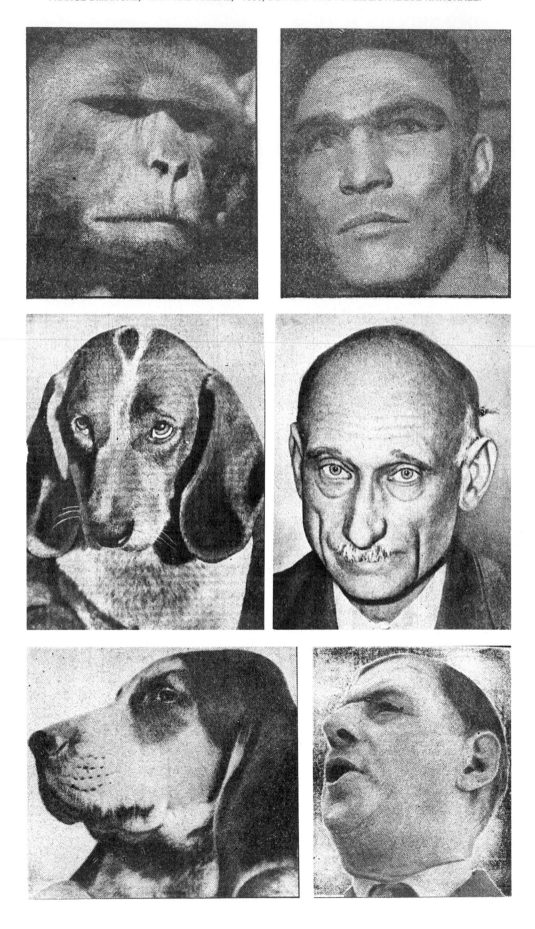

FRANCE-DIMANCHE, "MAN AND ANIMAL," 1950, DETAILS. PHOTO: BIBLIOTHÈQUE NATIONALE.

the zoomorphic method creates a fantastic human and animal bestiary. The doctrine would continue to be developed along these lines and according to such precise interpretations up until the dawn of our own era.

In the Middle Ages, the Greco-Roman physiognomies were rediscovered, both directly and via Islam. Polemon, whose second chapter deals with the resemblance between man and beast, the natures of the two sexes, and the method for deducing man's character on the basis of his animal counterpart, had been translated into Arabic as early as the tenth century. And it is to the Moslems that we owe an abridged version of Aristotle's treatise (*Sirr-al-Asrâr* or *The Secret of Secrets*), in the form of a letter to Alexander in which the philosopher advises the king on the selection of his ministers, his friends, and his slaves. Arab physiognomy also had its own tradition, however, with an abundant literature. Rhazes's medical handbook (*Al-Tibb al-Mansûrî*) devotes fifty-eight chapters to it. Among other important books, Al-Râzî's *Kitâb al-Firâsa* (1209) is replete with speculations on nature and on human animal forms, whereas Al-Damashkî (1327) linked physiognomy per se with the astrological elements that were for years to play a part in its propagation and development. Islamic thought has always been interested in all forms of divination.[4]

The West gained access to many of these works. The *Liber Almansorius* was translated into Latin by Gerard of Cremona (d. 1187), the *Letter to Alexander* by Philip of Tripoli (early thirteenth century) and in many subsequent versions in every European language. Michael Scot, astrologer and soothsayer to Frederick II, based his *Liber Physionomiae* on both these sources. Albertus Magnus's *Secreta* reflects the *Sirr-al-Asrâr*, as does Roger Bacon's physiognomy. The *Secretum secretorum* gives little space to zoomorphic signs, save that

eyes similar to those of an animal denote a vulgar temperament and feeble intellect. However, the majority of the great treatises of antiquity that do deal with the subject were well known. Pseudo-Apuleius figures in countless manuscripts of the twelfth, thirteenth, and fourteenth centuries. Pseudo-Aristotle was translated into Latin by Bartholomew of Messina with a dedication to Manfred, son of Frederick II and King of Sicily (1258-66). Polemon is reprinted in physiognomic collections.[5]

Peter of Albano's *Liber compilationis physionomiae*, which drew upon antique and Oriental sources, brought astrology into the picture as early as 1295. Descriptions of the human body with occasional references to animals were followed by a lengthy chapter enumerating kinds of appearance and temperaments determined by the planets and the signs of the zodiac. Astrology and physiognomy were increasingly closely linked.

In the fifteenth century they appear in the *Speculum Physionomiae* of Michele Savonarola (c. 1450)—the uncle of Girolamo and doctor to Duke Niccolò III d'Este at Ferrara—as two facets of a single doctrine,[6] as well as in the popular *Shepherd's Calendars* (1491, 1496, etc.). The sovereign's guide became a handbook of popular sciences with no change in its presentation. Men are born under sidereal signs that fix their characters and appearances. Their four temperaments correspond not only to the four elements but to four animals as well: the choleric to the nature of fire and the lion; the phlegmatic to water and the lamb; the sanguine to air and the ape; the melancholy to earth and the swine. The ensuing descriptions of each part of the body make no reference to animal likenesses, but in conclusion they recall, by enumerating them,

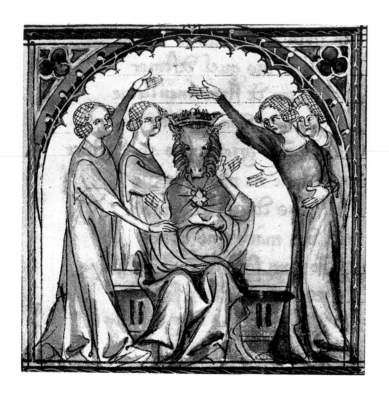

5

CREATURE, HALF-HORSE, HALF-MAN. FIRST THIRD OF THE
FOURTEENTH CENTURY.
BIBLIOTHÈQUE NATIONALE, MS. FR. 146.
PHOTO: BIBLIOTHÈQUE NATIONALE.

that all animal characteristics also appear in man, who is part of the so-called "small world, for, as such, he shares in the condition of all creatures." We have reached zoology, linked in microcosm.

The Middle Ages believed deeply in its concepts. The imagery and literature of the period are full of hybrid creatures that combine all kingdoms. Society as a whole is depicted in animal disguises in *L'Ancien Renart* and *Renart Novel* (1288), with Noble the Lion, Tardif the Snail, Bernard the Ass, Tybert the Cat.[7] Fauvel (1310-14), half man, half horse (fig. 5 and plate 1), whose name forms an acrostic of the vices (Flattery, Avarice, Vileness, Variety, Envy, and Laziness), embodies the same notion:

. . . men have become animals.
. . . We go by night, lanternless,
When governed by the bestial . . .[8]

The fact that the *Roman* appears in a collection[9] along with *Li Livres Aristole qu'est intitlé Secré des Secrez* [*The Aristotelian Books known as the Secret of Secrets*] in the version of Philip of Tripoli is certainly no accident. While following their own development, the bestiary and the grotesque humor of the illuminated margins and sculpted decor, so scathing since the end of the thirteenth century, are in harmony with the physiognomic theories of the period.[10] The fantasy of the Middle Ages drew upon numerous sources. The period linked together antiquity and the Orient, their sciences and their magics, their teratology and their legends, combining them into one single world. The atmosphere was particularly favorable to the propagation of fabulous systems in which man, his character, and his fate are revealed through mysterious indices, through similarities to animals and the configuration of the heavens.

The Renaissance continued to develop along the same lines. Peter of Albano's *Physionomia* appeared in 1474 in Padua;[11] Michael Scot (n.p., 1477) and Albertus Magnus (Bologna, 1478) followed. A new translation of Pseudo-Aristotle was published by Alde at Venice in 1497. In 1503, two Bolognese doctors and hermetic philosophers, Bartolomeo della Rocca, known as Cocles, and Alessandro Achellini, one of the first anatomists to have dissected a cadaver, published a vast treatise entitled *Anastasis,* which resurrected these doctrines. "The soul follows the habit of the body, i.e., the signs," the preface states. "Plato, the wisest, writes in his *Physiognomy* [another apocryphal item of information] that the analogy of animal features betrays the same nature in man. He who has an aquiline nose is magnanimous, cruel, and rapacious as an eagle. Men whose heads resemble that of a Spanish dog are quick to anger and great talkers"[12]

Among the sources cited in the course of the dissertation are Aristotle, Polemon, Rhazes, and Savonarola, and the entire second part of the book is devoted to astrological physiognomy. The work is a direct continuation of the medieval tradition. It is not until the end of the sixteenth century, following a methodical reexamination of the Greek authors[13] and a number of popularizing books,[14] that we witness any true renewal.

The *De Humana Physiognomia* of Giambattista della Porta (1541–1615), which takes up the subject anew, was published at Naples in 1586.[15] The author begins with a rapid historical review. Plato is mentioned as being insufficiently precise. The Stoics, with Chrysippus, undermined the spread of the system by holding that the souls of the dead reappeared in different bodies. The same was true of the Pythagoreans, who believed in metempsychosis. Aristotle is the real authority. An Arabic translation of his treatise exists at Rome. Debased through successive versions, the integrity of his thinking was reestablished by Polemon and Adamantios.

The quasi-divine basis of this science, which opens the window onto worlds man has jealously kept hidden, parallel to the art of the seer and the oracle who read the configurations of the body like a book, is zoomorphism. The principle, set forth in various ways in earlier works, becomes primordial and almost exclusive. Porta expounds it in the introduction to his treatise by constructing a syllogism whose major premise, minor premise, and conclusion state: Each species of animal has features corresponding to its properties and passions; the elements of those features are to be found in man; the man possessing the same features will, therefore, have an analogous character. Thus the lion, powerful and generous, deep-chested, with broad shoulders and large extremities. Humans with the same signs are brave and strong. Among animal features it is the forms of the whole body of the lion and of each member that most closely approach masculine features, while the panther presents the closest analogies with the bodies and habits of females. However, other beasts also offer such signs, their character repeating itself in us. The old speculations are rampant in this obsession with animality.

The head, hair, forehead, nose, mouth, neck—each sign is painstakingly analyzed, with references to historical texts and examples. Plato is compared to a dog, Socrates to a stag, Sergius Galba to the eagle, Vitellius to the owl (figs. 6, 7). The interpretation is full of nuances. To the dog Plato owes his high nose with its flaring nostrils, as well as the high forehead that, according to Adamantios and Polemon, denotes naturalness and common sense. The stag's snub nose reveals

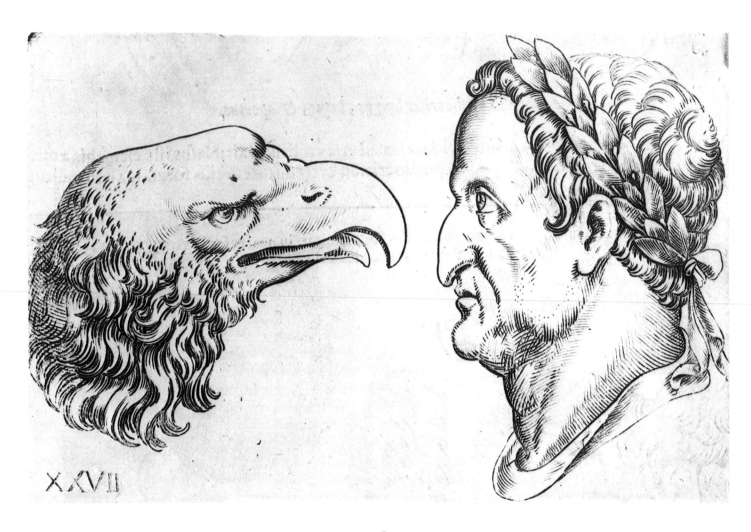

6

GIAMBATTISTA DELLA PORTA, SERGIUS GALBA–EAGLE (1602 EDITION, NAPLES).
PHOTO: BIBLIOTHÈQUE NATIONALE.

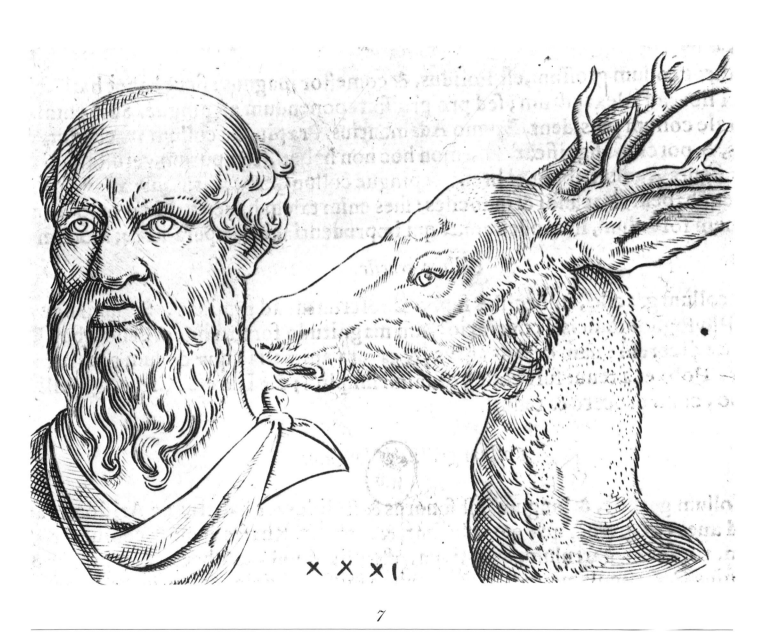

GIAMBATTISTA DELLA PORTA, SOCRATES-STAG (1602 EDITION, NAPLES).
PHOTO: BIBLIOTHÈQUE NATIONALE.

Socrates' sensuality. A huge head like that of an owl (Vitellius) indicates a vacant mind and stubborn nature. A small head, like that of an ostrich, betrays the mad or extravagant. Medium-sized heads, neither too large nor too small, extolled by Aristotle to Alexander, correspond to that of the lion. The meaning of a nose shaped like a bird's beak changes according to the species: the crow or the quail (impudence), the rooster (lubricity), the eagle (generosity). Those whose lips are thin, hard, and slightly lifted over the canine teeth, like swine, are contemptuous of honor and base of soul. Those with fleshy faces are timid and partake of the nature of asses. The eyes, the body's noblest part and the best indicators of the souls of all creatures, including man, are given special attention and countless comparisons are drawn. Homer had said that eyes are beautiful when large and like those of cattle. When we see someone with tiny pupils, like those of serpents, bandicoots, monkeys, and foxes, we know him to be evil and tricky. Lamb's eyes are signs of bad morals; those of the stag, of wit; of the ass, madness. Nothing is left out of these listings of bodily indices, neither attitude nor gesture. The person who walks straight, with head held high and shoulders moving slightly, is analogous to the horse. The horse—naturally—is glorious, ambitious. The appearances and natures of animals constantly serve for such observations, even when the authors cited do not draw the parallels. They are to be found at the end, in the last section of the book, which deals with the gamut of human characters. The uncouth are compared to bears, the just to elephants, the quick-tempered and irascible to boars, the stupid to goats. Detailed analyses terminate in overall vision.

The sources most frequently used are Greek *Physiognomies,* the medieval writings (Michael Scot, Albertus Magnus, Rhazes) serving solely as secondary references. We have a true reconstitution and renewal of antique thought, but in a more rigorous, more solemn form. In compiling his authors, Porta shows a clear penchant for the brutal and the unusual.

The treatise is important for its illustrations as well as for its text. Obviously, artists throughout the ages have always deformed human heads and accentuated human features by the use of animal similarities. Some of Leonardo da Vinci's faces, which resemble lions, monkeys, eagles, faces with flattened noses like muzzles, bearded like goats, are really physiognomical studies reminiscent of such theories (fig. 8). While deeming the doctrine to be fallacious and without scientific basis, the master still noted that "those men with portions of the face in high and low relief are bestial men."[16] Titian introduced morphological reasoning into an allegorical system. His *Signum triciput,* which has long interested iconographers, furnishes a remarkable example.[17] In it, Prudence is depicted as having three human heads—Memory, Intelligence, Precaution—to conform with an image of the scholastic doctrines. She thus corresponds to the phases of time—Past, Present, Future—which are also set forth, but in an animal form that echoes Macrobius's vision of the wolf dragging off memories like prey, of the lion sudden and violent, of the dog cherishing fond hopes for the future. The symbols are superimposed and complementary. Three human heads are shown over three animal heads whose features they naturally reflect, the feline in the middle, canines on either side. The philosophical and literary allegory is illustrated through a contamination of forms (plate 2).

The painting is anterior to G.B. della Porta's publication, which finally gives us, methodically in a technical work, a summation of a vast supply of prototypes and models for every case.

8

LEONARDO DA VINCI, PHYSIOGNOMIC SKETCHES, DETAIL.
PARIS, MUSÉE DU LOUVRE, CABINET DES DESSINS. PHOTO: MUSÉE NATIONAUX.

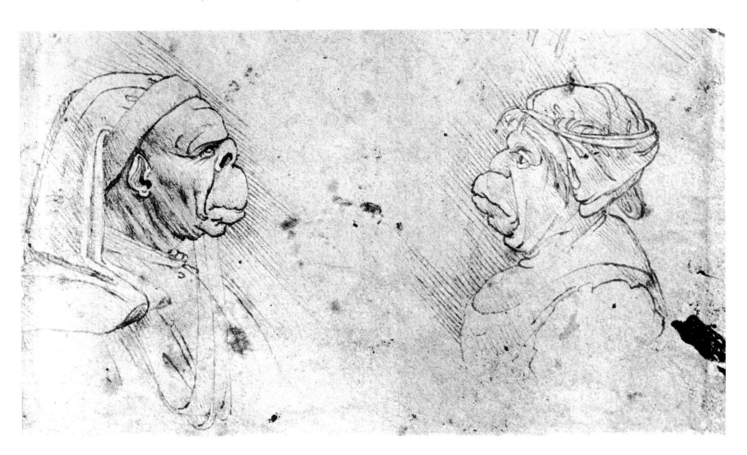

9–10

GIAMBATTISTA DELLA PORTA,
MAN-LION AND MAN-STEER (1650 EDITION, ROUEN);
MAN-SHEEP (1602 EDITION, NAPLES).
PHOTOS: BIBLIOTHÈQUE NATIONALE.

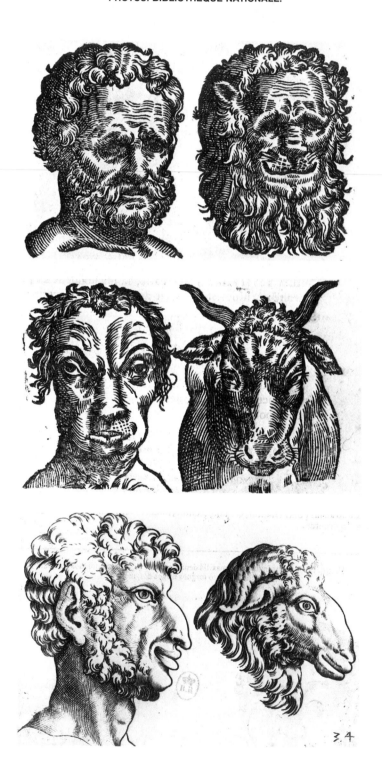

The demonstration is carried out through drawings that juxtapose the principal species (figs. 9–12). Historical characters (Plato, Socrates, Sergius Galba, etc.) are depicted from statuary or medals in the collections of Vincenzo Porta and Adriano Spatafore, the author's brother and uncle, and they are to varying degrees analogous to the corresponding animals. Dürer's rhinoceros (1515) is reproduced contra, its horn having no apparent relationship with Politian's prominent nose (fig. 11). On the other hand, type heads are made rigorously to conform. The man-cow, man-lion, man-sheep, man-dog, and man-pig are closer to the animal than the human species. They are wittily created but schematic monsters, an unreal world far beyond verisimilitude. The inventory includes some twenty compositions, but they are employed for the analyses of various bodily parts; thus, the bestiary is an element of the entire work. The illustrations as a whole establish an entire iconography of man the principles and elements of which will not change over the centuries.

The work had an immense success. Successive editions were published at Naples (1588, 1598, 1602, 1603, 1610, 1612, et seq.), Venice (1644), Hanover (1593), Brussels (1601), Leyden (1645). Two French translations (1655 and 1665) followed its publication in Latin at Rouen (1650). An astrological physiognomy in purest medieval and Arabic tradition, published separately in 1603, was often attached to the book.

A pathological doctrine also developed parallel to the study of such melancholic illnesses as lycanthropy or *folie louvière*. Already mentioned by Marcellus de Side and Avicenna, it naturally includes under all wolfish shapes the same antique cosmogonies. A. Du Laurens, a medical doctor and chancellor of the University at Montpellier (1597), forcefully restates it: "Man being a

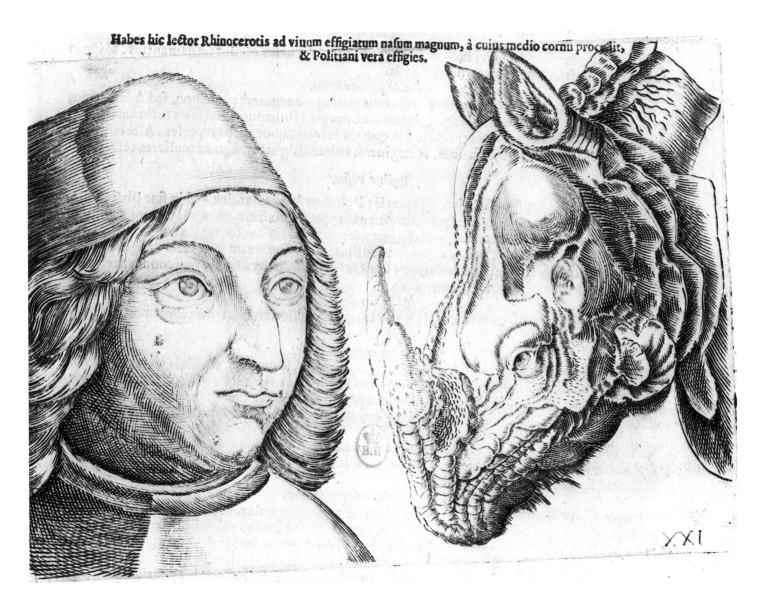

Habes hic lector Rhinocerotis ad viuum effigiatum nasum magnum, à cuius medio cornu procedit,
& Politiani vera effigies.

11

GIAMBATTISTA DELLA PORTA, POLITIAN-RHINOCEROS (1602 EDITION, NAPLES).
PHOTO: BIBLIOTHÈQUE NATIONALE.

12

GIAMBATTISTA DELLA PORTA, MAN-DOG (1602 EDITION, NAPLES).
PHOTO: BIBLIOTHÈQUE NATIONALE.

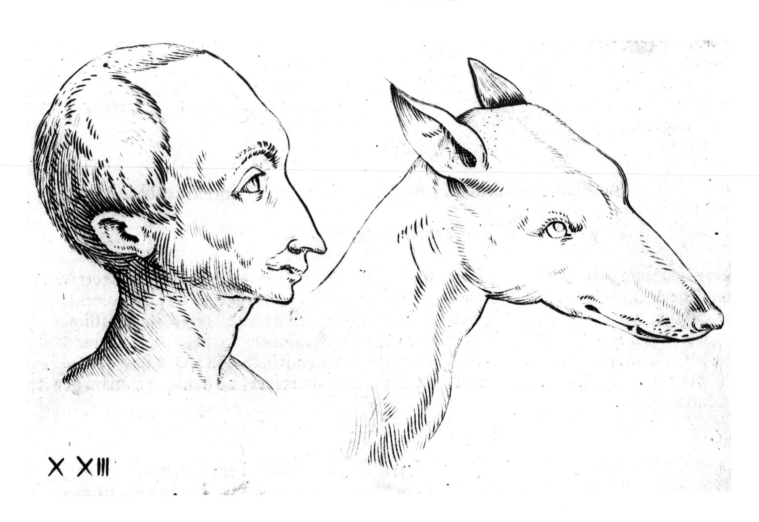

divine and political animal, the lycanthrope is a wild animal, moody, solitary, enemy of the Sun, i.e., of the King, who is himself the image of God."[18]

Systems were the rage. Porta was not the only one to have such ideas. Rubens, who spent time in Italy, also adopted some of these demonstrations, giving them even broader and stranger dimensions.

Man was first created a hermaphrodite, then divided into two sexes, but the virile form is the one that includes the perfection of the human face. The perfect idea of its beauty is the work of the Divinity, who conceived it as unique, according to its own principles. The creatures who came after progressively departed from this primal excellence. "Thus forms and character change, they take on various parts of the lion, the bull, the horse, who surpass all other animals in strength, courage, and bodily size."

Traces of such borrowings can be discerned in the structure of human heads (figs. 13, 14).

The resemblance to the horse is evident in Julius Caesar, whose face is long and oval, with a straight nose and salient bone structure, the expression unyielding yet still retaining something soft and delicate. The Farnese Hercules, a superhuman creature, joins the character and physique of three higher animals, with a preponderance of lion. Man, composed of the elements of the universe, participates in all animals, but it is only in the perfect man that all the forms combine. In most cases one animal is predominant.

The drawings illustrating these relationships are lively, precise, with a keen sense of classical purity. The animals have a savage nobility and their features lend supernatural strength to the human features. The artist proceeds by juxtaposing elements from which he draws secret similarities. Caesar is endowed with an animal mask, whose features he retains in the effigy that is set off to one side, like a medallion. The leonine (Hercules and other athletes) have somber, flattened features emerging from luxuriant manelike crops of untidy hair. The man-bull has a visage swollen with muscle on a thick neck, a fixed gaze. "The beauty of the human nose is imitated by that of the horse," whose nostrils are round; similarly the mouth, with its slightly protruding upper lip. Men concealing animals are brought together in one of these plates. Their faces are serious, shut in, without the slightest touch of irony. If certain of Porta's images approach the grotesque, Rubens's are all like the revelations of some mystery.

The painter does not appear to have had a copy of *De Humana Physiognomia* at his disposal. We know that he worked directly from antique statuary in Rome, where he lived from 1605 to 1608. Bellori tells how he used to note down in an album his observations on the subjects, proportions, anatomy, appearance of the works he saw,[19] and it is probably on the basis of such materials that the treatise was published by Aveline in 1773, with personal commentaries added to the drawings.[20] Even if some of its parts are apocryphal, as a whole it accords with the esoteric traditions of the sixteenth century. In the history of the science of human shapes, it represents a late blossoming of fantastic cosmogonies.

However, these in-depth speculations did not interrupt the spread of the antique bases for them. In spite of the popularity of Porta's work, editions of translations of Greek treatises continued to appear—a Pseudo-Aristotle in Bologna (1621),[21] a Polemon at Padua (1621),[22] an Adamantios at Paris (1635),[23] and several astrological *Physiognomies*[24] redolent of the Middle Ages. For a

13

PETER PAUL RUBENS, LEONINE MEN, AFTER P. AVELINE.
PHOTO: BIBLIOTHÈQUE NATIONALE.

14

PETER PAUL RUBENS, HUMAN BEAUTY REFLECTED IN EQUINE BEAUTY,
AFTER P. AVELINE. PHOTO: BIBLIOTHÈQUE NATIONALE.

while the various systems seem to have stabilized, while leaving room for the creation of a new branch of the science of man. This was the science of passions, i.e., of transient feelings and not permanent emotions, which now moved to the fore of the research being done in preparation of a revision of physiognomies per se.

This notion had undergone a parallel development since antiquity, which accepted it as proof of the relationship between body and soul. Cocles and Porta continued to maintain that passions modify and corrupt the body. Leonardo had speculated on the question and even set forth several practical instructions, but it is to Lomazzo (1584) that we owe one of the first dissertations on the problem as a whole.[25] Before being dealt with by a theoretician of the human features the subject was treated in depth by a theologian, Coeffeteau (1620),[26] a doctor, Cureau de La Chambre (1640–62),[27] and a philosopher, René Descartes (1649).[28]

The most important of these works, at least from the point of view of breadth of text, is the four-volume treatise by Cureau de La Chambre, but, since its publication was spread out over a twenty-two-year period, it was superseded by the work of Descartes, who had in the meantime formulated a new theory of physiology and the classification of passions. According to him, they were seated not in the heart but in the pineal gland of the brain, and their categories were not those laid down by the Ancients (the concupiscible and the irascible). There are in fact six primitive passions, with some forty subdivisions, with distinguishable mechanisms and even external signs. Charles Le Brun drew the conclusion for artists when he wrote, "And since we have said that the gland in the central portion of the brain is the site where the soul registers

the images of the passions, the eyebrow is thus the area of the face where the passions best reveal themselves."

He also drew up forty-one masks of simple passions and their composite derivatives in which everything is controlled by the movements of the eyebrows. The drawings were presented at a meeting of the Académie de Peinture in 1678 and were reproduced in the countless editions of his *Traité de l'Expression* [*Treatise on Expression*].[29] Thus, systematic studies in the science of humanity continued and carved out their own fields, but, in the background, there still lurked the shadow of the beast.

Cureau de La Chambre refers to it in the preface to his first volume (1640), when he states that a general rule to be followed consists in interpreting resemblances between men and beasts, to which he had intended to devote the second volume, but that in the interim his plans had changed. Descartes, in explaining the physiology of passions by means of "spirits" ("a certain very subtle air or wind," contained in the cavities of the brain; these are carried there by the blood and, in passing through the cavities, sense the soul's action, lodged in a small gland), dubbed such spirits "animal spirits." And this same gland was also to be responsible for Le Brun's return to the antique physiognomies when he too considered these problems.

We have four sources for the theories of the King's First Painter, as he presented them before the Académie: an *Abrégé* by Testelin, a follow-up to the *Traité des Passions*,[30] a manuscript by Claude Nivelon,[31] the abundantly illustrated dissertation of Morel d'Arleux,[32] and the Le Brun collection in the Musée du Louvre's Cabinet des Dessins.

15

CHARLES LE BRUN, KING OF GREEK GODS AND KING OF BEASTS.
PARIS, MUSÉE DU LOUVRE, CABINET DES DESSINS. PHOTO: FLAMMARION.

The system is systematically laid out in so far as it applies to painters. "Although it is maintained that the gesture of the whole body is one of the most important signs," it is nevertheless possible to confine oneself to the signs of the head, in which man wholly reveals himself, as Apuleius had earlier stated. If man is the universe in small, his head is the sum of his entire body. The head is a world, a body in résumé; with its gland, it is the seat of the soul, and it also contains an animal world. Beasts differ in their inclinations just as humans do in their affections, but they also furnish the surest alphabet of signs.

The artist studied such concordances by proceeding, like Rubens, on the basis of antique statues and live animals. The Louvre has nearly 250 of his physiognomical drawings.[33] With his hair like a mane around his high forehead, his straight nose and round eyes, the king of the Greek gods recalls the king of beasts (fig. 15). Hercules, with his powerful neck and short hair, bears a striking resemblance to a young bull. Effigies of historical personages—Nero, the incarnation of vice, and Antonius Pius of virtues—also provide useful information on the anatomy of character. Men can be divided into three general classes according to their passions: the mild passions that do not alter their features; the generous passions, which leave a particular mark; and the blameworthy and vile passions that degrade the features. Animals too can be classified according to complexions, lions being nervous and choleric, leopards tricky and subtle, bears savage, wild, terrible—but the indexing problem is complicated by the diversity of beasts with analogous instincts, for example the lubricity shared by goats, asses, and swine. To get round such difficulties and arrive at a precise evaluation of the sign, Le Brun suggests a geometrical process.

The character of a man and the nature of an animal can be measured by the angle created by straight lines passing through the axis of the eyes. If it falls on the nose, the subject is animated by noble passions; if on the forehead, by shameful impulses. The geometry of an animal's profile is particularly revelatory. The process is carried out on a drawing on which an equilateral triangle (ABC) has been constructed, one leg of which goes from the nose (A) to the ear (B), touching the interior corner of the eye (E). In addition, the figure includes a line parallel to BC, beginning from E (EG), as well as a line parallel to AB delimiting the superior level (LK), thereby multiplying the triangulations. The schema is completed by a straight line IH from the exterior corner of the eye (upper lid) (I) to the forehead (H) (fig. 16).

This test reveals the animal's character. According to whether the straight line EG crosses his muzzle or not, he will be either voracious or fructivorous. Carried on to the LK side of the large triangle, the line touches the sign of strength, which, if accompanied by a swelling toward the center of the nose, denotes the degree of courage. Even rabbits that unite the two signs are superior to their fellows and display daring.

"The prerogative inherent in the bridge of the nose of animals also extends to humans." Illustrious men of ancient and modern times have all had more or less aquiline noses. However, be careful! In a hero, this sign must be accompanied by a broad, high forehead and thick eyebrows. When the forehead is narrow and the nose unduly arched, the values degenerate. A nose like a parrot's beak betrays the proud and talkative man. "The greatest misfortune is reserved to the man who unites these fatal signs with a nose pointed like that of a raven: he will have no alternative but to be subject to the most condemnable passions."

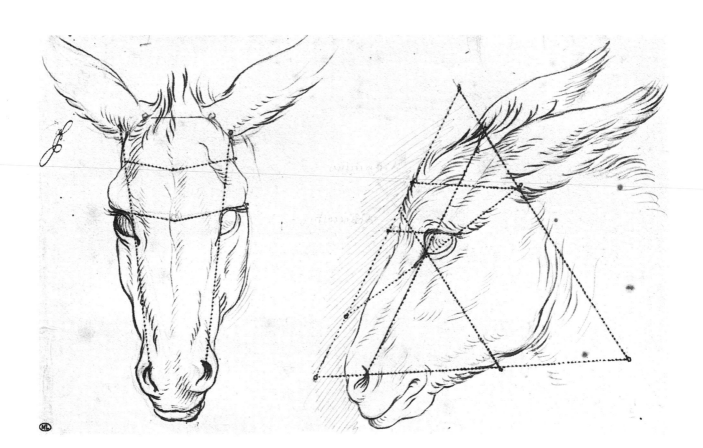

16

CHARLES LE BRUN, PHYSIOGNOMIC GEOMETRY.
PARIS, MUSÉE DU LOUVRE, CABINET DES DESSINS.
PHOTOS: FLAMMARION.

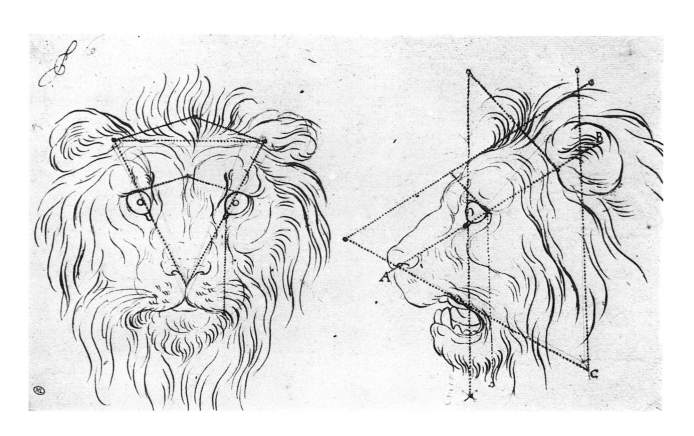

Line IH, which follows the brow, also provides several indications: sagacity, if it rises toward the forehead; a good-heartedness if it lies horizontally, viciousness if it goes down. The angle it makes with line LK reveals, if it lies above the forehead, mental ability, as in the cases of the elephant, the ape, and the camel; if it lies below, stupidity and imbecility—as, for example, with sheep and asses. Similarly, in the masks of the passions, the eyebrows of the animals are especially revealing.

In presenting this curious text, reconstructed on the basis of Nivelon's notes and second-hand information, Morel d'Arleux warns us that we must interpret it with great care, but that the images he reproduces are authentic and contain the master's principal subjects and physiognomic diagrams, which are still in the Louvre today.[34] Like Porta's work, they contain juxtaposed human and animal heads. There are additional comparisons; each type is presented with some varieties, two or three profiles and a full-face view, but there is the same layout, the same search for similarities, the same bestiary.

Le Brun had carefully studied *De Humana Physiognomia*, of which three recent editions had appeared in France alone, and he reworked its illustrations along the lines of his own concepts, eliminating and adding examples. There is no Socrates-stag or Plato-dog. The eagle is no longer discernible in the features of Sergius Galba. Three men with pointed, hooked noses, thin lips, large and brilliant eyes represent the rapacious. Since their foreheads are not unusually high, they cannot be noble heroes. New specimens include the parakeet (pride and volubility), the bear (the terrifying and savage), the camel (intelligence), the hare, the fox, the wolf, the boar. The repertoire as a whole is renewed and enriched.

These are fine, solid drawings, with firm lines and vigorous volumes. The animals are drawn from life, but the artist's concern for expression gives them a touch of human intelligence. Their hermetic masks seem to enclose unplumbed worlds. The men, on the other hand, are strongly bestialized, their features enlarged and deformed, with greater verisimilitude than we find in Porta. Their noses and mouths echo the shapes of beaks and muzzles with the maximum exactitude. Yet the heads are not overdone, they are not caricatures. It is very seriously done, and everything is calculated and carefully thought out (figs. 17–21).

Physiognomy is taught through theorems, with a proposition and a solution. Through this demanding and methodical transfiguration we arrive at an equivocal humanity that is tinged with something evil and terrible, a humanity that escapes words or understanding.

This intense, ambiguous life derives all its force from the eyebrows and the eyes, and the source of this concentration of effects is, again, the pineal gland. Le Brun performed countless experiments in this area, drawing a lion and a horse with human eyes (fig. 22), and all of his faces have the brows and eyes of the corresponding animals, giving them a look that is at once very familiar but empty of expression and distant. In performing these transplants the artist proceeded methodically, studying their features separately.

Plates covered with eyes resemble a table of the species, from which one can pick and choose. "Aspects and movements of eyes and eyebrows," reads the caption on the original drawings, reflecting the same terms as the *Traité des Passions*. Arranged in rows we have the eyes and eyebrows of man, the monkey and camel, the tiger, the lynx and the cat, the fox, the pig, the ram and the sheep. Eyes open and closed, brows

17

CHARLES LE BRUN, PHYSIOGNOMIC SKETCHES.
PARIS, MUSÉE DU LOUVRE, CABINET DES DESSINS.
PHOTO: FLAMMARION.

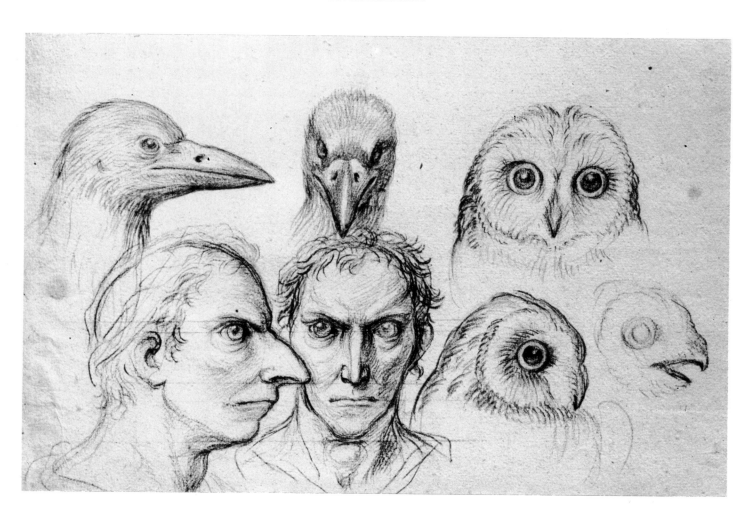

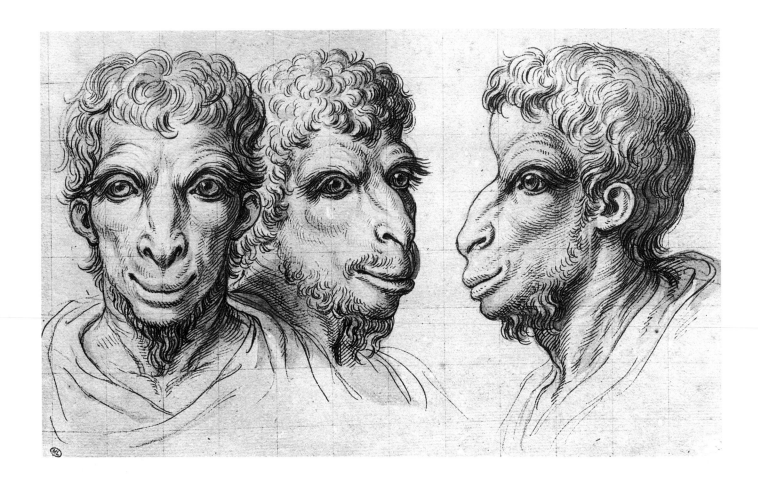

18

CHARLES LE BRUN, MEN-CAMELS.
PARIS, MUSÉE DU LOUVRE, CABINET DES DESSINS. PHOTOS: FLAMMARION.

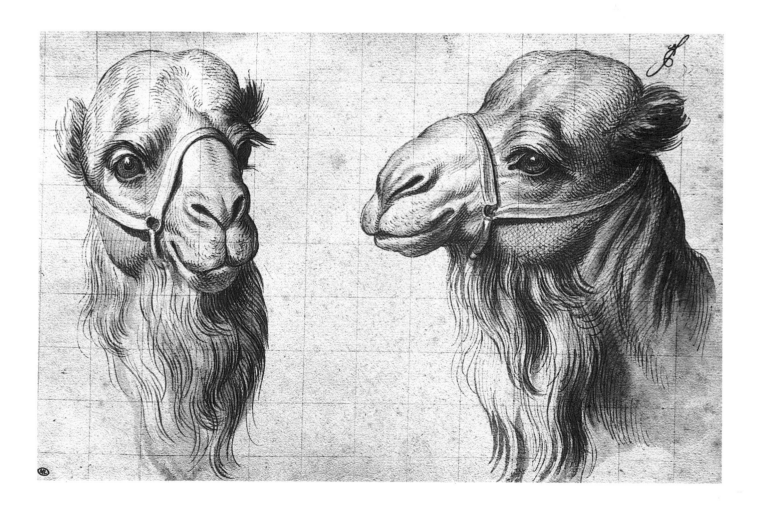

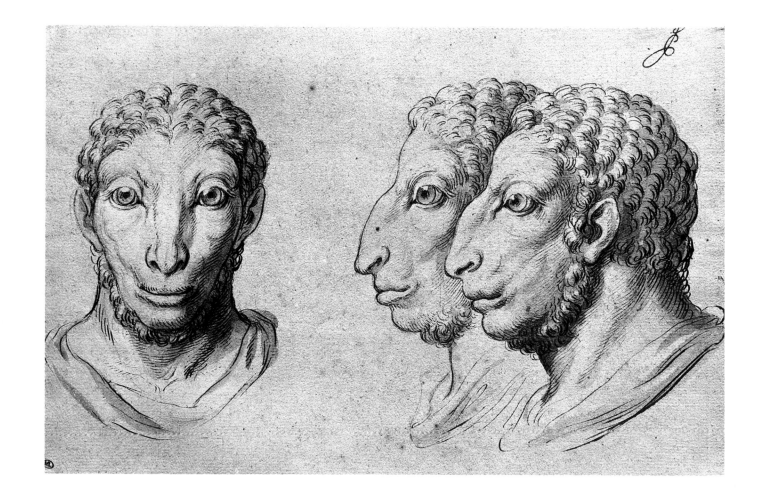

19

CHARLES LE BRUN, MEN-RAMS.
PARIS, MUSÉE DU LOUVRE, CABINET DES DESSINS. PHOTOS: FLAMMARION.

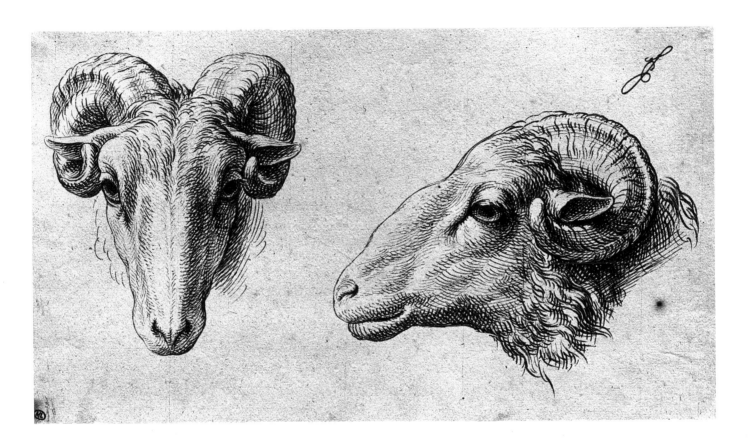

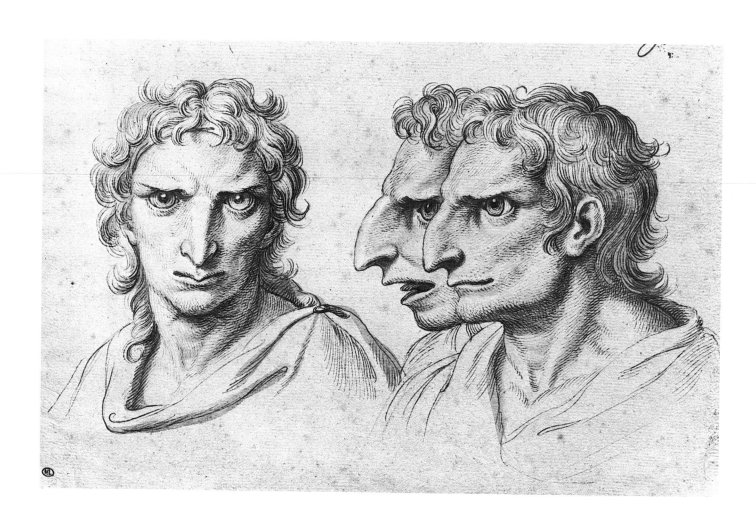

20

CHARLES LE BRUN, MEN-EAGLES.
PARIS, MUSÉE DU LOUVRE, CABINET DES DESSINS. PHOTOS: FLAMMARION.

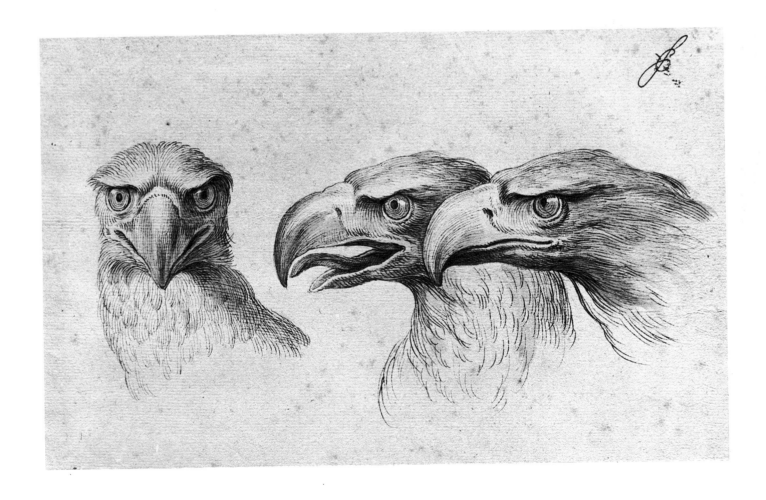

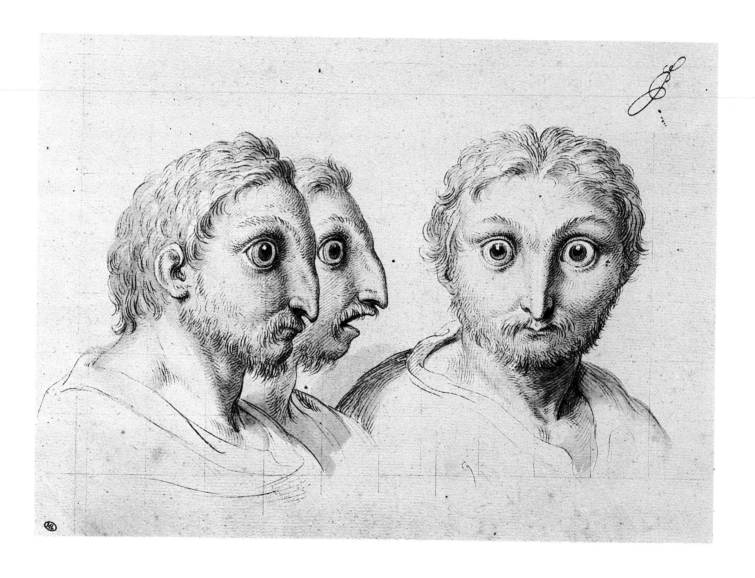

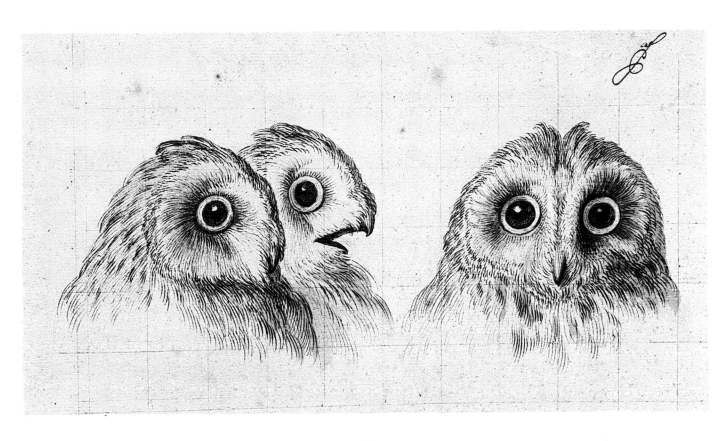

21

CHARLES LE BRUN, MEN-HOOT-OWLS.
PARIS, MUSÉE DU LOUVRE, CABINET DES DESSINS. PHOTOS: FLAMMARION.

23

CHARLES LE BRUN, ASPECTS AND MOVEMENTS OF THE EYES AND BROWS
OF THE TIGER AND THE LYNX.
PARIS, MUSÉE DU LOUVRE, CABINET DES DESSINS. PHOTO: FLAMMARION.

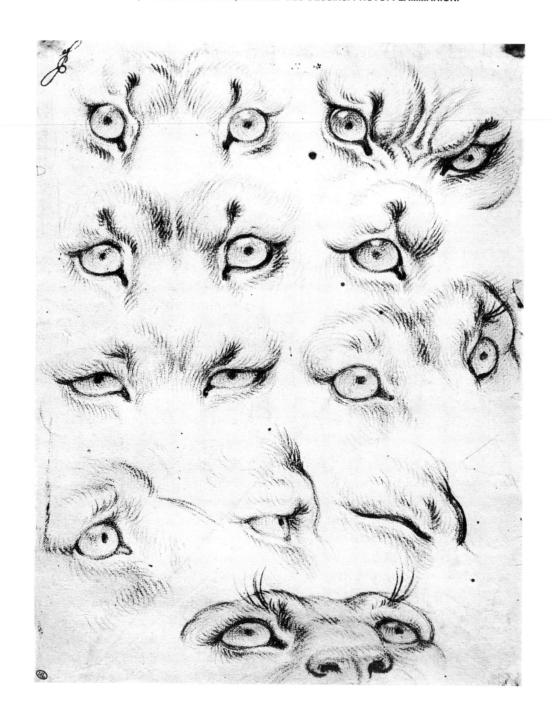

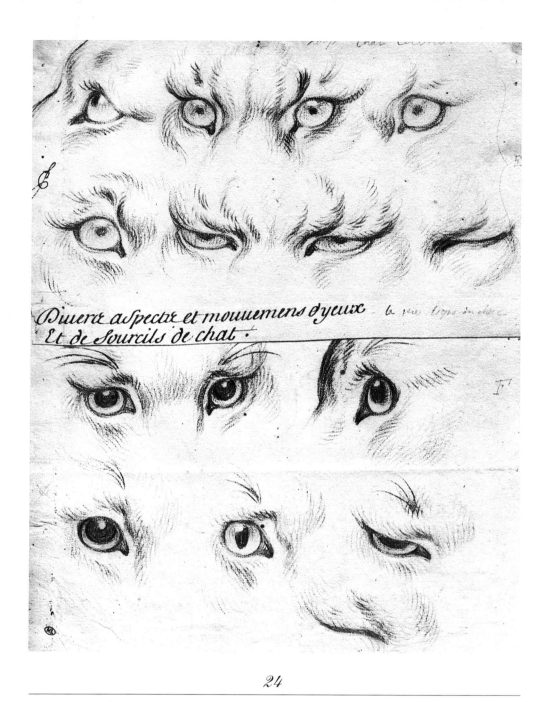

Diuers aspects et mouuemens d'yeux
Et de sourcils de chat.

CHARLES LE BRUN, VARIOUS ASPECTS AND MOVEMENTS OF CATS' EYES AND BROWS.
PARIS, MUSÉE DU LOUVRE, CABINET DES DESSINS. PHOTO: FLAMMARION.

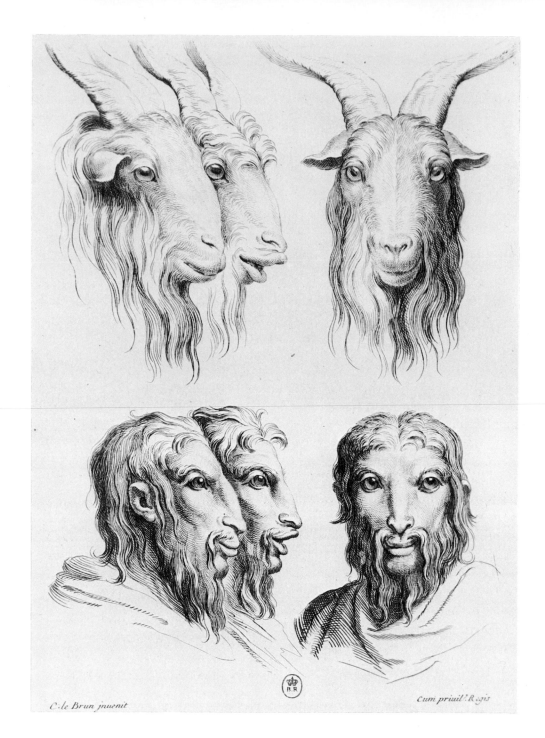

C. le Brun jnuenit

cum priuil. Regis

25

L. SIMONNEAU LE JEUNE, RAM'S PHYSIOGNOMY, AFTER LE BRUN.
PRIOR TO 1727. PHOTO: BIBLIOTHÈQUE NATIONALE.

of the eighteenth century and the first half of the nineteenth that we witness its widest popularity since the Middle Ages.

This renaissance took every form: animals acting like men, animals with human heads, men with the heads of animals began to proliferate in every kind of imagery. All the frontiers of the zoological kingdom were breached. The French Revolution created its own bestiary. Lafayette, always on horseback, was often represented as a hybrid (1791). The royal beasts being led to the Temple by the revolutionary *sans-culottes* are a turkey (Louis XVI), a she-wolf (Marie Antoinette), and wolf cubs (1792).[38] The members of the Conseil des Emigrants have zooidal faces.[39] Soon every class of society found itself assigned a place in these fairy tale surroundings. The years 1818 to 1825 saw the publication of series entitled *Têtes d'études d'après nature, Le Magasin du visage, La Galerie de grotesques, Les Oiseaux caractérisés*, with such punning and fanciful titles as "L'Abbé Casse" [*la bécasse*, "The Woodcock," also slang for "ninny"] or "Le Père Dreau" [*le perdreau*, "The Partridge"].[40] Around 1825 D.-F. Boissey began to specialize in *singeries*, monkeys and apes with human characteristics and vice versa. Then the great artists born at the turn of the century began to make their debuts: Grandville (1803-47), Gavarni (1804-66), Daumier (1808-97), who were all haunted to varying degrees by the bestiality of man and the irruption of political fauna. *Ménageries* and *Cabinets d'histoire naturelle* appeared, filled with marvels. Germany, led by Kaulbach, joined the parade. In England, Cruikshank published his *Zoological Sketches* (1834). The century's "animal mania" was no passing fashion in satire. It was an obsession that corresponded to a way of thinking and feeling about nature and about life.

Two elements can be singled out among the proliferation of these catalogues. First, there is a rebirth of the animalism of the Middle Ages—we are in a full-blown Gothic revival—but in contemporary guise, and second, we have an unleashing of fantasy in response to the bases laid by the new science, which set forth the data for it and which was to develop in tandem.

Around 1770, with the work of Camper (1722-89), we witness a renewal of interest in investigations into the passions and physiognomy and their final integration into modern anthropology. Le Brun appears to have provided the impetus for such studies by promoting his geometric method for measuring human intelligence.

The lectures given by the Dutch naturalist in 1774 and 1778 at Amsterdam's Academy of Drawing referred to the subjects of the communications imparted to the Parisian Académie by the First Painter to Louis XIV in 1671 and 1678: "The sure way to represent the various passions that show themselves in the face and the astonishing conformity that exists between quadrupeds, birds, fish and man."[41] The first lecture began with a tribute to his predecessor: "No one has dealt with this material more methodically than Charles Le Brun, and it is to his glory that we can say that all peoples have adopted not only his precepts but his very drawings."

With regard to mimicry, Camper expressed reservations with regard to the importance given the seat of the soul. Its mechanism must be sought in the action of the facial muscles and nerves. However, the recipes he proposes (nine masks) add nothing especially new, while his morphological demonstration of the relationships among species radically modifies their elements.

Man is the most perfect of creatures because he can walk upright and sit down. He is the only creature that can lie on its back. However, all creatures are made up of the same parts and according to the same principles. Birds and fish should be included in the

26

PETRUS CAMPER, METAMORPHOSIS OF COW INTO BIRD
AND QUADRUPED INTO HUMAN, 1791.
PHOTO: BIBLIOTHÈQUE NATIONALE.

quadruped class, as should horses and elephants. The skeletons of man, the dog, the eagle, and the penguin show striking similarities among their corresponding elements. The zoological world is one in its diversity. Thus, the anatomist attempts to lay down simple, foolproof procedures for drawing animals and for changing them, like a Proteus, one into another. Give or take this or that feature, a cow can be metamorphosed into a stork and the stork into a carp.

The process is depicted in two drawings (fig. 26). In order to transform the cow into a bird, its trunk must be brought upright, its forelegs must become wings, its neck must be elongated and made thin. A rearing horse undergoes the following modifications: the haunches are narrowed, the forelegs brought down the sides of the body, the thighs and legs follow the same vertical axis. The back loses its convexity. A beast in this position would naturally, like man, have a shorter neck, a rounder head, with a prominent nose and less jutting jaw, smaller feet. One need only follow physiological laws when rectifying the drawing (five toes for the foot), and the quadruped's metamorphosis is complete. Concluding his purposely paradoxical exposé, Camper expressed his own fear that he had not succeeded in laying down convincing rules for artists, but he hoped that he had given them "a broader notion of the progress nature appears to have prescribed in creating beasts," in other words, a mysterious and close affinity among all creatures.

The theory of facial angles, for which the scientist became famous, clarifies his concepts.[42] Man joins beast in the progressive sloping of the straight line from the forehead to the upper lip. The early demonstrations were set out in drawings of juxtaposed heads on the same plane. A forward inclination of the facial line produced a face "reminiscent of the antique," a backward inclination produced a black, and, gradually, "the clear profile of a monkey, a dog, a woodcock." A

simple displacement of the axis brought different creatures into being, one after the other, and simultaneously situated them on the evolutionary scale.

The geometric process, in short, followed the tradition of Le Brun, who had also worked with angles, but it changed their bases and added to them the notion of degrees of spiritual and physical development. Prior to formulating his conclusions, Camper brought in his observations of the cadavers he had dissected as a professor of anatomy at Amsterdam, the skulls he had received from the coasts of Africa and Asia, and Greco-Roman glyptics. With regard to the antique figures, he chose his materials carefully. Most of the engravings from gems were suspect because of their "Gothic taste." Nor was he pleased with Montfaucon's drawings, and it was well to be wary of Dürer who, although a clever man, had sown the seeds of a kind of bad taste that had subsequently spread throughout Europe, even to Italy. Winckelmann's fine works furnished the greatest number of valid ideas and reproductions.

A special apparatus consisting of a horizontal plane and a chassis with stretched strings was devised to take measurements and establish cranial axes as precisely as possible—countless drawings resulted from this process. The results showed that the facial angle is 42 degrees in a monkey, 58 in an orangutan, 70 in a young black and a Kalmuk, from 80 to 90 in a European, 90 in a Roman glyptic, and as much as 100 degrees in an ancient Greek. Beyond that limit, the head becomes deformed. Two plates (fig. 27) illustrate this succession of profiles and faces from simian to Apollo, whose skull has also been reconstructed. Although he established a barrier between beast and man in his dissertation,[43] in which he refutes current theories according to which the black was the issue of a white and an orangutan, Camper creates a film in which

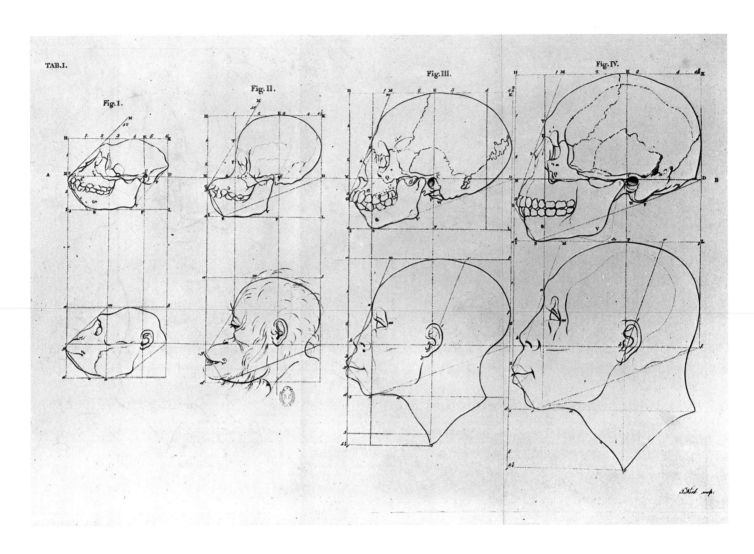

27

PETRUS CAMPER, CHANGE IN FACIAL ANGLE, FROM MONKEY TO APOLLO, 1791.
PHOTOS: BIBLIOTHÈQUE NATIONALE.

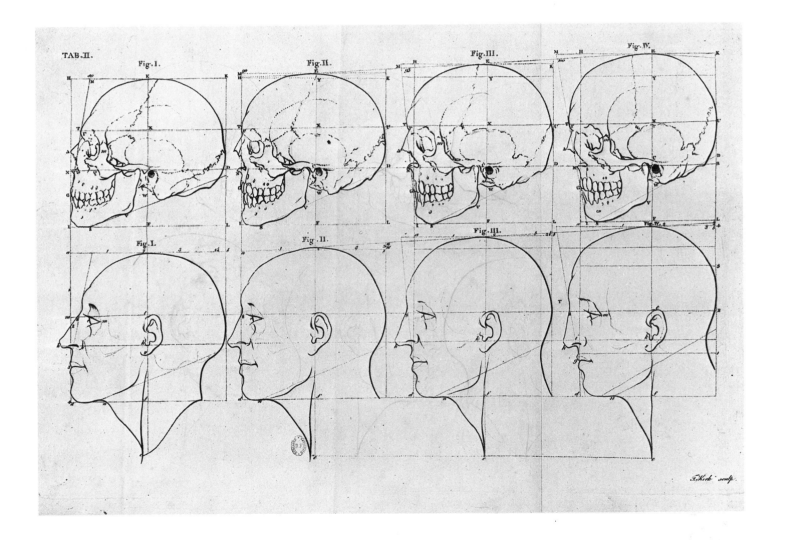

their images are linked by stages. The fruits of his labor, which represent a turning point in anthropology, did not appear until 1791, after his death, but he had communicated his results to the Amsterdam Academy in 1770 and to the Académie in Paris in 1778.

In the meantime, however, another scholar, some twenty years younger, had begun to publish important books on physiognomy. Lavater (1741-1801), a Swiss theologian and poet, took up the subject in 1772 at a meeting of the Société des Sciences Naturelles in Zurich. The publication of his paper gave rise to intense discussion, which in turn produced the four volumes of *Physiognomische Fragmente*, first published in German (1775-78),[44] then in a polished and recast French version published at The Hague (1781-1803),[45] and then at Paris (1806-9) in ten volumes, compiled by Moreau de la Sarthe.[46] The work is an encyclopedia both of theories on the question and its illustration, with a gallery of historical characters executed by artists through the ages—including Raphael, Michelangelo, Holbein, Rembrandt, Poussin, Hogarth. Two famous men, Chodowiecki and Goethe, were involved in the work. Chodowiecki did the illustrations, while Goethe closely oversaw the investigation.[47] Funk published 132 of the letters exchanged between them on this subject from 1773 to 1792.[48] On Lavater's own admission, whole sections of these fragments were written by the poet, who also did some of the drawings.

In the vast heterogeneous mass of information covering all branches of the doctrine, the nature of the passions, the expression of various ages, the ideal physiognomy, the physiognomy of beauty, illness, temperament, etc., the animal side was at first neglected. It comes up only in the second volume in German (1776) and in the two following volumes. In the Hague French edition, all of the zoological essays were assembled in the ninth *Fragment* of volume II (1783).

Lavater mentions Porta's theories, with negative comments, but his criticism is directed less at his matter than at his choice of examples, which are rife with doubtful cases and ignore the most striking resemblances. The monkey, the horse, and the elephant are poorly represented in his treatise, and yet they are the animals that enjoy the closest relationship with the human species. Nothing is more true than the proposition that identifies characters and forms, but the analysis should be more painstaking and imagination should be eschewed. In the German *Fragmente*, the illustrations—that of Socrates-stag among them—are borrowed from *De Humana Physiognomia*, in the French from Le Brun (the men-bulls), probably based on the *Livre de Pourtraiture* engraved by Simonneau.

Animal physiognomy is the principal subject of these chapters, but its study is pursued using procedures and criteria drawn up by humans: the expressions of animal heads and skulls are described in a similar way. Stupidity is evident in the fish, in its mouth and its relationship with the eye. There is something bogus about the horse's gaze. The curve of his nasal bone indicates malice, the jaw, sloth. The number and size of the elephant's bones reveal a violent character. Their rounded shapes are indicative of finesse, the mass of flesh, of flaccidity; the size and arch of the forehead indicates a strong memory. The lion has a "face," with a forehead like our own species's. The elements are reversed. We are no longer dealing with animal signs. The image of man is superimposed on the beast and reveals its character, even by contrast, for example with the monkey, which is nevertheless closest to us: "Do we find in the monkey that majesty that shines on the forehead of man, when his hair is drawn back?" Lavater exclaims during his presentation. "Where will you find eyebrows drawn with such art? their play, in which Le Brun found the expression of every passion and which, indeed, indicate much more than Le Brun thought to perceive in them?"

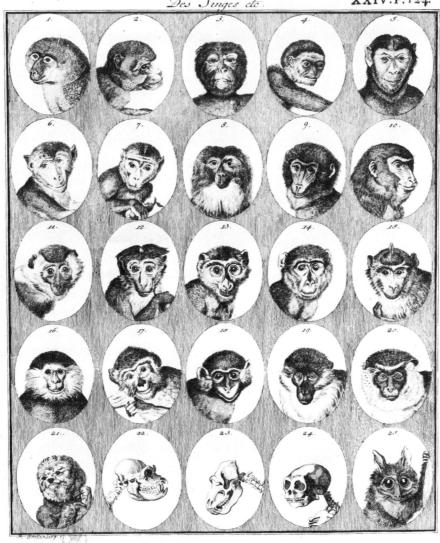

JOHANN CASPAR LAVATER, MONKEY PHYSIOGNOMY (1783 EDITION).
PHOTO: BIBLIOTHÈQUE NATIONALE.

The twenty-five simian figures (fig. 28) that accompany this text, wittily drawn as though to illustrate a fable, take on a deeply human tinge precisely because we compare them to this evocation of the higher being.

Shapes are all interpreted in the light of familiar notions. Thus, the physiognomist is nonplused when he encounters an anatomy that falls outside one of his common categories, like the elephant's ear, a large, united, flexible, soft ear that most likely has some great significance, but one impossible to decipher.

This zoological evolution by an author basically indifferent to his material created some surprise, and people wondered where Lavater had got the idea to introduce it into his work. Light was shed by Goethe. To a question put to him by Eckermann in 1829, "Was Lavater in his investigations turned towards nature?" the writer replied: "Absolutely not, his course led him towards behavior and the religious aspects. In Lavater's *Physiognomonie,* the material on animal skulls comes from me."

The chapter, the first in which the system appears in the *Fragments,* was delivered when the second volume was already being printed. Goethe was also the one who pointed his friend towards Aristotle's *Physiognomie,* raising the problems as a whole.

The text on skulls contains elements of the method followed in all other cases.[49] The skeleton is a schema of the external forms, one that sums up their data with dryness and concision. The signs are denuded and brutally laid bare. We are close to caricature, but in a transfigured world. With their jaws, their teeth, their empty eye sockets, these heads have an expressive power that is both supernatural and true, and they reveal to us an underside of life. In making his analyses, Goethe proceeds like an osteologist, while still scrutinizing the signs of mind. The fall of the dog's skull from the eye socket indicates, he finds, subservience to the power of the senses. In the wolf, the lower jaw bears the imprint of severity, whereas in the hyena, the back of whose head differs from the former, the knot in which it ends signifies a high degree of stubbornness and inflexibility. The beaver's long teeth, which meet in an arch, show kindness and weakness. With regard to the elephant, the summit, forehead, and occiput of its skull are the very image of prudence, understanding, intelligence, energy, and delicacy (fig. 29). We have seen that Lavater touched up these conclusions.

These are crackpot notions. The introduction to the chapter contrasts men with animals by returning to the old notion of a microcosm. The human skull rests on the spinal column like a dome atop a pillar, catching the sun, whereas in animals the head hangs down and the brain is merely the prolongation of the spinal chord, its powers limited to the needs of the vital spirits. However, the poet reads the bone structure of quadrupeds in keeping with anthropomorphic signs. The pungent effects of his vision, its philosophical and literary flavor, foreshadow modern German expressionism.

The same extension and reversal of method are to be found in Johann Heinrich Wilhelm Tischbein, who visited Lavater in Zurich from 1781 to 1782 and who traveled in Italy with Goethe (1787). His theories, as set forth in *Natur und Meinung* [*Nature and Meaning*], endow animals with the human temperaments (sanguine for plant eaters, choleric for carnivores),[50] and the animal physiognomy he published at Naples in 1795 is steeped in such notions.[51]

After having treated separately, albeit on the same level and by employing the same analytical systems, the physiognomy of men and the physiognomy of ani-

GOETHE AND LAVATER, PHYSIOGNOMY OF ANIMAL SKULLS (1783 EDITION).
PHOTO: BIBLIOTHÈQUE NATIONALE.

mals, Lavater ends up by constructing an evolutionary
theory. The last, posthumous volume (French version,
1803) shows the successive changes in species, analo-
gous to Camper's table. The author maintains that
this notion came to him prior to his reading the
Dutch scholar's dissertation, and that his presentation
is more precise: raising the facial line to 90 degrees is
a mistake, the most beautiful European heads never go
beyond 80. The gods and heroes of antiquity, which go
up to 100 degrees, are neither naturally handsome nor
humanly true. And he proposes his own scale of facial
angles, which he dubs "the line of animality," on
which one can see a development that also ends with
Apollo, but that begins not with the monkey but with
a frog, and that goes through twenty-four rather than
eight stages (fig. 30). The creatures that follow the first
batrachian head, "an image replete with the most ig-
noble and bestial nature," through to the midpoint in
this evolution undergo a progressive humanization.
They are fantastic monsters in which the nose, the
forehead, and the chin gradually emerge and the
mouth and eyes grow smaller. "The frog, more sensi-
ble" (no. 3); "the first degree of non-brutality" (no. 10);
"the first level of human character at 60 degrees" (no.
12)—all this is sheer imagination. Then we have "the
mixture of imbecility and goodness" (no. 14), heads of
the 62nd degree that combine dignity and reason with
the perfection achieved in no. 22. In their striving
after beauty the Greek profiles of nos. 23 and 24 trans-
gress the norm. The forehead is stupid, the eye inex-
pressive. The lowly animal, the antique god, men of
all categories, and marvelous hybrids are all lumped
together in one single group. A constant metamor-
phosis occurs on the basis of the same data and with
respect to the same line. We are no longer, as in
Camper, witnessing a rigorous demonstration based on
working drawings from life. Evolution occurs capri-

30

JOHANN CASPAR LAVATER, "FROM FROG TO APOLLO" (1803 EDITION).
PHOTOS: BIBLIOTHÈQUE NATIONALE.

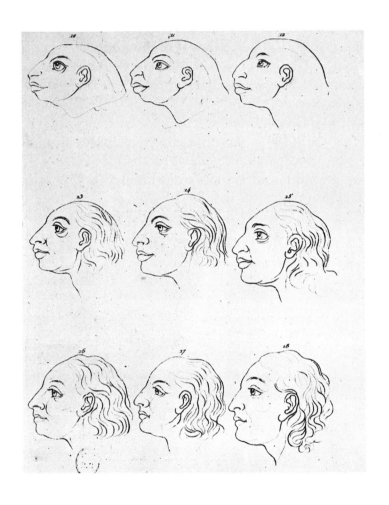

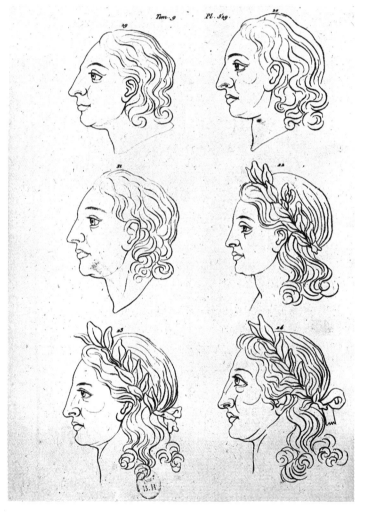

ciously, with invented creatures, but it includes the same kaleidoscope of human and animal forms. Gilbert Lascaut wonders if the drawings may not indicate some unconscious or conscious memory of the myth of Latona, mother of Apollo, who turned the Lycian peasants who lacked respect for her into frogs.[52]

Lavater's plate has aroused keen interest in certain minds alert to paradoxical games of this sort. In his article on caricaturists, Baudelaire was to write: "Experiments have been made on the head of Jesus and the head of Apollo and I think someone managed to make one of them resemble a toad."[53]

Obviously the poet of *Les Fleurs du Mal* was intrigued by these reproductions of graduated inferiority and perfection in the same body.

Anthropomorphic and zoomorphic studies did not bring such speculations to a halt. After Lavater came Dr. Gall (1758–1828), who invented a new branch of science he called phrenology, whose system consists in discerning the aptitudes of men and animals from the configuration of their skulls, which mold the brain.[54] Instead of a single gland acting as seat for the entire soul, as Descartes held, there are twenty-seven organs (their number was later increased to thirty-seven), each corresponding to one of the multiple faculties. Brain and soul are divided into dozens of chambers. In order to describe them, the doctor studied countless skulls and managed to establish a detailed topography of the characters and the passions. Thus, the organ of goodness was sited in an elongated protuberance in the frontal bone, prominent in Marcus Aurelius, Antoninus, St. Vincent de Paul, Henri IV. Animals have it in the same area. Horses with this area raised are gentle, docile, and good. They become wild and prone to bite if the area is depressed. Here we no longer see a mimicking expression, as we do in Goethe's study. The osteologist may be working with

pure shapes, but he arrives at the same result. Stables and prisons, the heads of beheaded murderers, death masks—Kant's among them—and old portraits: everything was grist for his observations. Dr. Gall lived among heads and skulls, deciphering on their surfaces the worlds they contained. Confined within clearly fixed limits, every faculty and every inclination—love, vanity, pride, craftiness, a tendency to murder, the meanings of words—could all be read like a relief map. It is as if the moral image had been recorded in the lumps, depressions, and level areas of the skull.

Relationships with the animal world underpin the method. Man as an animal cannot be isolated from the rest of the living world. The difference resides principally in the complexity of his organs and the degree of their power. Their topography is analogous and their action is identical. The functioning of a gland has an effect outside the moral domain; it also gives rise to physical reactions that are translated into movements. The resultant "pantomime" is dictated by the site of the motive force: when it is sited in the lower regions of the brain, the head and the entire body are lowered; they rise when the site is higher; two-part organs produce symmetrical movements.

In establishing this rule, the phrenologist observed spontaneous reactions in all creatures and found unusual similarities; for example, for the expression of affection, the organ for which is sited in the occipital region, one bends the head back and to the side. Thus, "In Raphael's *Madonna with Rabbit*, the Virgin presses this area of the head against the corresponding area on the head of the Child," while cats demonstrate their affection by turning their head laterally from top to bottom and gently rubbing the organ against the person they are caressing. The organ of caution, sited in the region of the parietal bones, causes one to move the head around and back simultaneously, the same movement in man, squirrels, hares, and cautious birds

like the woodpecker. Sited in the temples, the organ of the arts causes the head to tilt alternately in both directions, like birds or hunting dogs examining an object. The milliner examining a finished hat makes an analogous movement while drawing her work closer to the right-hand organ and then to the left-hand organ. Piranese, who is depicted on his tombstone reflecting on his art, is shown in the process of executing the same movement. The pantomime of men and animals is based on a similar physiology and is expressed through the same signs.

In the diversity of their concepts and methods Camper, Lavater, and Gall did no more than revive and develop the ancient sense of the close community that exists in animate nature among forms, characters, faculties, and passions. Age-old thinking about the occult, developed along with man himself, was given new impetus through positive research, but its spirit remained the same. The science of the unknown always comes up against the unsolvable. The more refined it becomes, the more rarefied its notions; the more it attempts to base itself on solid facts, the more it wanders off into fictions. The enormous success of these dissertations is, in the end, due to the scientific tenor with which they are imbued, with all its apparatus of anatomical cross sections, diagrams, plates, and scientific terminology. The romantics saw these three scholars as Fausts of the human phenomenon. Their fame was world-wide and their doctrines were in vogue in the most varied circles. Camper's works were printed at Paris in 1803, at London in 1821. The effect of Lavater's ideas was particularly striking in France. The house of the Alsatian poet Pfeffer, in which the *Sturm und Drang* poets met, and the vicissitudes of the French Revolution, which led to increased contacts between the emigrés and the Zurich pastor, also played their parts.[55] The 1806-9 Paris edition of the *Fragments* was followed by a second in 1820; two

years earlier came the final volumes of Gall, who had moved to Paris in 1808 and held court for his followers there.

Whatever the reactions to their learning and the nature of their studies may have been, these scholars were regarded as outstanding personalities; "one of the most singular characters of the century," Mirabeau (1786) said of Lavater,[56] whom he treated as a magician and a pious man, a bizarre mixture of dementia and wit, ignorance and knowledge, linked to Cagliostro. A popularizing work (1836) of the period informs us that "there is a kind of man who is privileged to plunge into the ineffable mysteries of the mind, to bathe in its infinite and eternal essences. Enveloped in the finite of the body and the boundaries of time, they break the mold . . . they have the gift of second sight."[57]

Such men were Pythagoras, Plato, Saint John of the Apocalypse, Dante, Swedenborg, Hoffmann. Lavater is one, while Gall represents the genius that breathed new life into the scientific life of Europe. Such exaggerated judgments illustrate, if not its precise impact, at least the stir and enthusiasm their work aroused.

The image of man as recreated during the course of this period's researches into reality could not help but be affected by modern anthropology. It is a rare occurrence in the history of forms that the relationships between poetic vision and scientific doctrine should be so close. This is as true for literature as it is for art.

We know Balzac's interest in physiognomy and phrenology.[58] He brings them in at every opportunity. "Lavater's *Physiognomonie* has created a true science that has finally won a place in human knowledge. Gall, with his excellent theory of the skull, has filled out and completed the Swiss [scholar's] system and given solidity to his acute and luminous observations," wrote the author of *La Comédie Humaine* in *La Phy-*

siologie du Mariage (limited edition prior to official publication, c. 1824), and he often employed their methods in describing his heroes. Balzac's descriptions involve physiognomical analysis, usually when characters are being introduced. These often take up whole pages, listing the characters' outward appearances and passions, often with reference to animals.

With his long nose, his flattened nostrils, and his large mouth, the old man in *Le Centenaire* (1822) resembles a bull. The physiognomy of the mysterious healer, with his vast strength and magnetic powers, is like a lion's (*Ursule Mirouet*, 1841). Count Adam resembles a goat (*La Fausse Maîtresse*, 1842). Père Séchard (*Les Illusions perdues*, 1837) has an ursine physiognomy; the Duke (*Massemilla Doni*, 1839) has a bizarre likeness to a dog, Bongrand (*Ursule Mirouet*) to a fox, Céleste (*Les Petits Bourgeois*) to a mouse. There are noses like the crow's beak (Moreau, in *Un Début dans la vie*, 1842) or hooked, like that of an eagle (M. d'Hausterre, in *Une Ténébreuse Affaire*, 1841), eyes like a cat's (Boniface Cointet, *Les Illusions perdues*), like those of a bird of prey (*Le Vicaire des Ardennes*, 1822), a goat (Goupil, in *Ursule Mirouet*). These are not chance images. The theory that man is marked by animal signs is borne out in all three examples. Balzac himself emphasizes this when, in *La Recherche de l'absolu* (1834), he says that Balthazar Claes's face, like that of a horse, could serve as further proof of "the scientific system that attributes to each human face a resemblance to the face of some animal." Furthermore, this horselike face bears on its broad forehead the protuberances Gall deemed to be the orbs of poetry.

The writer's physiognomy is not solely a rigorous application of the most recent developments in anthropology. It also revives the dreams and speculation of an earlier age. "The scientific system" whose laws are invoked is not in conformity with the concepts derived from Camper; it harks back to prior cycles. It is a return to the primitive notions and forms, but that very return is due to a contemporary factor.

The publication of Lavater's work by Moreau de la Sarthe (1806-9) entailed more than just the labor of the Swiss physiognomist. The work also included an exposé of modern (Camper, Gall) and ancient theories, and the latter took on a special scope; they were dealt with in the following order. After the "line of animality" and "the physiognomy of animals" there was a chapter on "the relationships of the physiognomy of man with that of animals." The author expresses reservations with regard to Porta's work, and the faces of men-bulls by Le Brun-Simonneau that accompany it in the 1783 edition (The Hague) are called caricatures in which the eye is grossly exaggerated and ill suited to an overly human mouth. At this point, something unexpected happens: an editor's note defends the scholarly Neapolitan, "usually so ingenious," and reproaches him only with having overlooked the dog, the animal the most friendly and essential to society. And it is precisely these two authors, with whom Lavater deals so harshly, that will occupy the main part of the book (volume IX, 1807). We find all the versions of the *Physiognomonie* of the First Painter to Louis XIV, the abridged version (Testelin) and the version by Nivelon-Morel d'Arleux, which had appeared less than a year earlier, in 1806, the entire series of drawings (including the men-bulls), along with extracts from Porta with the classical references (Aristotle, Adamantios, Polemon, Albertus Magnus, Rhazes) relative to each type—in short, the entire last section of *De Humana Physiognomia*.[59] The whole publication is a synthesis and reassessment of the antique foundations, but filled out with the latest concepts and practices. This most recent revival of such systems is rooted

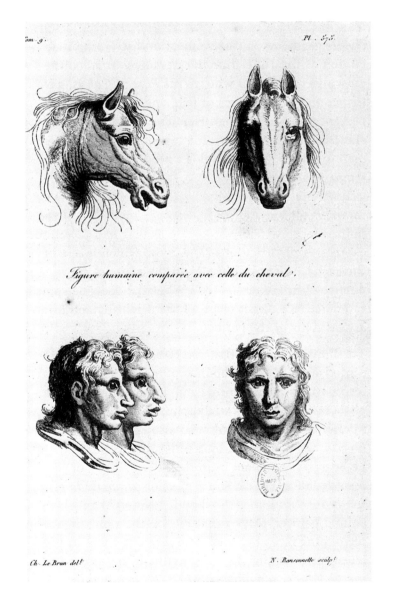

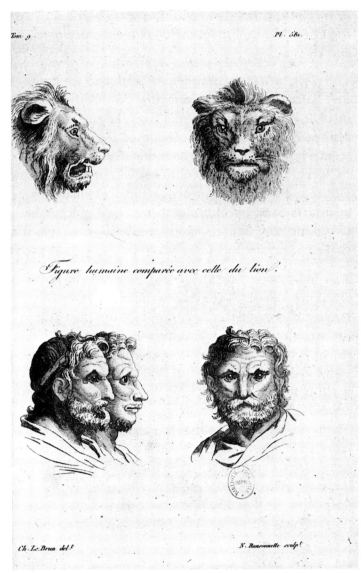

31

32

CHARLES LE BRUN, MAN-HORSE, AFTER EDITION OF LAVATER
PUBLISHED BY MOREAU DE LA SARTHE, 1820.
PHOTO: BIBLIOTHÈQUE NATIONALE.

CHARLES LE BRUN, MAN-LION, AFTER EDITION OF LAVATER
PUBLISHED BY MOREAU DE LA SARTHE, 1820.
PHOTO: BIBLIOTHÈQUE NATIONALE.

35

GRANDVILLE, "MAN DESCENDING TO BRUTE," 1843.

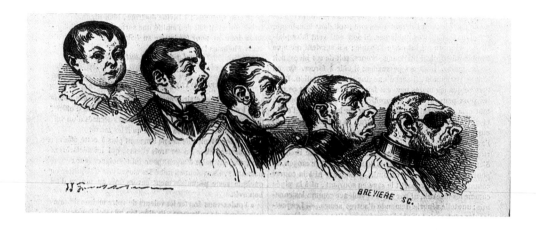

36

GRANDVILLE, "APOLLO DESCENDING TO THE FROG," 1844.

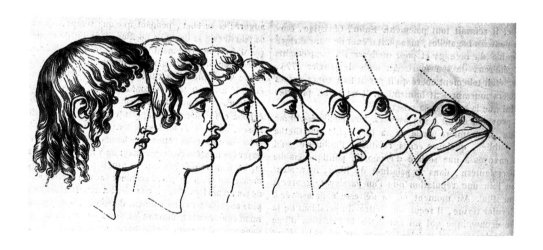

37

HONORÉ DAUMIER, "THOSE WERE THE DAYS . . . ," 1841.
PHOTO: BIBLIOTHÈQUE NATIONALE.

tion than at human merit. The work of the scientists was perfectly echoed in artistic milieus, but in Lavater it is always Le Brun who strikes us, and it is also owing to his work that humanist aspirations are reflected in these compositions. The delayed action is effective and extends to include a whole group of systems. The complex development by which he, in his erudite aberrations, renewed the bases of human zoology ended up by revivifying its original status on every level. The obsessions, which took on a dramatic form in the work of Daumier (1832-39),[68] work that oscillates between fable and life, arise out of this new and final blossoming of age-old traditions (fig. 37). In England, Cruikshank's *Zoological Sketches* (1834) form part of the same current (fig. 38). However, all types of such figurations of animals and hybrids as human beings, which now began to multiply in illustrations for La Fontaine, for droll tales and various spoofs, reflect this anthropology, whatever their immediate origins. "A lynx with a sheep's face" (1834), "a rabbit's head on what was once a snake" (1839),[69] said Gavarni, the "poet of the natural history of mankind,"[70] when describing some of his subjects, while Grandville's illustration of a dance in Paris with galloping horses, like the vision of a world upside down, provided Balzac with a new opportunity to voice his convictions: "Carnival, Sire, is the only superiority man can have over animals. This invention cannot be taken from him. It is at that time that we begin to believe with certainty in the relationships between Mankind and Animality, because at that time so many animal passions come to the surface in Man that such affinities become undeniable."[71]

This passage is a comment on a burlesque, but Balzac's way of presenting his thoughts, and the very terms he uses, refer directly to the kind of problems treated in learning works in the positive sciences. Ro-

38

GEORGE CRUIKSHANK, FROM *ZOOLOGICAL SKETCHES*, 1834.
PHOTO: BIBLIOTHÈQUE NATIONALE.

mantic illustrations were still inspired by such rigid logic. Men marked with bestial features, as if by a memory,[72] the circus of trained animals, finer and more capable than we, the burlesque game of caricature, all come together in age-old speculations about the secret relationships between beings. Even when no specific signs can be discerned, the notion of a type of fauna associated with a population or social class, with a "realistic" image of man, a notion that haunted romanticism, is in harmony with the essence and nature of that world.

The surrealists of our own time could not remain indifferent to these speculations on animal forms, and some of them drew upon them for their own early pictures. Two portraits of Philippe Soupault, one of the founders of the movement, by Labisse and Masson, draw directly upon their models: one is the man-dog by Giambattista della Porta, the other Rubens's leonine man, which were included in the first edition of the present work (1957).[73] Indeed, these are still the oldest illustrations of the doctrine that is today coming back into its own (figs. 39, 40).

Antique thought, which traversed the Middle Ages and the Renaissance and was recast in seventeenth-century speculations, is revived in all its multiple aspects. By a curious contradiction the innovative ideas of human science reanimate and propagate primitive beliefs that are defined by some vision, some feeling. The primal beast has always manifested itself in our movements and features. The photographer who caught such likenesses and laid out side-by-side comparisons with contemporary heads for a Parisian weekly did so spontaneously, sure of their deep significance, as was probably also the case in the beginning, at the dawn of time. Romantics found the same similarities, but via the legends and theories to which they gave birth.

39

PHILIPPE SOUPAULT BY MASSON, *LE MONDE,* 1981.
COPYRIGHT SPADEM.

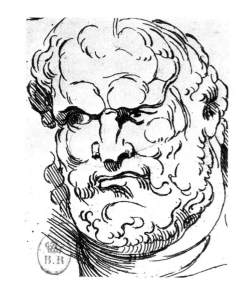

40

PETER PAUL RUBENS, LEONINE MAN.
PHOTO: BIBLIOTHÈQUE NATIONALE.

Plates

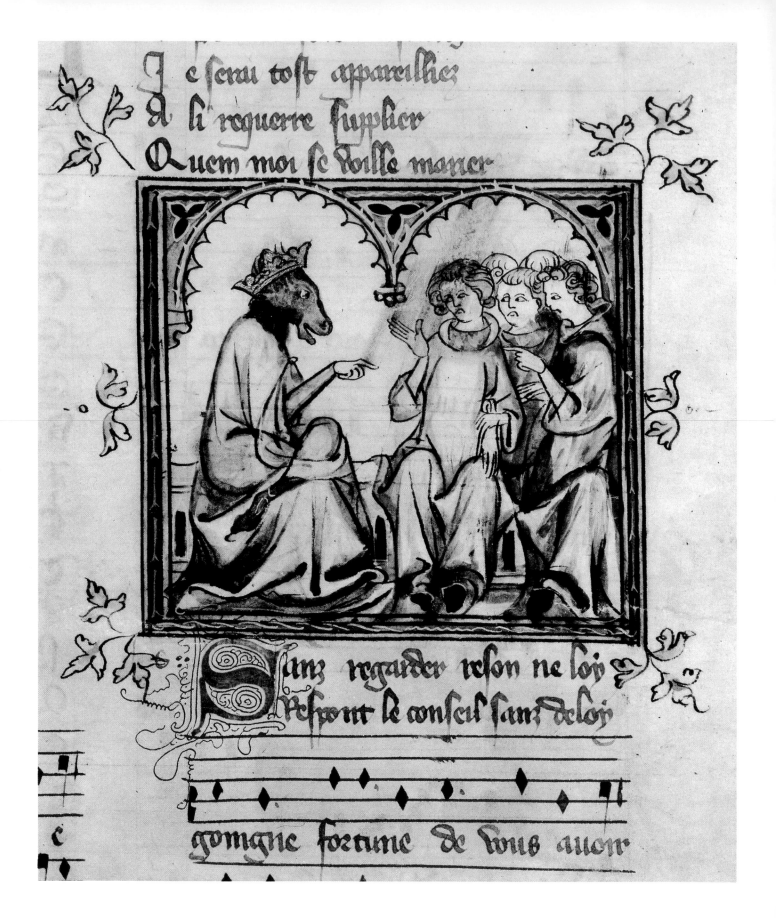

Plate 1

CREATURE, HALF-HORSE, HALF-MAN. FIRST THIRD OF THE FOURTEENTH CENTURY.
BIBLIOTHÈQUE NATIONALE, MS. FR. 146. PHOTO: BIBLIOTHÈQUE NATIONALE.

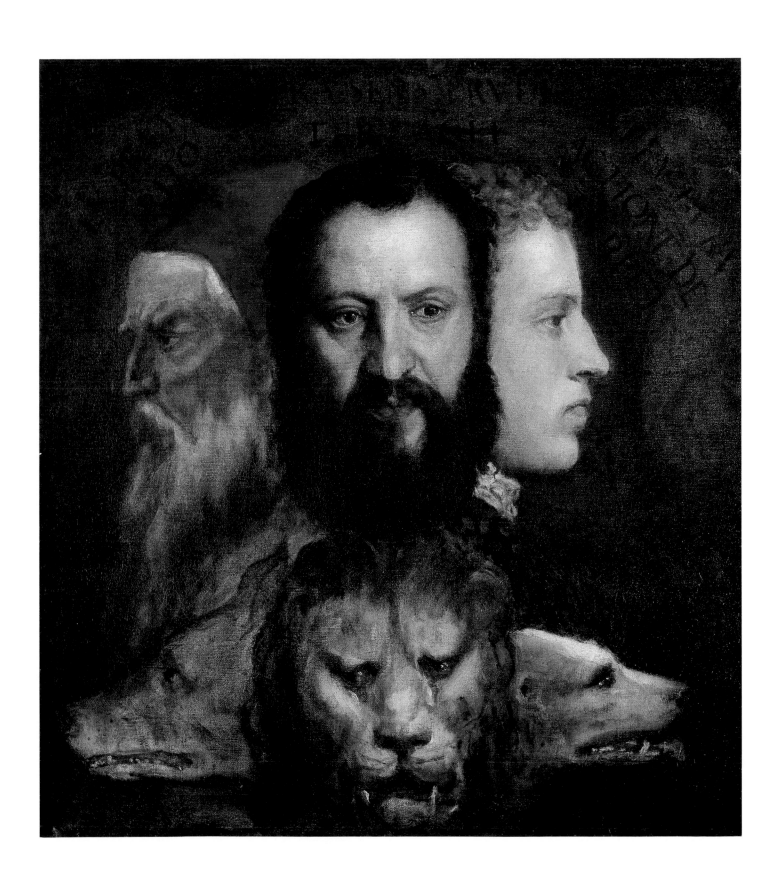

Plate 4

RUINIFORM MARBLES.
COLLECTION OF CLAUDE BOULLÉ, PARIS. PHOTOS: FLAMMARION.

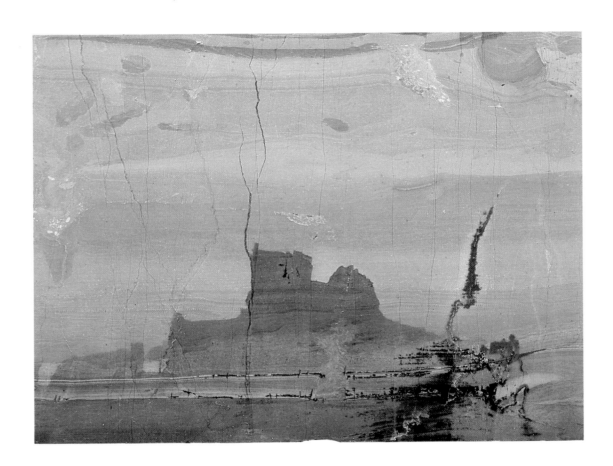

Plate 5

LANDSCAPE STONES, TUSCANY.
COLLECTION OF CLAUDE BOULLÉ, PARIS. PHOTOS: FLAMMARION.

Plate 6

ABOVE: JASPER, OREGON;
BELOW: JASPER SANDSTONE, PROVINCE OF SALAMANCA, SPAIN.
COLLECTION OF CLAUDE BOULLÉ, PARIS. PHOTOS: FLAMMARION.

Plate 7

SEPTARIUM, CANTABRIAN COAST, SPAIN.
COLLECTION OF CLAUDE BOULLÉ, PARIS. PHOTO: FLAMMARION.

Plate 8

ORBICULAR JASPER, MADAGASCAR.
COLLECTION OF CLAUDE BOULLÉ, PARIS. PHOTO: FLAMMARION.

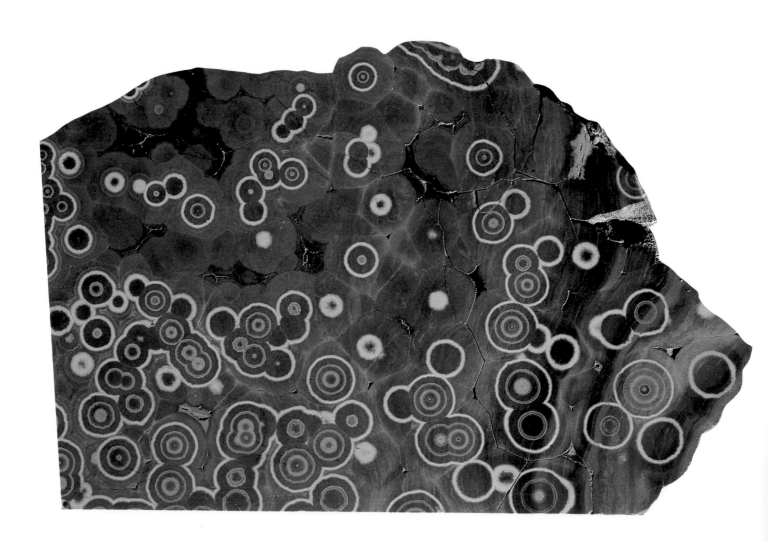

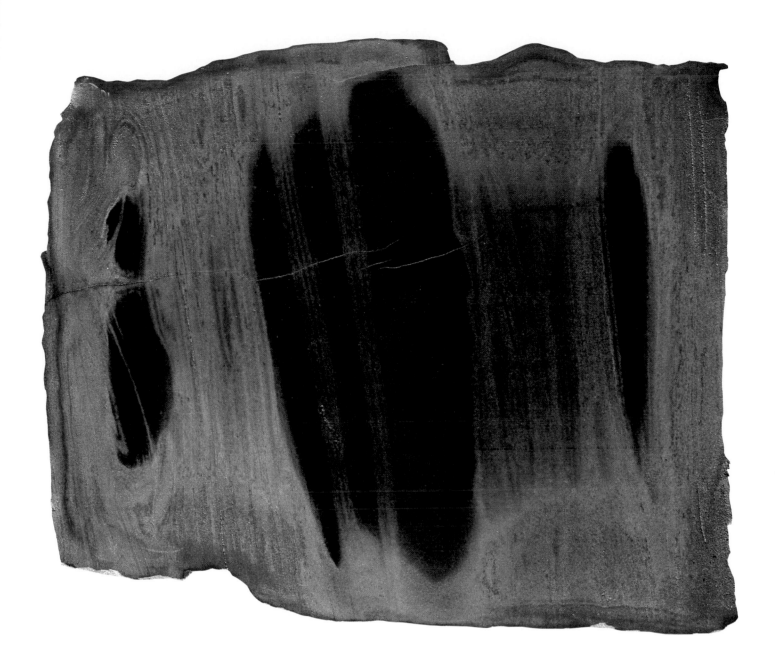

Plate 9

DOLERITE, GABON.
COLLECTION OF CLAUDE BOULLÉ, PARIS. PHOTO: FLAMMARION.

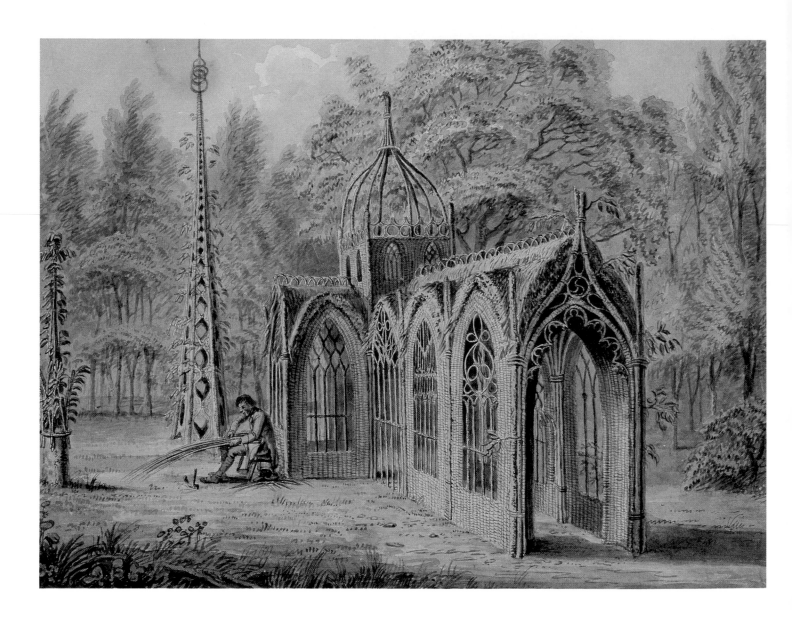

Plate 10

EDWARD BLORE, *J. HALL'S ARBORESCENT CHURCH,* MID-NINETEENTH CENTURY, WATERCOLOR.
LONDON, BRITISH ARCHITECTURAL LIBRARY, RIBA. PHOTO: J. STRAUCH.

Plate 11

BOTTICELLI, *MYSTICAL NATIVITY,* 1501.
LONDON, NATIONAL GALLERY. MUSEUM PHOTO.

Plate 12

HUBERT ROBERT, *PAYSAGE COMPOSÉ.*
ROUEN, MUSÉE DES BEAUX-ARTS. PHOTO: ELLEBÉ.

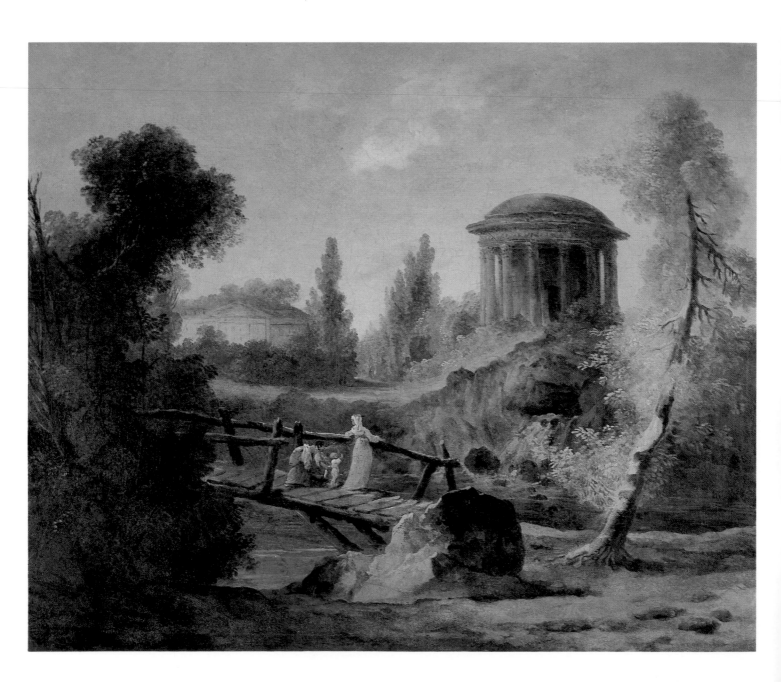

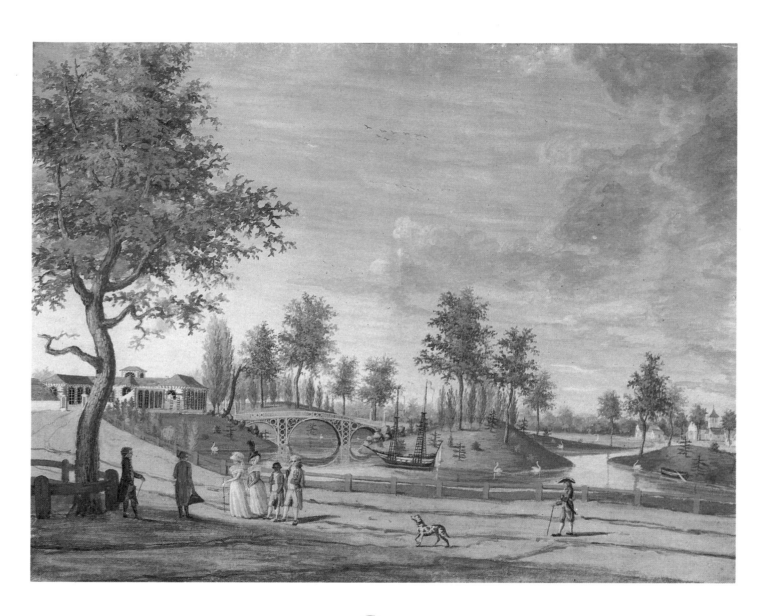

Plate 13

CARMONTELLE (LOUIS CARROGIS),
SCÈNE RIANTE: L'ORANGERIE, LE PONT ET LE RENDEZ-VOUS DU RAINCY.
PARIS, MUSÉE MARMOTTAN. PHOTO: J. MUSY; COPYRIGHT CNMH SPADEM.

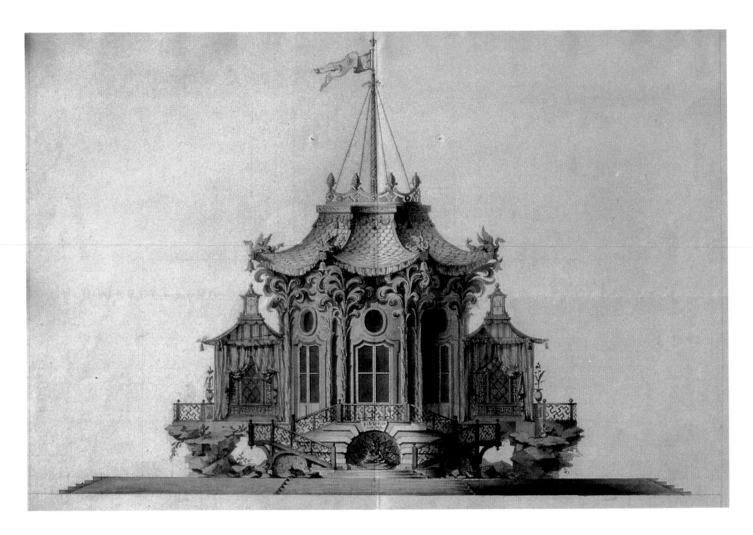

Plate 14

M. B. HAZON, ELEVATION OF A CHINESE BELVEDERE.
BLOIS, ARCH. DEP. DU LOIR-ET-CHER. ARCHIVE PHOTO.

Plate 15

"CONSTRUCTIONS FOR DECORATING GARDENS," LITHOGRAPH BY D. MOTTE
IN *PLANS RAISONNÉS DE TOUTES LES ESPÈCES DE JARDINS,* 1820.
PARIS, ÉCOLE DES BEAUX-ARTS. PHOTO: J. MUSY; COPYRIGHT CNMH SPADEM.

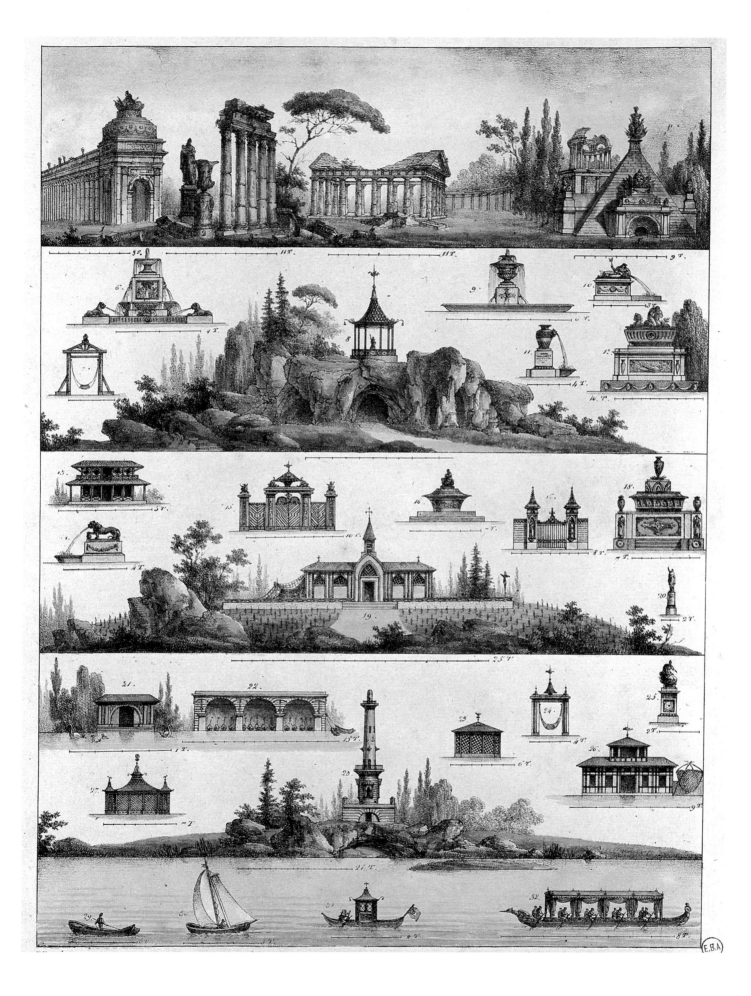

Pictorial Stones

41

MATIEU DUBUS, *DESTRUCTION OF SODOM AND GOMORRHA*, SEVENTEENTH CENTURY.
COLLECTION OF J. COMBE, PARIS. PHOTO: FLAMMARION.

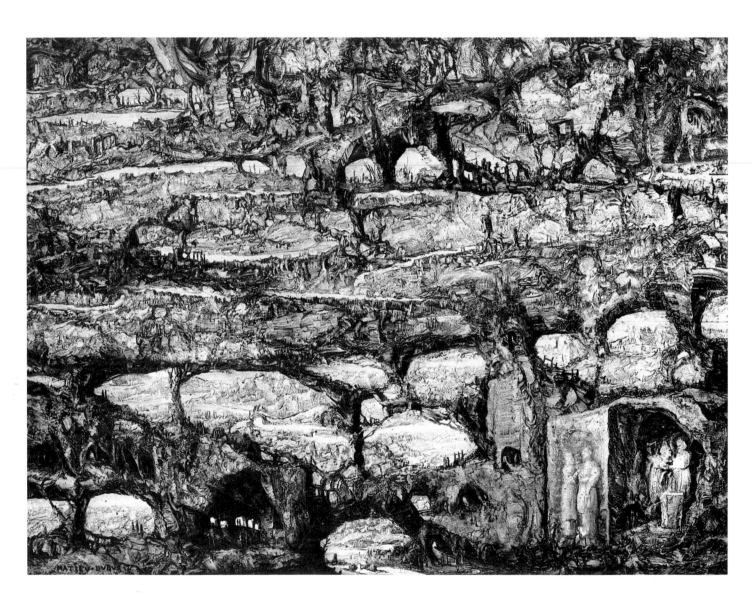

If you look at walls that are stained or made of different kinds of stones and imagine some kind of scene, you begin to see them as creating a setting and you can think you see in them certain picturesque views of mountains, rivers, rocks, trees, plains, broad valleys, and hills of different shapes. You can also find in them battles and rapidly moving figures, strange faces and costumes, as well as an infinite number of things you could reduce to a clear and complete form.

And all that appears confusedly on walls is very like the vibration of bells: you can hear in their ringing all the sounds or words you want to imagine.[1]

This text, among Da Vinci's best known, is directly applicable to a strange picture that seemed at first glance to be nothing but a rubbly wall, on whose surface fantastic landscapes now appear to loom (fig. 41).[2] The mortar outlines and joins areas until they look like the wide meshes of a net. Petrified trees like the rocks create an irregular armature, slabs of marble reveal limitless spaces with rivers and valleys, mountains and lakes. There is a desolate landscape strewn with rocks. On the upper levels ragged ruins with increasingly bizarre shapes—dolmens, menhirs, gaping archways, tumble-down walls, gibbets—stand on every side, a vastness of death and punishment through which minuscule figures wander aimlessly. Whole cities lie in ruins in the aftermath of some fire or earthquake, reduced to skeleton shapes. It is a landscape of catastrophe which, at the top of the picture, is absorbed into the chaos of the mineral veining as though into the smoke of a furnace.

In the right foreground two people are standing in a cave, one in an attitude of supplication, behind a rustic table (an altar?); to the left of the entrance is another group of three men who seem to stand out in relief against the face of a rock wall. Yet the living figures and the stone figures both seem to be partici-

pating in the same action, giving us as it were the key to the composition in which every vision has been created by or derived from the minerals. Everything in this picture is a puzzle, confusion, but we can still identify a story from Genesis. The three persons mysteriously delineated against the rock are the three men who appeared to Abraham prior to the destruction of Sodom and Gomorrha, the two others represent the patriarch interceding with God on behalf of the two condemned cities. Beyond lie the devastated Cities of the Plain, their inhabitants, and the fruits of the earth. They are consumed by the sulphur and fire God has caused to rain down upon them. The figures making their way through the maze of roots and ruins, in groups of two or three, represent the survivors. It is not so much a scrupulous illustration as an evocation of the event veiled in the stone, in the same way that we seem to hear words in the ringing of bells.

The picture is the work of a Flemish artist living in The Hague, Matieu Dubus (1590-1665), and was painted in the middle of the seventeenth century. The process had been in use for some time, but in general it had been used for painting directly on stone. We know of several pictures in which the figures have been painted on slabs or sheets of agate or on marble, the natural texture of which creates the surrounding landscape decor. Philipp Hainhofer, an Augsburg art lover and merchant, made a specialty of dealing in such works. The *Kunstschranken* or "chests of marvels" that he delivered to Philip II, Duke of Pomerania, in 1617 and to the Swedish King Gustavus Adolphus in 1632 bore a number of sets of this type.

The description of the first of these pieces of furniture, written at the time it was created, lists painted stones and indicates the figurative character of some of them; there is a jasper inset depicting the three Fates whose markings evoke a site with "resembling" buildings.[3]

42

PAINTING ON AGATE: THE SANGUINE, THE PHLEGMATIC, THE CHOLERIC, AND THE MELANCHOLIC.
BERLIN, KUNSTGEWERBEMUSEUM, CABINET OF PHILIP II.
PHOTO: STAATLICHE MUSEEN PREUSSISCHER KULTURBESITZ.

This clever interplay between the material and the subject it supports is to be found in many compositions. Medallions of the Four Temperaments have allegorical figures on agate whose brilliant, veined surface suggests depths and lights (fig. 42). We can make out bodies of water, rocks, vistas of sky, and varied landscapes. Each stone was selected to fit the theme: solid, undulating layers for the Phlegmatic (a sea god and a triton), formless clouds for the Melancholic (a man and woman lost in thought) and the Sanguine (a pair of lovers and a musician), and marbled brightness for the Choleric (two armed warriors and a lion).[4] We see a half-abstract decor that sets off the image as a musical background enhances the recitation of a poem.

In certain cases the iconography seems to spring directly from the stone's arabesque. The *cabinet* for the Swedish sovereign has two large agate insets (43 × 35.5 cm.) on which the scenes of the Passage through the Red Sea and the Last Judgment seem to burst from the veined volutes in the stone.[5] Johann König (1586-1635), the creator of these scenes, had only to follow the pattern. The column of the children of Israel advances through the space created by the marbling, which resembles the divided Red Sea. The rising clouds, the reforming waters, the towers of spray, all are created by the mineral concretion that engulfs Pharaoh's chariots, horsemen, and entire army (fig. 43). The scene of the Last Judgment depicts the damned drowning in a similar flood while Christ, seated on a rainbow between the Virgin and Saint John, and the other elect are placed in the more peaceful upper portion of the inset. The milky veining and deep smoky markings in the stone recreate the very image of some cosmic upheaval (fig. 44). The piece is also decorated with marble plates, one of which depicts the sea, with a painted naval battle copied after Callot (fig. 45).[6]

Hainhofer had his pictorial stones shipped from Italy. In his correspondence with his brother, at Florence in 1611, he often mentions mineral rocks that contain images of landscapes and trees. He frequently uses the adjective "Florentine" when referring to them: he mentions "Florentine stones" *"mit selbstgewachsenen Landschaften und Geböwen"* [with naturally created landscapes and buildings] and "a pretty landscape created by God and Nature in a Florentine marble, very like a city with a high tower" in his account of his journey to Dresden and to Innsbruck, where he went in 1628 to take delivery of a *cabinet* made in Tuscany for the Archduke Leopold of Austria. The piece, which is like the ones he himself had had made, was encrusted with agates, cornelians, chalcedony, and jasper and also had small oil paintings in which art and nature played with each other (*"ars und natura mit ain ander spielen"*).[7]

The interplay of art and nature was integrally represented by art when the marble was created in paint as well. Landscapes, houses, ships in storms, human figures, whole scenes were created by apparent mineral meanderings that were actually imitations created by the same hand. The altars of the rural church at Appending (Bavaria), with their wooden *faux marbre* panels, are fine examples of such counterfeits. The work was done in the workshop of the Zellnes, father and son, who specialized in *Gemalten Marmorierungen* [painted marble work], in which the genius of the baroque pursued its imaginative game even on a poorer substance.[8] Miraculous stones that somehow seemed to reflect the surrounding world were very fashionable at this period. They can be found in most of the *Kunstkammern*, always piled high with works of art, scientific instruments, exotic objects, and all sorts of natural oddities, and in particular in one of the most famous of these collections, at the Tyrolean

43

JOHANN KÖNIG, *CROSSING OF THE RED SEA,* PAINTING ON AGATE, 1632.
UPPSALA, CABINET OF GUSTAVUS ADOLPHUS. PHOTO: UNIVERSITY OF UPPSALA.

44

JOHANN KÖNIG, *THE LAST JUDGMENT,* PAINTING ON AGATE, 1632.
UPPSALA, CABINET OF GUSTAVUS ADOLPHUS. PHOTO: UNIVERSITY OF UPPSALA.

45

NAVAL BATTLE AFTER JACQUES CALLOT, PAINTED ON MARBLE SLAB, 1632.
UPPSALA, CABINET OF GUSTAVUS ADOLPHUS. PHOTO: UNIVERSITY OF UPPSALA.

Castle Ambras, the cradle of the collections of the House of Habsburg. As late as 1687 a visitor to the fourteenth gallery there noted "stones representing trees, fruits, shells, animals, that are pure works of Nature."[9] Not only were there panoramic views; living creatures and objects also emerged from the sinuous markings on the stones.

Museum catalogues frequently mention such wonders, with detailed descriptions of their appearance. The catalogue of Olaus Worm, a Copenhagen doctor, which was published in 1655 at Leyden, is particularly revealing.[10] Like Hainhofer, he calls such stones "Florentine." In general, they are ash-gray in color, but covered with dark lines and areas that form towers, temples, mountains, rivers, and entire cities. The collection included three such fragments: first, an unpolished marble slab showing a city on two rivers, stumpy towers and ruins "standing out as clearly as if they had been painted by an artist's brush." Second, a polished stone also showing a tower, buildings, and irregularly placed houses. Third, a terrestrial globe harmoniously created by Nature.

The commentary adds that, according to the Italian naturalist Ferrando Imperato (1599),[11] another marble, the Mount Sinai marble, had analogous properties: the stone is whitish in color but sometimes veering toward red, and it depicts plant forms. No matter on what side one cuts it, it reveals deep designs of trees and shrubbery.

The royal museum in the same city also possessed marbles with "various elegant figures," one of which depicted Christ on the Cross "in all the variety of his colors, as in those Florentine stones in which Nature herself has depicted cities, towers, and roofs." An engraving of it exists (fig. 46). It shows a framed picture of the crucified Christ as a lighter figure against the sky, between the sun and the moon. The veining and

46

**CHRIST ON THE CROSS, NATURAL MARBLE IMAGE.
COPENHAGEN, 1696.**

47

"FERRARA MARBLES," URBAN LANDSCAPE AND RUINED CITY.
AMSTERDAM, 1703. PHOTO: BIBLIOTHÈQUE NATIONALE.

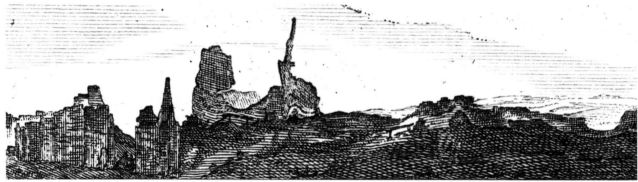

cracks evoke a mountain landscape.[12] In this connection the catalogue[13] notes that Athanasius Kircher had reported that a stone with the monogram INRI had been found in 1664 in a field near Tivoli and that a marble or flintstone existed that naturally reproduced the image of the Virgin. The *Ephemerides Medico-Physicae Germanorum* of 1670 mentions a marble globe with the arms of the House of Austria.

Thirty extremely rare pieces of "Florentine marble" were assembled in the Brackenhoffer Museum at Strasbourg.[14] At Kiel there are "Florentine marbles" in which nature has depicted trees like those in the Sinai stones.[15]

Illustrations in a Dutch collection give us some notion of some of these rarities.[16] They show two "Ferrara marbles," in one of which the tightly packed stratifications create an expanse of urban landscape crenelated against the sky and contrasting with its clouds. The other depicts ruins that resemble the devastation in Dubus's painting (fig. 47). There is also an "Egyptian marble," in which the image of Saint Paul seems to have been touched up, and a "German agate" whose colored layers create—probably not without the intervention of the artifice of marquetry—a rustic gallery opening onto a valley. According to some reports, German mines also produced stones depicting plants and fish.[17]

A Nuremberg inset of 1631 shows the apparition of a lion-shaped excrescence on the city wall, near the west tower, but this is a political allegory: the Swedish lion is ready to pounce on the dragon of the Papacy, translated into modish lithology (fig. 48).[18]

Italy, which furnished minerals to all of Europe, also had its collections.[19] The catalogues of Milan's Settala Museum (1664)[20] and of the Cospi Museum at Bologna (1677)[21] describe various stones: feldspar (oval in shape

48

THE NUREMBERG LION, FRONTISPIECE, 1631. PHOTO: FLAMMARION.

showing a cross), alabaster (with a majestic bearded head), agate (showing the plan of an octagonal fortress),[22] many "Florentine marbles." These were made famous by foreigners like Worm, the Italian text notes. Natural pictures differ from painted pictures because of the depth of their penetration. They do not lie solely on the surface, like the figures executed by an artist. They penetrate the entire depth of the stone. Florentine marbles were primarily of landscapes: cities, mountainous landscapes, seascapes, all under cloud-filled skies. Descriptions of them precisely echo the themes familiar to us from the combined compositions of the northern artists. "The images are so well done that no art could improve them. . . . Hung where they are, these pictures are worthier ornaments than certain tapestries, or even the purple."

A similar subject is mentioned in both collections. In the Milan gallery "two plaques of a stone cut in half depict Ilion ablaze in so lifelike a manner that Zeuxis himself could not have painted it better." In the Bolognese collection was conserved "a white marble veined in red, black, and other colors disposed by Nature in such a way that they recall to mind the misfortunes of Troy, the burning of the city and the rocks." The passage must be compared to the work of Dubus, in which the stones are colored by touches of red ochre, green ochre, and brown ochre on a base of ivory white, and where we also see depicted ruined cities. The wall the Flemish painter erected was made of Florentine marbles, and it transmitted an analogous vision. Only the interpretation varied. Italy saw in it an antique epic, the northerners a biblical cataclysm. Mineral veining is constantly associated with flames and conflagrations. While seeing different figurations, both texts agree on the picture's iconography.

One of these works also describes marbles altered by the artist. The Milan catalogue mentions two: one represents a mountain with a grotto, to which has been added a Saint Jerome with the lion; the other, a tree filled with birds. The text notes that all these adjunctions are the work of an artist: "ars pinxit," "ars adaptavit," unlike the terms usually used to describe natural images, "a natura sine omnis artis ministerio," "a natura depicti." It is very precise on this point.

Two compositions attributed to Antonio Carracci (1589–1618), once part of the Farnese collection and now in the National Gallery at Naples,[23] illustrate this method. They show the Virgin and Child with Saint Francis and the Annunciation, painted on an alabaster slab (fig. 49). The markings create shadows and celestial light. Mary, holding her Son on her knees, is seated on a vaporous meander. The Dove of the Holy Ghost appears within a fluid halo, while the angel seems to be emerging from a rift created by a wind through the mist. The painter has cleverly arranged his graceful characters, but nature has provided the supernatural element, the breath of mystery.

In Bonavita's work *The Vision of Saint Paul*, painted on a slab of particolored marble (Ajaccio), men and horses are caught up in a mineral cataclysm (fig. 50).

Stones containing an imagery, marbles, agates with their tortured landscapes in which figures are placed, so popular in the seventeenth century, all result from the same speculations on art and Nature and on the nature of art, in which stone and life are superposed and mingled in an outpouring of baroque fantasies. They all spring from the same metaphysical source, the same antique legends that, in turn, are given new life through such shapes.

Athanasius Kircher, a German Jesuit stationed in Rome, a visionary and scholar with boundless ambition, has given us the most complete résumé of these doctrines. His work, which dates from 1664,[24] com-

49

ANTONIO CARRACCI, *VIRGIN AND CHILD WITH SAINT FRANCIS AND ANNUNCIATION,*
PAINTED ON ALABASTER SLABS, PRIOR TO 1618.
NAPLES, NATIONAL MUSEUM OF CAPODIMONTE. PHOTOS: SUPERINTENDENT OF FINE ARTS, NAPLES.

50

**BONAVITA, *THE FALL OF SAINT PAUL*. AJACCIO, MUSÉE FESCH.
PHOTO: GIRAUDON.**

bines numerous sources but renews them and shapes them into a synthesis that forms a vast cosmogony. The *Mundus subterraneus* is vast and enchanted (figs. 51, 52). It is covered with seas of fire and water that are connected by canals and rivers feeding into oceans and surface volcanoes. With its cavities and arteries, the section of the terrestrial globe reminds us of some animal organism. Its caverns are inhabited by men and demons, beasts and dragons. Minerals and metals are created spontaneously, often taking on strange aspects. Nature is a geometrician, an optician, who uses all the laws of perspective, who is a painter. It thinks and acts like a human or, rather, it is subject to the action of the same higher powers. The first section of Book VIII, devoted to mineralogy, deals in depth with the shapes and images Nature draws in rocks and in gems, with their origins and their causes.

The author proceeds methodically. He groups stones by subject (figs. 53–56): geometrical figures and all the letters of the alphabet; celestial visions (asteroids and stars, the lunar crescent and the sun); the terrestrial world (landscapes, vegetation, cities); animate creatures (birds, quadrupeds, man); religious figures (Christ, the Virgin and Child, Our Lady of Loretto, Saint John the Baptist, Saint Jerome). And he explains such formations in four ways: chance; the disposition of a certain terrain to act as a matrix and the ability of shapes and humors to petrify; magnetism that draws similar shapes together; divine and angelic dispensation.

Plants and stones are created in the very earth in which their substances are mingled. The result is contamination. The vegetable substance penetrates the minerals and becomes petrified grasses and fruits. Shrubberies blossom in crystals and marbles. Some stones shaped like animals are fossils. But perfect likenesses can also be created in terrains and materials

particularly apt to receive them, as well as through the action of magnetic currents that set up a process like electroplating. Holy effigies take shape inside stones in the same manner. Religious objects, crucifixes abandoned in the ground during the creation of earthworks, can leave their imprint behind them after a certain amount of time, as in the case of the INRI inscription found at Tivoli. Enclosed between two buried slabs of marble, the figure eventually penetrates deeply into their substance. However, all of these immediate causes bear fruit only by dint of divine providence, which alone can cause such a vast number of wonderful natural effects. The genesis of images in stones is controlled by the same force that controls the genesis of new stars in the sky and of monsters on earth.

The same book also contains chemical formulae. Figures can be painted on paper by mixing vitriol and other corrosive substances with the color. When placed between two carefully polished marble slabs, the painting will then penetrate their substance after two or three months. One can also execute a work directly on the surface of a white marble slab by using ammonia and nitric acid carefully and scientifically combined with other elements. The drawing will penetrate the whole of the solid. Many pictorial stones were probably fakes.

The text is illustrated with examples drawn from museums (principally the Aldrovandi Museum, a single example from the Kircher) in various parts of the world, from the Holy Land to Chile. Sometimes the figures emerge but dimly from the stains and imperfections, at others they stand out clearly. In some instances the illustrator gives the corresponding image with its shape barely altered.

ATHANASIUS KIRCHER, *THE INNER WORLD,* FIRE AND WATER, 1664.

PHOTOS: FLAMMARION.

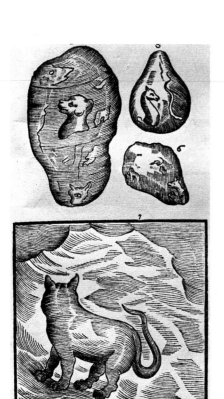

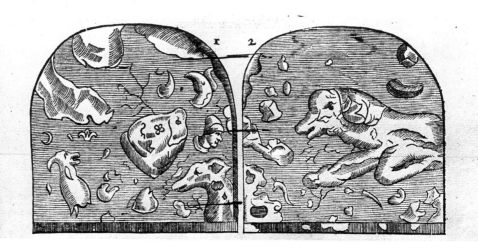

55

ATHANASIUS KIRCHER, PICTORIAL STONES WITH QUADRUPEDS, 1664.
PHOTO: FLAMMARION.

Figura Palliata

Homo Sacerdos In Silice Fœminæ effigies

Silex apud Ambrosinum
Beatæ Virginis cum
filio in brachys

A

B

B. Virginis cum filio
et draconis effigies

ATHANASIUS KIRCHER, PICTORIAL STONES WITH HUMAN FACES, 1664.
PHOTO: FLAMMARION.

transmutation of matter within the same form.[32] Every lapidary wonder was to be brought into a complete and coherent system in turn.

Sixteenth-century scholars continued to speculate on such data, either by returning to antique sources or by improving upon the fantasies of the Middle Ages. Astrology and alchemy and all the magical sciences continued to dominate men's minds, and the pursuit of mineralogy was often like dealing with a kind of wonderland. A book on gems produced by nature in which the principal treatises were united—*inter alia*, that of Gethel (Thetel)—was published at Venice in 1566.[33] It makes constant reference to the theories of Albertus Magnus. Pomponazzi (c. 1520) gives lengthy extracts from them.[34] Gerolamo Cardano, in 1550, expressed doubts about the agate of Pyrrhus[35]—an artist had painted the mythological group and nature had done the rest, the gem having been found in a place "where agate stones are customarily engendered"—but he himself possessed two incontestable specimens. In one, nature had painted the orbits of the celestial globe and the earth round as from above the waters, in the other a fissure in the earth seems to be emitting a smoke that "beclouds" the atmosphere. The description could refer to slabs of agates that seem to represent cosmic turbulences. The agate reproduces forests, fields, animals, rivers, flowers, trees. At a later date, we see

en sa glace
Vivement empreinte la face
D'hommes et d'animaux divers,
La terre, le ciel, les étoiles,
La mer grosse de vents et voiles,
Monts, rochers, fleuves et bois verts . . .
Rémi Belleau, 1576[36]

[in its mirror/vividly imprinted faces/of men and various beasts/ the earth, the sky, the stars/the swelling sea with wind and sails/mountains, rocks, rivers and green woods . . .]

Poissons, bêtes, oiseaux, bois, antres cavés,
Plaine, fleuves y sont par Nature engravés.
Isaac Habert, 1585[37]

[Fish, animals, birds, woods, cavernous places/plains, rivers, all engraved by Nature thereon.]

Scientific poetry seems to rely less upon Pliny[38] than upon Marbode and Mandeville. However, Cardano's attention is focused more on the legend of stones in general.

Stones have life, they can suffer illness, old age, and death. When cut, stones can grow. Stones cover themselves with figures. According to Alberti, nature had carved Solomon's seal on a stone found in a field near Verona, as if with a ruler.[39] At Freiburg, a stone "of alabandite" bore the image of monkeys. At Anneburg, "another stone of alabandite" had the shape of a cross. In the forest on the Hercynian mountains (*Erzgebirge*), gold spots on rocks create such varied shapes as "a sea perch, a salamander, a rooster, a bearded head, and the Virgin and Child Similarly, in Lake Alsatia, near the Misnesis Mountains, figures of frogs and fish, in copper, have been found drawn upon the surface of stones."

Scholars like Scaliger (1484–1558),[40] Agricola (1490–1555),[41] and Gesner (1516–65)[42] also mention many unusual examples. In Constantinople's Santa Sophia there are two pieces of split white marble with ashy stains disposed by nature in such a way as to represent Saint John the Baptist wearing a camel's skin. One of his feet is not well drawn. The Turks show it to the Christians. In Ravenna's San Vitale, the smoky colors in a marble reproduce the image of a Franciscan friar.

CONRAD GESNER, PRISMATIC ROCKS AT STOLP, BOHEMIA, 1565.
PHOTO: BIBLIOTHÈQUE NATIONALE.

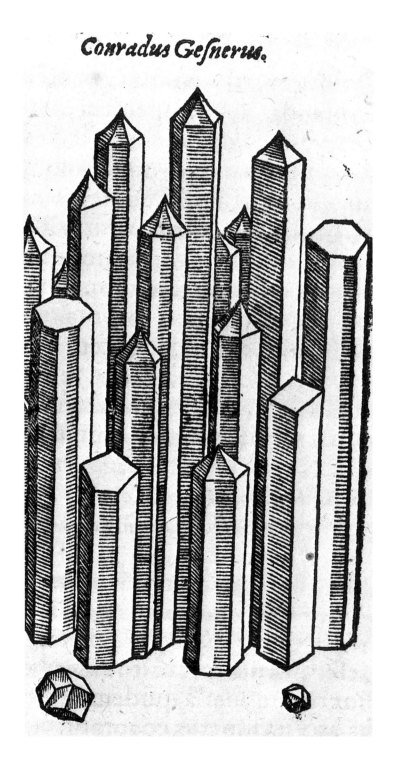

At Ratisbon a bearded face, probably that of Saint Paul the Hermit, appears on an unpolished piece of marble. Religious representations are connected to their antique precedents: Pliny's Silenus, to which is added the head of a young Pan found inside a cracked stone at Chios, "autoglyphs" with the image of the Mother of the gods, and the Pseudo-Plutarch's crystals with effigies of crowned men. However, as in the medieval version, the Gorgon is explicated as the poetic symbol of nature's labor of petrification. Geometric stones, starred stones, undulating stones, verdant or arborescent stones are also described and reproduced. At Stolp, in the neighborhood of Dresden, there are prismatic rocks standing like the skyscrapers of a modern city (fig. 57). Minerals can at any instant take on the most unexpected shapes.

Far from falling into line with the evolution of the natural sciences, the lapidary world became odder and odder. In the middle of the seventeenth century Gaffarel, Cardinal Richelieu's librarian and the king's almoner, was to take up the same doctrines, in an independent milieu, accentuating their fantastical side.[43] He was not satisfied with Cardano's explanation of Pyrrhus's ring. The notion of a painting changed into marble was absurd. And there are plenty of spontaneous images, both in the past and in the present. Nyder (c. 1475) reported that "the Marquis of Baden had a precious stone that, from whatever angle it was viewed, always showed a crucifix."[44]

Monsieur de Brives, traveling to the Levant in 1605, had seen in San Giorgio at Venice a Christ on the cross "within a marble stone, but so naturally drawn that one could discern the nails, the wounds, the drops of blood."[45] The same church possessed "a *gamahé*"—the term evokes antiquity via the Middle Ages—"or marvelous and totally natural figure" on the facing of an altar in jaspered marble representing a

59

ULISSE ALDROVANDI AND B. AMBROSINI,
MARBLE SECTION WITH IMAGE OF A MONK, RAVENNA, 1648.
PHOTO: BIBLIOTHÈQUE NATIONALE.

60

ULISSE ALDROVANDI AND B. AMBROSINI,
HERMIT AND TURK NATURALLY DEPICTED IN A MARBLE,
SAN GIOVANNI DA PISA, 1648. PHOTO: BIBLIOTHÈQUE NATIONALE.

covered with delicate vegetation or thick forests, "anthropomorphite marbles" whose markings depict human features, "cynite marbles" showing the shapes of dogs, "scombriform marbles" with fish, "polymorphite marbles" strewn all over with monsters, dragons, birds, quadrupeds, and men. "Oriental marble" shows swirls of shells, algae, and ocean waves "such as no painter's hand could imitate" (figs. 61, 62).

The treatise is more valuable for its illustrations than for its confused and overloaded text: Aldrovandi, who gave an important place to imagery throughout his work, was nicknamed "Nature's Illustrator." The figures he reproduces form a collection of the principal varieties, of which certain specimens had been known only through cursory descriptions. The drawings are often fantastical, but they show us how such spontaneous images were regarded in those days. Visions emerge from disorder and the accidents of stains and imperfections, but they all fall into precise categories. The two fish in scombriform marble reproduce the sign of the zodiac, a common theme in marble inlay work.[49] Birds, peacocks, and a spiral serpent on a porphyry slab are probably also inspired by Eastern decor. Since Albertus Magnus, Venice, Ravenna, Constantinople, and Pisa, all famous for inlay and mosaic work, have always been associated with these wonders. Most certainly, confusion also often played a part.

However, such subjects were prevalent elsewhere as well. Polymorphites teemed with fantastic beings identified as creatures of the Gothic Middle Ages, among them the bat-winged dragon and Renaissance grotesques. The sources that fed the doctrine are present in its themes. Lastly, there are antique elements. The streaking of "anthropomorphitic ophite" reveals "the shape of a human head wearing a Turkish cap which, and even more wonderfully, reveals another face when turned round, one created backwards." The dovetailed dual image is a specific of Greco-Roman glyptics. Introduced into a series in which the legend of marbles takes the place of the legend of gems, it symbolizes a process of continuity.

Images emerge from the stone as though seen in a clouded mirror. In the beginning pure ornament, veined and spotted, a fluid drawing devoid of figurative content, marble seems, in several instances, to be moving toward a pre-mosaic stage, one in which man can rectify the living features he thinks he has perceived. Figures join together and seem to create some secret life.

In the propagation of forms and fables and the fame of "Florentine marbles," Aldrovandi's work and his museum, to which was added the Cospian Museum with its paintings and tapestries of the fall of Troy, were of prime importance. In formulating his own theories, Kircher drew inspiration from it and derived from it a large number of examples. Even its text is a rich source for artists.

In commenting on jasper, which can easily depict either a river or a scorpion, Ambrosini notes that Rudolf II's *armoire* contained magnificent examples showing swamps and forests, clouds, trees, and rivers that appeared to those who looked at them to be not of stone but of paint. He derives this information from Anselm Boèce de Boot, a native of Bruges and physician to the Emperor, whose *Gemmarum et lapidum historia* appeared in 1609.[50] The interpretation of the scorpion is incorrect. It must have been *engraved* on the jasper at the time the sun entered its zodiac sign in order for the stone to acquire all of its prophylactic virtues. However, the *armoire,* the *scrinium,* was probably the sovereign's *cabinet,* now at Vienna, which resembles the pieces of furniture delivered by Hainhofer to the Duke of Pomerania and the King of Sweden. Anselm

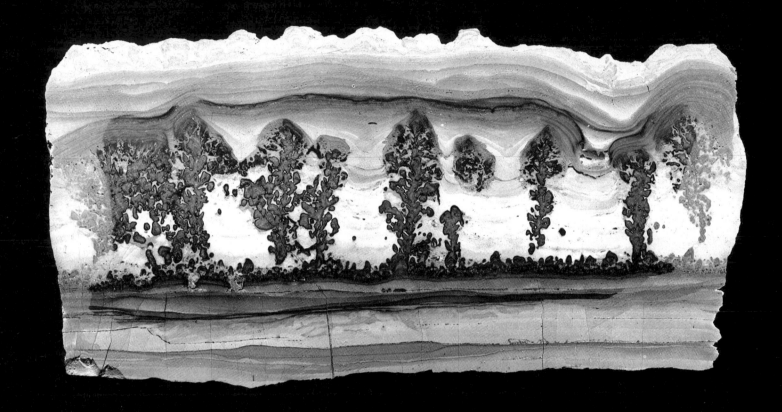

LANDSCAPE MARBLE, GLOUCESTERSHIRE.
COLLECTION OF CLAUDE BOULLÉ, PARIS. PHOTO: FLAMMARION.

No matter how obvious and irrefutable, the *lusus naturae* underlying the composition of the figures left some theoreticians sceptical. After the destruction of its legends, the stone was itself subject to question. All the subtleties of the old doctrines were swept aside at one fell swoop. There was never any action on the part of nature, even combined with Art. At the very end of the nineteenth century Montbarlet, a scholar from Bordeaux, was to attribute all mineral figurations to the hand of man.[62] There are abundant rock examples. In the valley of the Dordogne there is not a single one that was not sculpted, engraved, or painted by an artist. In the "desert" of Juillac (Gironde), the strange figures and pictures appearing on the rocks are religious symbols, not some mineralogical happenstance as some experts continue to maintain. One can even find inscriptions that provide information as to the monument's history. It was a druid sanctuary inaugurated during the time of Antoninus Pius, two centuries after the conquest of Gaul. The date of the pictorial rocks is even earlier and less precise, but their hieroglyphics bear witness to the same cult. There are countless numbers of them, and they are of true artistic value. There are often tiny "masterpieces," the beginning of a long and multiple evolution. French art, faithful to the traditions of ancient Gaul, was to draw inspiration and profit from them. Mentioning these latest illuminations André Breton wrote of them in *Le Surréalisme même*.[63]

The close association of art per se with natural pictures, of natural pictures with art per se, of course worked in the opposite direction as well. The new forms and subjects of continuously evolving painting were successively discerned. Roger Caillois drew attention to such contemporary figurative and nonfigurative themes in the *Natura pictrix* of the Ancients.[64]

Sawn in half and opened out like a diptych or a book, slabs of marble and porphyry compose symmetrical arabesques. A rigorous order emerges from the disorder of nature's irregular motley. The pictures have been compared with the abstractions of modern painting. The system had been practiced for centuries. Dézallier d'Argenville points it out in a "German agate that equals Eastern art in beauty and clarity." "Its flowing sections of round forms and centred banks are of an extreme beauty and seem even more so when the two halves are joined. The background is a light violet and the other areas are white and pink" (fig. 71).[65]

Artists and art lovers are already fascinated by pure forms. Some of the rocks conceal astonishing accumulations in their depths. Broken, sliced, their brilliant, smooth surfaces reveal perfected ordered veins and pigmentations, signs of some secret writing, bizarre shapes. Rare pieces are sought after with the same passion as in the sixteenth and seventeenth centuries, but in the new framework of modern mineralogy, with its detailed nomenclature and its much wider investigative scope, in which each species represents an artistic form and style.

The diversity of agates, milky (chalcedony), red (cornelian), dark black (onyx), colored in stripes or spots (jasper), implies a variety of themes: nebulous fluid figures, abstractions, calligraphic writings, "nascent birds," eyes.

Jasper reveals celestial visions, uncoiling like some gigantic shell, and images of the earth: a dark stand of trees stark against a luminous glow that stretches across a vast violet sky, a volcano with its mushroom of smoke rising above the cracked earth (plate 6, top).

Tuscan limestones were not confined to "masurate stones." Graphic limestones, *Verde d'Arno* limestones, are covered with sharp, intricately connected triangu-

73

SEPTARIUMS, CANTABRIAN COAST AND SPANISH NAVARRE.
COLLECTION OF CLAUDE BOULLÉ, PARIS. PHOTO: FLAMMARION.

"VERDE D'ARNO" LIMESTONE, TUSCANY.
COLLECTION OF CLAUDE BOULLÉ, PARIS. PHOTO: FLAMMARION.

Emptied of their pictorial substance, the triangles of a
Verde d'Arno limestone collide and crisscross like
rockets against a night sky, an inextricable tangle in
movement, whereas in a jasper we find circles, golden
pellets capriciously strewn and drawn together against
the burnished gold of the stone like enamel work on
a reliquary (fig. 74 and plate 8). And not only linear
shapes: the colors (shades of green) are spread harmo-
niously through (pink) dolerites as though brushed by
a master hand. It could be some abstract avant-garde
painting (plate 9).[66]

Contemporary knowledge does not weaken the effect
of the tales told by pictorial stones. On the contrary, it
enriches them. The multitude of agates of every color,
the carefully classified marbles and limestones of
every variety, new types of minerals that now play a
part in such speculations, only serve to increase our
enjoyment. The geographical area of such contribu-
tions is also being enlarged in all directions. Tuscany
remains a special site, but other important centers, in
Spain and England for example, are furnishing remark-
able pieces. They are being sought as far away as Ga-
bon or Oregon. And we are also discovering a vast new
repertory, abstractions, fantasies, a sign of the times.
Yet we still have the same mysterious and astonishing
process. Intelligent amateurs are still attracted by min-
eral configurations, the hieroglyphics of impenetrable
nature, through spiritual refinement, refined taste.

The Romance of Gothic Architecture

Three texts on Gothic architecture offer an unusual concordance of views. When the young Goethe found himself standing before the cathedral at Strasbourg in 1772, he saw it as mounting toward the sky like a sublime tree with a thousand branches, its millions of twigs and leaves countless as the sands of the sea, spreading the glory of the Lord, its Creator. . . .[1] Thirty years later, Chateaubriand, in his *Génie du Christianisme* (1802), compared Gothic architecture to a forest: "Those vaultings carved with foliage, those ribbings that support the walls and terminate suddenly like broken tree trunks, the cool of the vaults, the shadows of the sanctuary, the dim wings, the secret passages, the low doorways, all form and repeat woodland labyrinths in Gothic churches, all inspire religious terror, the mysteries of the divinity. . . ."

Even the sounds of the forest echo in these naves: "The Christian architect, not content with constructing the forest, tried as it were to construct its murmur, and by means of the organ and suspended bronze he brought into the Gothic temple the very sound of the winds and thunders that sound in the woodland depths. The centuries evoked by these religious sounds pour out their ancient voices from within the stones and sigh through every corner of the vast basilica."[2]

The vision of timeless trees evokes the France of the druids. The forests of Gaul have "been brought into the temples of our fathers, and our oak forests have thus preserved their sacred origins." This is more than a poetic description; it is a definition of an architectural order determined by its historical genesis.

The third text is by Friedrich Schlegel and was written in Cologne in 1805.[3] His analysis is closer and he proceeds methodically, studying every aspect of the cathedral. From the outside, with its multitude of excrescences, towers and turrets, flying buttresses, gables, pinnacles, it resembles a forest. Within, we find ourselves beneath the proud vaultings of a grove of giant trees. Its nature is vegetal, but there is also a crystal vegetation, a flowering of polyhedrons infinitely repeated, ever larger, ever higher, disintegrating, always carved in the same manner. It would be impossible to express it more precisely. In its constant renewal and in the world of its endless repetitions, the crystalline cathedral reproduces a miraculous flora. Gothic architecture has a meaning, the highest meaning: it is the image of a living world. The Nature that presided at its birth is that of the Northern lands, the opposite of the gross artifices of Greek architecture.

In his philosophical writings Coleridge, profoundly influenced by Schlegel, evokes two juxtaposed buildings: on the one hand the imperial palace of the Gothic king Theodoric, a sinister, threatening palace, and on the other hand, facing it, dominating it from on high, the Christian church in which barbarian and antique pomp is crushed by the Spirit and in which there stands, at the end, nothing but Christ and the Cross. Soon that church becomes "a cathedral like that of York, of Milan, or of Strasburgh with all its many chapels, its pillared stems and leaf-work, as if some sacred grove of Hertha, the mysterious deity of their pagan ancestry, had been awed into stone at the approach of the true Divinity, and thus dignified by permanence into the symbol of the everlasting Gospel."[4]

Speculating on the forms of art, on their technical origins, on their aesthetic effect and their spiritual significance, Hegel too referred to woodland architecture. "When we penetrate into the interior of a medieval cathedral, we have the impression of being transported into a forest with countless trees whose branches lean together so as to form a natural vaulting."[5]

In France it is to Chateaubriand especially that we now owe the spread of such poetic doctrines. Their echoes can be heard in Baudelaire (1861):

La Nature est un temple où de vivants piliers
Laissent parfois sortir de confuses paroles;
L'homme y passe à travers des forêts de symboles
Qui l'observent avec des regards familiers.

—**Spleen et idéal, IV, Correspondances**[6]

[Nature is a temple in which living pillars/ Sometimes emit confused words; / Man walks through forests of symbols / Which gaze on him with familiar eyes.]

Here, indeed, we have closely associated nature, the temple, the forest and its living pillars, and the mysterious labyrinths of the *Génie du Christianisme*. The word "Gothic" does not appear in the sonnet of the *Fleurs du Mal*, but the whole quatrain is redolent of the disturbing magnificence of the romantic Middle Ages.

"Grands bois vous m'effrayez comme des cathédrales" [Great woods, you frighten me as cathedrals do], Baudelaire was to write in *Obsessions*, reversing Chateaubriand. The poet sees before him not the woodland labyrinths in Gothic cathedrals but, rather, a vision of churches in the forest.

The obsession with the Gothic forest lasted into the early years of the twentieth century. Huysmans expressed it in the same terms, but with some added details:

It is practically certain that man found in the woods the oft-discussed appearance of naves and ogives. The most astounding cathedral nature ever built out of the pointed arches of its branches is at Jumièges. There, near the magnificent ruins of the abbey, three long alleys of age-old trunks are laid out in straight lines: the center one, very wide, and the two others on each side of it, narrower; they form the precise image of a nave and its side aisles supported by darkened pillars and vaulted by networks of leaves. The ogival is clearly reflected in the joined branches, even as the supporting columns are imitated by the vast trunks.[7]

This description should be compared to a passage by Père Laugier (1765), who also speaks of trees, not in Jumièges, but in Paris: "Here are the great alleys of the Tuileries. It is as though those great bowers formed by two rows of age-old trees furnished the model for our Gothic churches."[8]

In this instance the association is being made by an architectural theorist. He continues,

I can imagine that a church in which all of the columns would be the trunks of palm trees, spreading their branches right and left, the highest of them forming the contours of the nave, would make a marvelous effect. . . . The ogives of the vaulting would be palm leaves and the interstices could be decorated with sculptures. . . . After all, this vision would only be an imitation of nature, but nature perfected.

Of course, the passage does not refer to the forests of Gaul with their druidic oaks, but it is still the same vision that, shorn of its poetic eloquence, provides us with a technical explanation of an architectural style that corresponds to the state of mind and attitude of an entire epoch.

The comparison of Gothic forms and vegetal forms underlies the distinction that must be drawn between two worlds: the Middle Ages and classicism. It is a weapon much used to combat both, the Middle Ages in particular.

In 1699, in his *Dissertation touchant l'architecture antique et l'architecture gothique,* Jean-François Félibien, son of the biographer and brother of the historian of Saint Denis, took up this weapon to deliver decisive blows.[9] The relationship is painstakingly described: buttresses, vaultings, ribbed columns, ogival crossings, and arches. The extremely slim columns of Gothic churches resemble the branches and twigs of trees. "Sometimes several rise up together to form a single pillar and branch out at its top, using it as a trunk. Sometimes the columns are bound together in fascia. . . . They conceal the great masses that support the vaulting. They support the transverse ribbing that resembles other branches. . . ."

The system is counter to the "principles of true and apparent solidity and beauty" on which classical architecture is based. Although antique columns also imitated trees, they imitated their trunks, not their flexible branches "which are designed to support, at the utmost, foliage and flowers for garden bowers." The loss of a unique tome (Vitruvius) and the destruction of almost all of the buildings of antiquity both served to create such misconceptions. The author does agree that some of these Gothic productions resist criticism because of their grandeur and their harmonious proportions, but these are a result of chance and not of any precise calculation. He concludes by dismissing and condemning the whole system.

Félibien's thesis sums up the classical viewpoint, and for fifty years it was universally accepted. A pamphlet published in 1733 augmented his argument on certain points. "To take exact account of the defects of Gothic taste," its author, Le Blanc, made several journeys through France and to England and Flanders. The results of his investigations: all Gothic architecture is disproportionate and corrupt. Its vast dimensions? They remind us of "a giant mounted on a very small horse," or of "an immensely fat and powerful giant supported on two long skinny legs." Its mass? It is destroyed by the huge bays, and "the genius of Gothic taste is to allow such a small amount of light to pass through such large windows." Of course, "we can reduce the ridiculousness of this bizarre taste somewhat by attributing it to the veneration felt by the Gauls of yore for the obscurity of the forests they used for temples and in which they set up the statues of their gods. It was to retain this venerable and impressive obscurity that they employed the stained glass that obstructs the effect of light, as do branches and leaves in making forests places of darkness."[10]

However, the explanation of the origin of stained glass windows does not justify the style as a whole. The beauties of the Gothic are deceitful and false; its faults are incontestable and real.

Two important treatises, Germain Boffrand's *Livre d'architecture* (1745)[11] and Jacques-François Blondel's *Architecture française* (1752)[12] take up the same notions, based on the work of Félibien, but they posit different origins for the Gothic style. One attributes its invention to the Gauls and, like Le Blanc, regards it as preserving the memory of druidic temples (Félibien employs a vague term, "the northern peoples"). The second, who is dealing with "French architecture," treats such huge buildings—"which, although solid, seem more astonishing than submissive to artistic rules"—by connecting them with Islam. According to him it was the Moors or Arabs, with their love for ornamentation as supercharged and superfluous as it is removed from nature, both in their architecture and in their poetry, who created such unusual forms, reproducing not only trees, but branches as well. The influ-

ence filtered in through Spain. Arab letters, science, philosophy, medicine, and mathematics, and, with them, Arab architecture, spread across Europe from the countries bordering the Pyrenees. Many churches were built in the Moorish taste. The cathedral at Amiens, Saint Nicaise at Rheims, the work of Jean Ravi in Notre Dame, and the Sainte Chapelle at Paris all serve as examples. When Laugier envisages palm trees in Gothic naves he is recalling these exoticisms. "French architecture" was not to be restored until the reign of François I.

In addition to supporting the refusal to include Gothic architecture in the embrace of a kindred civilization, the notion of Islamic origins had long been used with regard to other problems. Florent le Comte compared Gothic monuments with the Moorish constructions in Africa and Spain in 1699.[13] Fénelon (d. 1713), for his part, when comparing faulty eloquence to medieval buildings, with their vast vaults rising to the clouds on attenuated pillars, with stone cut out like cardboard, states that "this architecture, called Gothic, is, we are told, Arabic."[14] In short, to achieve his purpose Blondel had only to make use of long-standing opinion.

Arboreal and Moorish doctrines were interpreted in the same way by Sobry (1776)[15] and Dézallier d'Argenville (1787)[16] and by Millin with certain reservations (1791),[17] but, in the meantime, minds had begun to change.

A new appreciation of nature led to a revision of architectural concepts. The movement began in England, and it was in the country of Milton that the new doctrine was most forcefully formulated. Warburton, in his commentary on Alexander Pope, whose *Temple of Fame* (1711) had had a Gothic north façade with figures of bards, druids, and Goths, expressed it in his own volume, which appeared in 1751, a year before that of Blondel.[18]

The elements of the argument are unchanged, but the values are inverted. Gothic architecture was a reaction to the first series of medieval "Saxon" monuments, related to the buildings of Palestine, Greek-decadent in style. It was conceived during the Goths' occupation of Spain and based on principles and notions far nobler than classical pomp and show. Used to practicing their religion under the trees, the peoples of the North attempted, since their new religion demanded roofed buildings, to retain a similar aspect in their churches in so far as possible. Their goal was attained both with dispatch and with art thanks to the assistance of the Saracens, who had developed construction systems suitable to this need. It thus follows that only those cathedrals that provide the imagination with an alley of trees can truly be called Gothic.[19]

It is a highly logical architecture. With its creation, all of art's irregular transgressions, all monstrous offenses against nature, fade away. Everything has its place and its purpose in a harmonious whole. Can there be another shape for arches than the pointed line when the architect is imitating the intertwining branches of two tall adjacent trees? Can columns be constructed in any way other than by forming them of separate ribs when they are intended to represent the trunks of several trees growing close together? The tracery and glass of the windows are established on the same principles, one corresponding to branches and the other to the leaves of a burgeoning forest, both together perpetuating the dim light and creating religious fear and respect among men.

For those used to Greek architecture, this aversion to the apparent solidity of masses appears absurd. However, if we consider that the astonishing lightness is needed to instill the notion of a site for a sylvan cult, we cannot fail to admire the cleverness of such solutions. All of these qualities make Gothic buildings superior to Saxon monuments, which ape the debased antiquity of the sanctuaries to be found in the Holy Land and which were to be debased even further by massive sumptuousness when Christianity became a state religion.

All the integral elements of Gothic form—support, roofing, the scale and disposition of masses, the systems of bays and windows—are derived from the analyses of Félibien-Le Blanc-Boffrand, but for different ends. We find a total rehabilitation of the Middle Ages, an approval of pagan artifices and a rediscovery of a superior order derived directly from nature; this was also occuring in England.

It is to the very man who had treated Gothic architecture as a senseless and fantastic architecture, lacking in proportion, redolent of some dim and heavy sadness attributable to the Goths and the Arabs,[20] that we owe the most ringing defense of the forest. John Evelyn's *Sylva* (1664),[21] a work of arboriculture designed to combat the deforestation of His Majesty's domains as a result of the growth of certain industries (glass making, iron smelting), earlier than *Paradise Lost* (1667–74), is both legend and cosmogony. The oak, the pine, the cedar, the elm are described with affection and poetry. Ancient writers, Ovid, who made trees spring up at Orpheus's song (*Metamorphoses*, X) and the divine Spencer (1552–99) with his noble knight praising the trees of the wood, are evoked, following technical descriptions, and are in turn followed by "a historical memoir on the sacred character and the usage of arboreal sites."

From the earliest antiquity trees have been used for religious purposes, not only in the cults of pagan gods and goddesses but in the service of the true God, by the patriarchs themselves: Abraham dwelt in the plain of Mamre among the oaks and raised there an altar unto the Lord as though in a temple (Genesis 13). The covenant between the faithful and the Father was made in a grove of trees, and Abraham planted a grove in Beersheba and called there on the name of the Lord, the everlasting God (Genesis 21). The Feast of Tabernacles recalls patriarchal devotions held in the forest shadows. Since the creation of the world (Adam beneath the sheltering trees of Paradise, Abraham, who received divine messengers, not in his tent, but out of doors beneath an oak), leafy trees have comforted souls and disposed them to divine contemplation. They have often been planted in a circle, the shape of the universe and the sky used for the earliest sanctuaries. The chapels and synagogues of the ancients were built in forest retreats. Paradise itself was a nemoral temple or sacred wood planted by God, who presented it to Man, the first priest. The Fathers of the Church always exalted the pious uses of wooded places.

The pagans, who inherited from God's children this innocent veneration of the forest, corrupted it, alas, with dangerous superstitions. According to Virgil, the *Pinea Sylva* belonged to the Mother of the gods. Venus owned several forests, in one of which, at Cnida, stood statues sculpted by Praxiteles. Ceres, Proserpine, Pluto, Vesta, Castor and Pollux all had their consecrated groves. A forest of antiquity was rarely without its temple, a temple rarely without its surrounding woods, in which idols and altars were set up. The druidic mysteries were celebrated beneath the trees. According to several historians, their courts of justice also met beneath such canopies.

Condemning the heresies of all cults other than the True Faith, Evelyn also deplored the abandonment of the forest in his own day and exhorted philosophers and Christians to revert to practicing meditation and other earlier delights. Trees are miracles and contemplating them elevates thoughts and feelings. Some of them are hard as iron and solid as marble, of a legendary majesty and grandeur. The corrupted tree (like man, of whom it is the inverse symbol) must be reborn in all its glory and beauty, like the fortress it once was. This is very like theology.

The rediscovery of Arcadia, where the spirits of antiquity revel in a benevolent landscape, is preceded by an appeal to Sylva, the holy place and natural temple made by the Creator for prayers and meditation, the model of the first religious architecture.

The treatise went through several printings, the fifth in 1729. Discerning the shapes of age-old trees in medieval churches, the same dream was being revived. The Gothic cathedral is a sylvan City of God. When the Northern peoples brought the naves of their dark forests indoors, they were spontaneously reestablishing their original concepts. The corrupted tree regained its sanctity and at once redressed the errors committed in laying out earlier sanctuaries, including those of the churches in the Holy Land.

Since the Goths were a primitive people without experience in the art of building, competent architects trained in the pernicious Greco-Roman tradition had to be employed. The Arab solution, which was turned to for reasons other than those given by Blondel, had already been advocated in England by Wren (1632–1723), a universal man, astronomer, physician, and Pascalian polemicist, who had played a prime role in the reconstruction of London following the Great Fire of 1666. However, it is not his theory of the Gothic,

born in the Orient and spreading through France during the Crusades,[22] that we find in Warburton, but its Moorish-Hispanic version (avoiding Palestine). Far from compromising the prestige of these monuments, their exoticism only serves to enhance their fabulous and mysterious side.

Widely distributed, along with a poetical work, Warburton's commentaries had a great influence and his work is constantly quoted in technical books. Dellaway mentions it as late as 1800.[23] It even served for a practical demonstration.

The demonstrator, a man named Hall, had been struck by the beauty of the French cathedrals he had visited on his way home from Italy in 1785, and he began to wonder about the sources of the grandeur and daring of their effects, which the most famous modern monuments were unable to equal. Warburton's theories so convinced him that he set out to confirm them by constructing a building himself, using only tree trunks and branches (figs. 75–77).

He proceeded in the following manner: ash poles were planted in two rows at intervals of 1.20 meters and three-meter-long willow saplings were then set around them, like a fascia of thin columns, intertwined at the top in such a way as to recreate the armature of a Gothic vault. The vault was then covered with thatch. A man could walk upright beneath it. The miniature church had a choir and a transept, and the portal was an imitation of the one at Saint Mary de Beverley. The windows were made up of bent twigs that exactly reproduced the desired effect. Eight willow poles planted a few feet to one side formed the pyramid of a bell-tower (six meters high), after the spire of the church at Bunny, in Nottinghamshire.

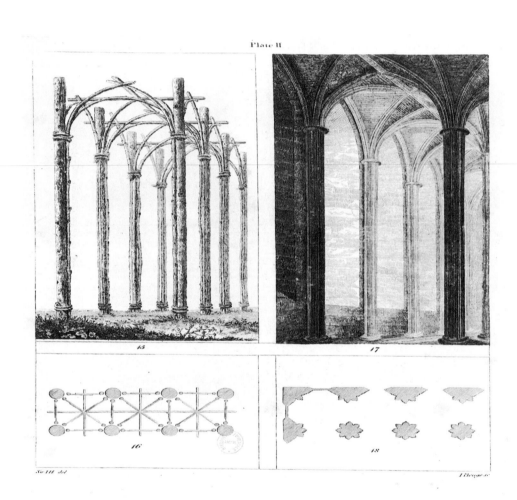

RECONSTITUTION OF A GOTHIC NAVE WITH ASH POLES AND WILLOW BRANCHES.
EXPERIMENT BY J. HALL, 1798. PHOTO: BIBLIOTHÈQUE NATIONALE.

76

BEVERLEY PORTAL AND BUNNY SPIRE IMITATED IN CUTTINGS.
EXPERIMENT BY J. HALL, 1798. PHOTO: BIBLIOTHÈQUE NATIONALE.

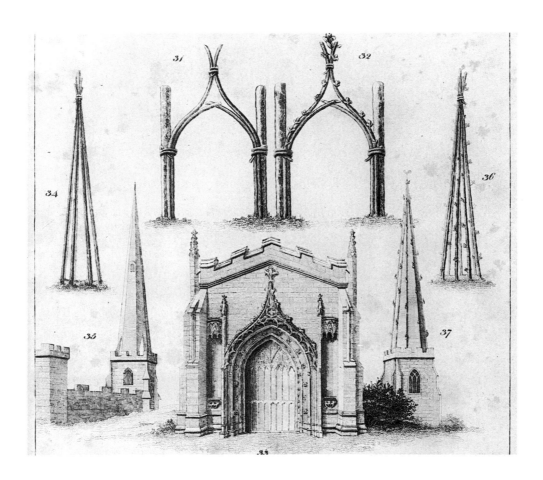

77

GOTHIC WINDOW IN SPLIT CUTTINGS, DEMONSTRATION BY J. HALL.
PHOTO: BIBLIOTHÉQUE NATIONALE.

The work was done during the winter of 1792-93. The elements of the building having taken root, the cathedral burst into leaf in the spring and the foliage appeared at exactly the same places as its sculpted stone counterpart. The report on this demonstration was published by the Royal Society of Edinburgh in 1798,[24] with many illustrations by Joseph Halfpenny, the author of a monograph on York Cathedral (1795–1807). A watercolor by Edward Blore (1789-1879) shows the church, planted in Hall's garden, still standing in the middle of the nineteenth century. It rises up like a vegetal masterpiece, like the prolongation of the woods, vibrant with the same light and shadow (plate 10). In Italy a similar edifice, an arboreal aisle and nave, was created in Castellazzo's geometrical garden in the outskirts of Milan. An engraving illustrating the verse description of its "delights" by Leonardi (1743) shows it standing mysteriously amid towering walls of greenery (fig. 78).

Such a poetic evocation of the Middle Ages by means of a bower planted in the earth, like a prodigy of nature, is really no more than a *jeu d'esprit*. Gothic chapels and other such creations, set up in landscape gardens, were frequently constructed along similar lines. In the work of Paul Decker (1759)[25] an edifice with three naves created by fantastically twisted tree trunks and roots, like some ornate "decorated pile," stands behind a Gothic portal that reminds us of its prehistoric model. A similar construction is to be found in the book by Charles Over (1758),[26] which also has a polygonal pavilion made up of trees in imitation of the archaic style. Blind and pointed arcades of branches and tree trunks appear throughout Warburton's treatise (figs. 79–81). Grohmann (1797), who reproduces an English edifice, notes in his explanation of the picture: "The structure is supported by tree trunks acting as columns, their branches forming a natural arch. We can recognize the origins of Gothic architecture."[27]

The structure recalls Hall's church, save for the rusticity of its execution. It is the memorial chapel for a beloved pet, built in a park. In the nave is a sarcophagus and above, like a trophy, hangs a horse's head.

These are some of the decorative fancies that sprang up parallel to serious speculations on the nobility and mystical character of the woodland realm. The legend has its rustic version. In discerning relationships between the style of a monument and its surrounding landscape, Home (1762) found that the Gothic accorded best with the rough and ignorant country of its birth.[28] Its spread to the lovely countryside of France and Italy, more suited to buildings in the Greek taste, was a mistake. A profusion of great and savage gives a more truthful image of the period. Multiplied in gardens that reflect nature in its primal state, such chapels and chalets, like some woodchopper's hut, seem almost to be reverting to their original environment. The awakening of the Middle Ages seems to be occurring in a theater furnished with appropriate decor and under appropriate direction. The dream of the *sylva* and its architecture is brought to life in these pastoral, idyllic representations of an ancestral world, one as yet uncorrupted by civilizations and brought into direct touch with its earliest sources.

The vision is singularly in line with Renaissance concepts, which also regarded Gothic architecture as a method of building suitable only to primitive, forest-dwelling peoples. Félibien and his followers had Italian precursors: Filarete, Antonio Manetti, and Vasari summarily attribute it to the *nazioni barbare*, to the Goths and the Teutons.[29] A famous letter ad-

78

VAULTED PASSAGE, CASTELLAZZO GARDENS.
IN L. DOMENICO, *LE DELIZIE DELLA VILLA CASTELLAZZO* (MILAN, 1743).
DOCUMENT PIERRE BERÈS, PARIS.

79

CHARLES OVER,
PAVILION "CONSTRUCTED PRINCIPALLY OF TREE BRANCHES," 1758.
PHOTO: SOC. AMIS BIBL. ART. ARCH., PARIS.

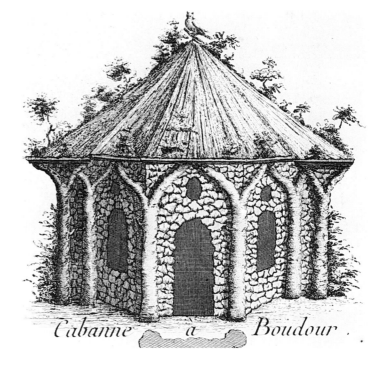

80

LE ROUGE, RUSTIC EDIFICE, 1785. PHOTO: BIBLIOTHÈQUE NATIONALE.

81

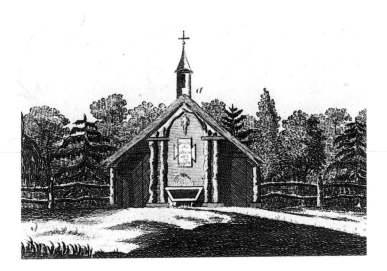

J. G. GROHMANN, ENGLISH FUNERARY MONUMENT
ERECTED TO THE MEMORY OF A PET ANIMAL, 1797.
PHOTO: BIBLIOTHÈQUE NATIONALE.

dressed to Leo X and written c. 1518–19 by an author sometimes identified as Raphael or as one of his friends (Baldassare Castiglione?) explains it in the same way as do the eighteenth-century theorists. Teuton Gothic architecture is replete with confusion and disorder, but those defects are due to the fact that it was born of "still uncut" trees, their branches bent and intertwined in pointed arches. This form does not have the grace our eyes find in the perfection of the circle, but nature seeks no other.[30] This is obviously no more than a technical definition of a rudimentary process, far from the poetic transports and sudden insights of the romantics, although it does have a hint of them. Nations uncorrupted by civilization, virgin forests, buildings sprung from nature—all this can be glimpsed beneath the dry presentation of facts. We are not yet in the Arcadia of the innocents nor even in an eighteenth-century landscape; we are still in the world of humanists who were strongly attacking the Middle Ages and their deviations from classicism. Nevertheless, even in this period we can detect a few underground currents less rebellious against that past.

In the *Mystic Nativity* Botticelli painted at Florence in 1501,[31] a wooden dwelling is set in surroundings heavily freighted with religious significance. The manger is placed at the mouth of a cave beneath a wooden roof or lean-to that rests on two tree trunks. They are "uncut trees" growing out of the earth. A branch of each bends toward the center to form a pointed arch, although its peak is hidden beneath the roof it supports. Within the grotto and beyond it a forest creates a symbolic decor, like a prolongation of the sacred hut in the foreground, flanked by angels (plate 11).

The style takes on different aspects around this period, as it is beginning to crystallize and take form. In 1498, decorating the ceiling of the Sala delle Asse of the Pal-

azzo Sforza at Milan with a rose of Arabic interlac-ings,[32] Leonardo da Vinci surrounded and framed it with leafy trees (fig. 82). We see a tunnel of braided branches and luxuriant foliage, but one that rests on solid supports. The straight trunks branch out, like a Teutonic monument, into the fasces of ogival arches and wall-ribs, bearing the entire weight of the abundant leafage and verdure. Once again, this caprice depicts "uncut trees," knotted into an inextricable ornament. The relationship to the text of the pseudo-Raphael is so close that there have been questions whether the report to the Sovereign Pontiff might not have been inspired by this composition or by some idea thrown out by the master.[33] A leafy architecture created by man and nature, the sylvan pavilion at Milan might be making the same demonstration as Hall's bower.

This unique reproduction of a Gothic vault in its original freshness is not just a genius's improvisation. German buildings were being covered with vegetation, treated with the realism of the period, at the very moment transalpine theorists and artists were identifying them with trees, and some examples are particularly revealing. Dehio notes a group of monuments in Saxony that evidence the development of analogous themes.[34] At Zwickau (1465–1506) the filling and tracery of bays, gables, and baldaquins are sculpted in the form of branches. At Chemnitz (c. 1525), rough branches frame the entrance of the castle chapel, creating an armature three stories high, with ramifications of pointed or ogee arches (fig. 83). It is as though the rustic scaffolding erected prior to construction had been retained in order to give us both key and model.[35] Carvers multiplied the flexible budding branches and blossoming vines that proliferated over the surfaces of buildings. The doorway depicted in

Dürer's *Circumcision of Christ* (from his series *The Life of the Virgin*, 1500–1509) furnishes an example of the Saxon style, at once light and overcharged. Gothic vaulting was also interpreted in the same manner, *inter alia* at Seefeld in 1466 (fig. 84). The polygonal choir of Saint Mary of Pirna (1502–46)[36] has ribbing that is completely "naturalistic," creating the effect of interlaced branches, among which "wild men" can be seen climbing. The tale of forest peoples associated with the genesis of this style of architecture is literally depicted here, and the sanctuary is the site chosen to depict it. At a given moment the Middle Ages too had been aware of such resemblances and had accentuated them with symbolic images. Combining them in his arboreal vaulting, da Vinci was playing with the elements of an authentic legend.

France also has examples of such aftereffects and survivals. When Philibert de l'Orme described the orders of classical columns, he added tree columns (1567):[37] not wooden columns, "but of actual stone and resembling trees," and he includes a drawing showing the gnarled trunk and its foliage opening out not only at the capital but also along the length of the shaft or trunk, well below the astragal. Such usage was deemed meet in numerous circumstances. Why not have recourse to it all the time? "Consider whether a doorway, peristyle, or facade for a house would not be handsome with all its columns made in the form of trees and the capitals like cut branches. . . . It would be a very fine thing to behold."

The doorway would have the appearance "of a fine forest." Ivy, "tree branches extending out," would form friezes and cornices. The terms themselves are the same as those used by an eighteenth-century writer to describe a Gothic nave.

82

LEONARDO DA VINCI, ARBORESCENT VAULT,
PALAZZO SFORZA, MILAN, 1498.
PHOTO: ANDERSON-GIRAUDON.

LVDOVICVS
MEDIOL · DVCA
QVOD · MORTV
IN · GENTE
NON · PO

83

**ARBORESCENT PORTAL TO THE CASTLE CHAPEL, CHEMNITZ, C. 1525.
PHOTO: BIBLIOTHÈQUE NATIONALE.**

Of course the scale of the building should be adapted to human scale, in keeping with the antique traditions Filarete and Francesco di Giorgio reestablished with such rigor: a masculine scale for the Doric, a female scale for the Ionic, the scale of a girl for the Corinthian. And trees are to be selected that will correspond naturally with the desired proportions. However, this identification of tree with man, "of whom it is the symbol" (Evelyn), reveals an attraction to nature and a barely concealed desire to use nature as the basis of a building canon.

In this connection we recall that it has been noted that Philibert de l'Orme's thinking, which reconciled his art with world architecture, has more in common with the enigmatic and complex genius of da Vinci than with Italian Neoplatonism and its refined doctrines: his thoughts on universal harmony stem directly from medieval symbolism.[38]

The dream of the forest is present in the architectural vision of the romantic Middle Ages in their decline, of the Middle Ages concealed in the eddies of classicism, of the Middle Ages that were revived with the nostalgia of romanticism, in every phase of an evolution in which we find form rising above technological and historical factors and attaining the field of fiction.

That permanence and those revivals are due to the fact that the Gothic system as developed during the thirteenth century contained within itself the germs of an interpretation: its legend was born deep within it and the nature of its effects, and for centuries effect thus eclipsed form. But the data are always the same: trees and branches define the building but their validity varies in keeping with the changing attitudes of schools and periods: barbarous solution, caprice,

84

ARBORESCENT RIBBED VAULTING IN A CHURCH, SEEFELD, TYROL, 1466.
PHOTO: ALBRECHT-BILD, INNSBRUCK.

higher order, rustic poetry. The cycles regularly repeat themselves. At the beginning of the sixteenth century England and Italy were opposed in the same way as were England and France in the middle of the eighteenth century. The same complex of persistency and underlying conflicts can be found in different classical circles. The myth is handed down. It crops up again spontaneously under similar conditions, and each time with renewed strength. The power of the illusion increases as we move further away from it in time. The most sublime, the vastest visions spring back to life in the unexpected revelations of philosophers and poets at the beginning of the nineteenth century.

The flowering of the naturalist legend, which was supposed to solve the question of the origin of architectural monuments in their native soil, in no way weakened the theories of foreign origin. The romantic Middle Ages were based on contradictions. The Arabic tale, strangely linked with the druidic forests, also revived and spread at the same time, so that Chateaubriand himself was forced to take it into account. He mentions it in a footnote, almost regretfully, before evoking the oaks of the ancient Gauls.[39] The affinity of the Gothic order with Egyptian monuments led him to believe that it had been brought from the Orient by the earliest Christians, which did not prevent him from touting the role of the ancestral forest. Every architectural style is created in the same manner: the Greek column, the palm tree, the Egyptian pillar, the sycamore and other huge African and Asian trees. Their art varies according to the climate.

Three works that energetically reaffirmed the Oriental and Islamic theories and that appeared two years prior to *Le Génie du Christianisme* give likely explanations for such changes. Legrand's text, which accompanies the plates in Durand's *Recueil et parallèle des édifices*,[40] a remarkable monument of documentation for the period, takes up Warburton's thesis, but from a broader perspective. Any architectural style arises out of the conditions of its birth. The buildings of Asia preserve the lightness and elegance of tents. The temples, tombs, and palaces of Egypt have the mystery, austerity, and boldness of grottoes and monuments shaped by nature, while Gothic churches do not reflect solely the darkness of Celtic oaks: "frail supports multiplied in luxury and softness also depict the flowery bowers erected by the Moors and the Arabs." The Arabian, Moorish, or Saracen Gothic developed most fully in Africa and the Orient. Cairo, Alexandria, Rosetta, Aleppo, Constantinople are among the names cited. The Goths assimilated it in Spain, in keeping with the classical doctrine for half a century. But "our richest and best decorated Gothic churches" give only an imperfect notion of it.

The *Essays on Gothic Architecture* published in this same year, 1800,[41] brought together several studies by the principal authorities on the question, among them Grose,[42] who passionately adhered to the entire Orientalist position, throwing the Gothic monuments of Isfahan into the argument, while Dellaway[43] supported Wren's Palestinian hypotheses, but without regarding France as a transmitting agent. The English Crusaders introduced the Saracenesque or Gothic style into that country directly from the Holy Land. There it gave birth to many others. During the reigns of the two Edwards, the "Saracenesque" style gained precedence. Far from fading away, the Oriental legend crystallized and evolved through the work of scholars, forcing Chateaubriand to seek a Christian compromise.

Lenoir described the Gothic section of the Musée des Monuments Français, installed in the convent of the

Petits-Augustins in 1796, as "Saracen."[44] The architecture incorrectly called Gothic is in reality an Arabic architecture introduced into France by the Crusades. Saint Louis took the famous Montereau with him to Palestine. The Sainte-Chapelle at Paris, decorated with magnificent stained glass, with its paintings and antique gilding, was a perfect imitation of Arabic monuments. This is the restitution the curator proposed to make in the museum's thirteenth- and fourteenth-century rooms.[45] And, indeed, so well was the Orient evoked that, upon entering, Napoleon exclaimed, "Ah! I'm back in Syria!"

For Lenoir, Persian architecture also offered analogies with Gothic churches. The same was true for the Palace at Cordova, built by the Arabs. The comparisons were based principally on two publications: for Iran, Le Brun's *Voyage* (1718),[46] which Grose had also used; for Spain, Laborde's *Voyage* (1806).[47] All of Islam lived again in the West. The "Lombard" buildings erected by Charlemagne in France were followed by a "truly Asiatic architecture," further developed in the fourteenth century. Next combined for a brief period with "Lombard" elements, it disappeared under François I, when Palladio's writings and work put the accent on the genius of the artist. In England, the Oriental thesis was still upheld by Whittington (1809)[48] and Haggitt (1813),[49] in Germany by Stieglitz (1820).[50] Up until the nineteenth century monuments that did not obey the rules established since the Renaissance were regarded as puzzles, as isolated and unique examples, so exclusive were the laws upon which they were based. Gothic architecture fell somewhere outside European civilization in the full sense of the term and was tainted with other worlds distant in both time and space. The key to its mystery was even sought in the Egypt of the Pharaohs.

In an odd work published at London in 1795,[51] Murphy sees pyramids everywhere: on the façades of Westminster Abbey and York Cathedral, on transept towers, on the turrets and buttresses of medieval churches. The "pyramidal tendency" dominates the overall layout of the building, down to the canopies above the niches. The only arch that can fit harmoniously into it is the pointed arch. Thus it is nugatory to seek the origins of the Gothic in branches and trees. The monuments of the Valley of the Nile eclipse the forest. Indeed, nothing could be more like a Gothic nave than an Egyptian room as described by Vitruvius.

Must we conclude, the author asks, that the Occident has consciously adopted these ancient traditions? No one has so far postulated such a thing. But let us not forget that the towers so frequently found alongside old churches in Ireland resemble obelisks and that the old Saint Paul's was higher than an Egyptian pyramid. And if we travel through our own country, we will find more pyramids in one single shire than are to be found today in Memphis or Sakkara. Thus, we are entitled to surmise that the spires of our bell towers derive, to a certain extent, from an Egyptian notion grafted onto Christian principles.

The pyramid was sacred to the subjects of Pharaoh, who used its shape to express the origin of all things. They erected it in their cemeteries, as do the Christians, to signify the immortality of the soul. Like the flame, it represents the spirit of the dead leaving the body and mounting to its divine repose. The Gothic cathedral, in its elements and as a whole, the symbolism of its forms, is a transposition of an Egyptian mode. The book was regarded as authoritative and is often quoted in architectural treatises.

In *L'Origine de tous les cultes* of Charles Dupuis, a mythographer and member of the National Convention, which was published the same year as the above-mentioned (1795) and in which the pyramid is also interpreted as being the geometric expression of fire, all of Christianity is depicted as arising out of the Egyptian solar cults, the cradle of all religions.[52] The figures sculpted in churches are hieroglyphics.[53] It is not the Virgin but, rather, Isis whom we see on the façade of Notre Dame, surrounded by the zodiac. Goddess of the Franks and Suevians, who always linked her with her symbolic ship (a vessel that is still to be seen on the city's crest), she is the tutelary goddess of Paris.[54] "It is to this Isis, Mother of the God of Light, that the people come to offer candles on the first day of the year." The Cathedral of Notre Dame is her temple. According to Horus-Apollo, the year is designated by the Egyptian Isis. Speculating on ancient cosmogonies, the secular France of the Revolution returned to the sources of the humanist Renaissance and all of its pseudo-lore with regard to Egyptian emblems.

Lenoir's iconographic labors took him in the same direction. "The majority of the emblematic figures decorating the portals of our churches are kinds of hieroglyphs resembling those of Egypt," the curator of the Musée des Monuments Français stated,[55] and he deciphered the reliefs, which for the most part consist of stories, by using the methods laid down by Dupuis. He even made out the figures of mummies on a capital at Issoire, thereby indicating that not only the allegories and religious beliefs of ancient peoples had been introduced into Gaul but their rites and their method of burying their dead as well. Several mummies were discovered in the region, among them "an Egyptian mummy, found in Auvergne," and were installed in the Cabinet d'Histoire Naturelle at Paris.[56]

Gothic architecture must derive from the same world. It is further linked to it by the symbolism of its arches. "The ogive itself is nothing but an Egyptian emblem. The ogive is a representation of the sacred egg, considered by the Egyptians to be the principal creator of the great goddess Isis and even of Osiris, her brother, both hatched from an egg fertilized by the substance of light."

Give or take a contradiction or two, the Arabic factor does not rule out a vast network of transmission.

An England bristling with pyramids and obelisks and a France full of Egyptian symbols suddenly loom out of the monumentary landscape of the Middle Ages. The myth owes its interest not only to its validity, but also to the stature of the men who created it.

The Gothic cathedral is an incarnation of the multifaceted *Temple de la Renommée*, in which every part of the world is joined together: the druidic North, the Egyptian South, the Islamic East. The fourth side, however, is not antique,[57] but Chinese.

Deploring the proportion of the bays that conceal the architectural mass, Le Blanc wrote in 1733: "The Chapelle of the Palais at Paris far surpasses the Chinese lanterns, some large as rooms, mentioned by Père le Comte: this whole building is a lantern. It is all windows, the masonry is barely evident."[58]

As for the Jesuit Father, he was dazzled by such lanterns and speaks of them with enormous admiration.[59] Some are gigantic, up to thirty feet (approximately ten meters) in diameter. They are lit with countless lamps and marionettes as large as humans are operated there. Others are four feet tall. With their armature of gilded wood, their taut skin of fine transparent silk, they have several rectangular panels upon which are painted flowers, trees, rocks, and, sometimes, figures.

"The painting is beautiful, the colors vivid, and when the candles are lit the light shed is so brilliant that the whole production is utterly agreeable."

The stained glass window could be described in similar terms. Did Ruskin not cause Aladdin's lamp to glow?[60] Whatever Le Blanc may have thought of their effect, the stained glass windows of the Sainte-Chapelle glow for him like Chinese lanterns in the darkness. In presenting a paper on the zodiac to the Académie Royale des Sciences in 1785, Le Gentil de la Galaisière noted that he had sought out representations of it not only in India but also in Europe, since he was aware that "the genius that had guided Indian masons or architects in the construction of their pagodas is the same who in our own land presided over the building of our Gothic churches."[61]

His reasoning is supported, in France, by Notre Dame de Paris and Saint Denis, in England by the Walmgate Church at York, confirming the relationship between the western Middle Ages and Buddhist Asia that the astronomer mentions as if it were common knowledge.

In China itself evidence was found of the medieval system associated with other factors. "They are Gothic in their gigantic or mean proportions, in the dryness and contortions of their forms," Delatour declared in 1803[62] with regard to the palaces built for the Emperor at Peking. Lenoir (1809) extended his scope far beyond the countries of Islam and Egypt: Indian and Chinese architecture have the same elements as Gothic-Arab architecture. The motifs of an Indian monument and a Chinese palace are brought together at Saint Denis.[63]

The German romantics were also dreaming of India around this time. Schelling mentions it in his consid-

erations on the origin of the art of the cathedrals, which he traces back to distant sources (1802–4):[64] "Indian buildings in fact present a striking and astonishing similarity with the Gothic. . . . The architecture of temples and pagodas is completely Gothic; even ordinary edifices have their Gothic spires and pointed towers. . . . The excessive taste of the Orientals, which knows no limit and aims at the boundless also appears in Gothic architecture. Indian architecture goes even beyond the latter in size, for it can create buildings that are as large as a big city and that resemble the most gigantic vegetation on earth."[65]

So, by a curious route, we are back to the plant kingdom. The passage cited follows descriptions of German forests and their temples that revive the deeply held feeling that a Gothic cathedral is a Universal City of God, but one in which a Saracen element has managed to insert itself.

Lanterns, pagodas, and Far Eastern palaces sprang up as if by magic, reflected in buildings that seemed to welcome any style, any influence. It was a confused period, dominated by but one thing: an obsession with the exotic.

Around the middle of the eighteenth century Chinese and Gothic styles were often lumped together. In a letter dated August 1, 1750, Horace Walpole wrote to a friend visiting Florence: "The country is acquiring new features. . . . The new constructions—and by that I mean churches, bridges, etc., are usually Gothic or Chinese. Which adds a touch of whimsicality to newness."[66]

In that statement both styles of architecture seem to emanate from a similar fantasy. In addition, it has been shown that, at the time, the irregularity of cer-

tain medieval designs was being imputed to East Asian principles,[67] and that the same was also evident in gardens. Architects commissioned to create them frequently confused the two elements. The pavilions illustrated in a collection (1753) by the Halfpennys (William and John Halfpenny, to whom Joseph, who participated in Hall's experiments, was probably related) are both medieval and Far Eastern. The ogee arches and spires of a "Chinese Temple" framed by two palm trees are little different from a fifteenth-century chapel. The "Gothick Lodge" that follows it in the album has almost the same layout (figs. 85, 86), excepting that a gable has replaced the central Chinese tower with its bells and the vegetation surrounding it is no longer tropical. The "Elevation of a Church Partly in the Chinese Taste" made by the two architects in 1752[68] is a hybrid: with a pagoda for its roof, the church has an impeccably Gothic portal, gables, and arches (fig. 87). The disparate forms are surprisingly harmonious and the ensemble is almost organic, as if to demonstrate the paradox of Le Gentil de la Galaisière. In Over's work (1758),[69] Gothic fantasies with trees are accompanied by "Chinese" and "Gothic Churches," rotundas with flower-decked arches that can be recognized as churches only by the motifs of the central spire and the legend accompanying the drawing (fig. 89). In the Bagatelle at Paris, the "Pavillon du Philosophe," built by Bélanger in 1782,[70] consists of a series of arches set in an octagon, all of whose elements, lancets, quatrefoils, and trefoils, copy those of the Sainte-Chapelle, the whole topped by a curved roof (fig. 88). The building is set on a rock shaped like a bridge and, to the side, there is a mast topped with a parasol and two dragons. The site designed for meditation combines Gothic bays with "a Chinese lantern."

After a lengthy germination within an architectural world mysteriously constructed out of two eras, interrupting the progress of classicism, legendary themes surfaced on several levels: in a new lyrical impulse, in thinking, in archeological and historical notions, and in the decor of romanticism.

The works that succeeded this "Gothic revival"[71] and laid the earliest foundations for a positive knowledge of the Middle Ages[72] began by destroying them. After Caumont (1823–50) and Bourassé (1841), Choisy (1892) still felt impelled to refute the forest tale, still being told not only by Huysmans (1898) but also by archeologists. A communication by Lambin to the Soissons Société Archéologique in 1899 illustrates this: "Leave a woods to enter a cathedral, or leave a cathedral to go into a woods, and you will believe that you still have the same vaulting above your head, the same light shining down upon you. . . ."

In support of his contention the author refers to an experiment similar to that of Hall carried out by a member of the Société des Antiquaires in Picardy, who planted two rows of trees leading to the apse to replace the destroyed nave of the church at Ourscamps, restoring its elevation.[73] Already refused by May (1774)[74] and Milner (1798),[75] the Islamic theories began to be violently attacked,[76] but the question was soon abandoned in investigations into Gothic systems, which are Western *par excellence*. However, everything in the legends and paradoxes that so obsessed a great period was not false. The Middle Ages themselves were aware of the sylvan likenesses that had spontaneously appeared in an architecture that made its own laws as it went along. Arabic and Chinese forms were also identified. Ogival crossings had been preceded by the ribbed coverings of the monuments of Persia, the Maghreb and Moslem and Mozarabic Spain,

85

WILLIAM AND JOHN HALFPENNY, CHINESE TEMPLE, 1753.
PHOTO: BIBLIOTHÈQUE NATIONALE.

86

WILLIAM AND JOHN HALFPENNY, GOTHIC PAVILION, 1753.
PHOTO: BIBLIOTHÈQUE NATIONALE.

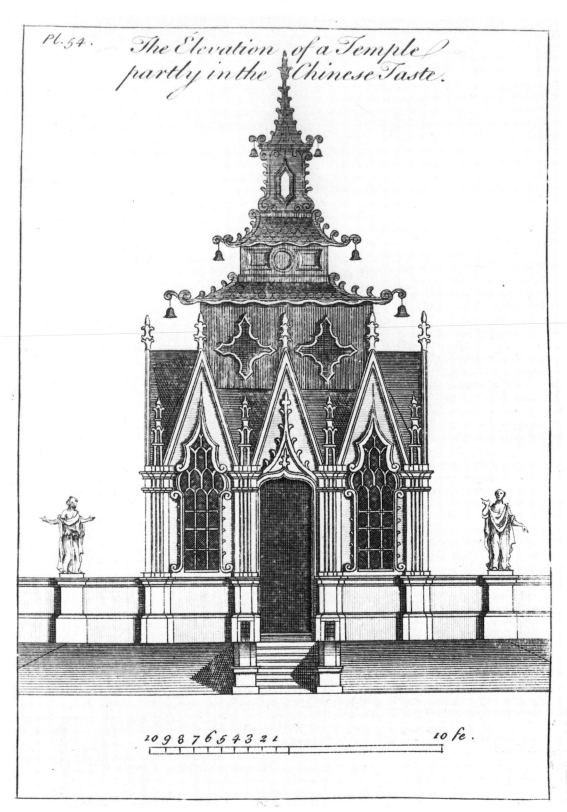

Pl. 54.

The Elevation of a Temple partly in the Chinese Taste.

20 9 8 7 6 5 4 3 2 1 10 fe.

**WILLIAM AND JOHN HALFPENNY,
TEMPLE "PARTLY IN THE CHINESE TASTE," 1752.
PHOTO: BIBLIOTHÈQUE NATIONALE.**

88

J. CH. KRAFFT, 1812, BAGATELLE, PAVILION OF A
CHINESE PHILOSOPHER BY F. G. BÉLANGER, 1782.
PHOTO: BIBLIOTHÈQUE NATIONALE.

89

CHARLES OVER, GOTHIC AND CHINESE TEMPLES, 1758.
PHOTOS: SOC. AMIS BIBL. ART. ARCH., PARIS.

90

GOTHIC NICHE IN A FUNERARY MONUMENT, BLANGY (SEINE-MARITIME).
PHOTO: ARCH. PHOT.; COPYRIGHT SPADEM.

CHINESE BUDDHIST VOTIVE STELE, WEI DY, 551.
THE ART INSTITUTE OF CHICAGO. MUSEUM PHOTO.

and they had played a part in the complex genesis of Gothic vaulting.[77] The festooned arches and window traceries of the thirteenth and fourteenth centuries are clearly related to the Arabian polylobes. All of the varied counter-curves of the "ornate" phase of the "decorated" and flamboyant styles—the four-centered arch, the pointed arch, the ogee arch, and accolade—are also to be found in China (figs. 90, 91).[78] The Gothic cathedral combines exoticisms and age-old dreams in its universal grandeur and unity. The legends to which it has given rise have managed to spread and persist so stubbornly because they contain a part of the truth. Its system of construction and its forms have enjoyed this romanticized existence because of their profound poetic content. The men who revived the Middle Ages have all felt and expressed it in their various ways. Even its Egyptian aberrations evoke the visionary aspect of the Gothic and multiply its illusions. Knowledge of the Gothic world is incomplete without the perspective of legend. In their incoherence and in their precision, each of the tales of its architecture corresponds to one of the aspects that most excited their creators.

Gardens and Lands of Illusion

92

**JOHANNIS ZAHN, HEXAGONAL CATOPTRICAL BOX, 1685.
PHOTO: BIBLIOTHÈQUE NATIONALE.**

The Gardners are not only Botanists but also Painters and Philosophers.

William Chambers

1. *Beds of delicate flowers.*
2. *Garden with aligned trees.*
3. *Group of dancers.*
4. *Pyramids and towers.*
5. *Odd dwellings built in desert regions with old trees and stones retrieved from ruins.*
6. *Royal residence with splendid decorations, gold columns, and magnificent furnishings.*

This is no fairyland in an eighteenth-century garden but an account of the scenes depicted in a catoptrical box described in *Oculus artificialis*, a book by Johannis Zahn, Canon of Erfurt, published in 1685.[1] It is a hexagonal box divided into six compartments with mirrors set at 60-degree angles, each of which seems, through the magic of reflection, to fill the whole of the interior. The subjects are painted on the inside of the box's shell, made of opaque glass through which light passes as through stained glass. Each side has a peephole. The apparatus could be set up on a revolving platform so that the scenes appeared in sequence before the seated viewer. The device is just one of many such pieces, boxes containing mirrors in which, by looking through various orifices, one could view gardens, cities, landscapes, fantastic treasures, all in miniature. Kircher (1646) and Du Breuil (1649), among others, offer models whose origins go back as far as the catoptrical theater of Heron of Alexandria. However, in the layout of its scenography, Zahn's hexagonal device contains the whole history of the development of such depictions of nature, which it anticipated by a half century (fig. 92).

"A Frenchman puts geometrical figures in his garden, an Englishman sets his house in the midst of a field, a Chinaman sets frightening shapes in front of his windows: there are three kinds of abuses. Each of them, when corrected, leads to true beauty."[2] With those oft-quoted words the Duc d'Harcourt (1774) defined the three types of gardens prevalent in his day. Linking architecture and landscape, the art of gardens combines the three in various ways, in some cases adopting extreme solutions: here, regular forms, there irregularity; on the one hand, levels, steps, and terraces, squared beds with rigorously patterned designs and geometrically trimmed plantings, fountains and ponds set in alleys, squares, or circles; on the other hand, lawns, casual slopes, grasses, wild flowers planted at the hazard of sun and wind, wild woods and copses, lakes or running streams following their natural course. We have two opposite systems, one of which is symbolized by France and the other by England: "Nature subjected to the dwelling" and "the dwelling subjected to Nature" (the Marquis de Girardin, 1775),[3] an artifice and a piece of "natural" landscape (figs. 93, 94). However, nature can also be created artificially: hillocks and rocks constructed in a flat field, irregularities created in a smooth stretch of land, bodies of water precisely located and their flow regulated, vegetation selected and planted according to a master plan to create a composition. The artifice of geometrical nature contrasts not only with "real" nature, but also with the man-made arrangements associated with the Chinese.

The life of imagery in form has always wavered between these two concepts. It is during the eighteenth century and in gardens, however, that we witness a rapid development in which reality takes the place of abstraction, where the unreal takes over from reality, opening the way to fantastic visions, and it is solely in connection with gardens that we have a vast literature on the question. No treatise on painting gives us so much information on thinking and technical methods as do dissertations on the direct arrangement of nature.

The *Traité du Jardinage* by Jacques Boyceau (1638) describes the elements of his compositions by constantly employing various architectural terms: "The raised groupings of the trees that demarcate and divide up spaces . . . are created by alleys or galleries covered over by trees or by bowers or ceilings of foliage. Whole suites of salons, rooms, small retreats can be created in foliage, domed or vaulted, like actual buildings or pavilions with decorated architectural doors and windows all created by tying and clipping."[4]

"The artifice of clipping" creates arcades in the foliage, niches with their underframes, capitals, and cornices. Trees and shrubs simulate buildings, while the flower beds are laid out like carpets of a Moorish design, with arabesques, grotesqueries, rosettes, coats of arms, and devices. Nature is totally eradicated, transformed into a leafy palace extending and enlarging the stone buildings set in it.

The work of Dézallier d'Argenville,[5] the "Bible" of French gardens, which went through four editions from 1709 to 1747, depicts the majority of such layouts. We find massive and somber walls that make a powerful monumental effect, heavy portals with buttressings, and light arcades. The *palissades* at Arminvilliers are trimmed to look like baroque façades and pediments. The bowers and galleries of Marly (1679), with their trained and clipped shrubberies, form the armature for a magical vault of slender, airy arches (fig. 95). Cones, pyramids, balls, vases, any shape—excepting plant shapes—was reproduced in flora. These witty constructions, which Le Nôtre,[6] with unparalleled talent, managed to endow with grandiose perspectives, control the abstraction of nature. Fifty years

Dessein d'un Labirinte avec des cabinets et Fontaines

93

ANTOINE JOSEPH DÉZALLIER D'ARGENVILLE, GEOMETRIC GARDEN, 1747.
PHOTO: BIBLIOTHÈQUE NATIONALE.

94

LE ROUGE, LANDSCAPE GARDEN, 1775.
PHOTO: BIBLIOTHÈQUE NATIONALE.

95

ANTOINE JOSEPH DÉZALLIER D'ARGENVILLE, ARCHITECTURAL PLANTING.
PHOTO: BIBLIOTHÈQUE NATIONALE.

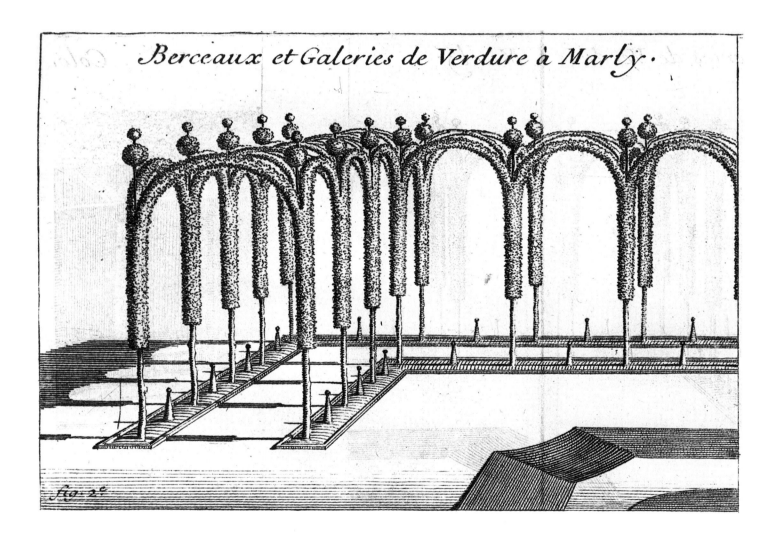

Berceaux et Galeries de Verdure à Marly.

after the death of Louis XIV, the system had still not been abandoned.

In England, the apology for the geometrical figure was still being put forth by Wren (1632–1723): it is "naturally more beautiful than any other irregular figure."[7] In 1704, John Dennis was writing in the same vein: "The Universe is regular in all its parts, and it is to that exact regularity that it owes its admirable beauty."[8] However, in 1715 Stephen Switzer criticized mathematical gardens, comparing them with the riant charm and infinite variety of unregimented nature.[9] "Is there anything more shocking than the rigidity of a created garden?" asked Batty Langley,[10] who, in his 1728 treatise, proposed a style that would be "grander and more rural" than that followed hitherto. In 1762, at a time when great strides were being made in landscaping in his country, Home took up the attack: "Straight lines, circles and squares look better on paper than in a field."[11] The gardens of Versailles, that lasting monument to the most depraved taste, created at infinite expense by the best artist of the day, show only the "non-natural" mistaken for the "supernatural." This English reaction against a schematic ordering corresponds to profound changes. It was not a question of modifying forms within the decor. The rediscovery of Nature was like a revelation. The irregular "meadow" in which the house was set was an Eden, a new image of the world.

Since ancient Persia and Babylon, the garden had always been associated with Paradise.[12] The sacred landscape in the gardens of antiquity, the Garden of Venus (Pliny and Plautus), the Epicurean Earthly Paradise of the sage in his ataraxia (Lucretius), all obeyed the same impulse. In *Le Songe de Poliphile* (1467), the Isle of Cythera is a paradise garden with towers, walls, whole scenes, hunts, chariots, and boats carved out of vegetation. Mansart was still inspired by such visions,

which constantly recurred in classical French gardens, when he created his colonnade at Versailles, built between 1684 and 1687.[13] However, it was the untamed Paradise, which England rediscovered in Milton (*Paradise Lost*, 1667–74), that was to be recreated in its parks.

Upon leaving the confines of his house, William Kent realized that all of nature is a garden, in its primal splendor, and he put it in his work. According to Horace Walpole (1771), "he was a painter, an architect and the father of modern gardening. In the first field he was beyond mediocre, to the second he restored science, in the latter he was an original and inventor of the art realized by painting and perfected by Nature. Mahomet imagined an Elysium, but Kent created many of them."[14]

Rousham, Claremont, Esher, Carlton House, Chiswick, Stowe, where he worked from 1730 until his death in 1748, are incarnations of paradisiacal landscapes.[15] However, he was not alone in creating the revival. Two other names are closely associated with his: Charles Bridgeman,[16] active from 1724 to 1734, who created a transitional style that relaxed the laws of rigid gardens, and Alexander Pope, the poet of a "more antique gardening, nearer to the work proper to God than poetry itself," to whom we owe not only the philosophical underpinnings of the revival but also many practical suggestions.

Returned to the freedom of foliage, earth, and water, Paradise now presided over the development of landscape gardens,[17] the glorification of Nature heretofore denatured by artifice. Contrasting his Elysium, the Orchard at Clarens, with arrangements of aligned trees pruned into parasols, fans, marmosets, monsters, and dragons, Jean-Jacques Rousseau (1761) evoked the myth that had grown up around the new emancipa-

tion.[18] However, the Arcadia of antiquity was not merely the site for some enchanted visit. Since the world was a garden, the garden enclosed the world. Thus, monuments were added to fill out the vision. This notion, too, is in line with one of Pope's allegorical concepts. It is like *The Temple of Fame* (1711), around which a medieval legend had sprung up, whose four façades, each different in architectural style but equal in beauty, represented the four parts of the universe: the west façade with Greek orders, the north façade, Gothic, the east, the Orient from Assyria to China, and the south façade, covered with hieroglyphics and Egyptian obelisks. Now, however, there was to be no composite order, but rather different buildings scattered over the verdant setting. And the author himself proceeded to destroy the monolithic monster.

Egypt and Greece were represented by an obelisk raised to the memory of his mother and a circular temple in the untamed landscape of the park of his property at Twickenham, purchased in 1718, the plans for which he drew up himself in 1726 (fig. 96).[19] There was also a grotto with optical devices to enlarge the imaginary perspectives:

As soon as the doors to the grotto are closed it is transformed into a camera oscura in which the Thames and all the surrounding scene, ships, mountains and woods, spring to life on the walls and create a kind of moving picture. When the grotto is artificially lit it presents the eye with another prodigy: it is completely encrusted with shells mixed with bits of angled mirror. . . . When an alabaster lamp is hung myriad luminous points are created which reflect back from every part of the grotto,

Pope wrote in his letter of 1725 to Edmond Blount.[20] This is another catoptrical device like that of Zahn in the first landscape garden, as at Versailles in the Grotto of Thétis (1676),[21] which was already ahead of its time. The multiplication of horizons and images of the outside world in its reflections was like a maquette of the microcosm now being sought in gardens.

The dual universe of Twickenham became ever more complete. At Rousham, the design of which was finished by Kent in 1730, to his borrowings of certain elements of Pope's layout to the south (the pyramid) and west (arcades and antique temples), he added a Gothic edifice on the north façade.

At Stowe,[22] where Kent succeeded Bridgeman in 1734, the Orient was represented by a Chinese house that can be seen in a 1750 engraving. There were thirty-eight monuments: a temple of Venus and Bacchus, a temple of great Britishers, an Egyptian pyramid (fig. 97), obelisks, and a Gothic church, were all sited here and there in a "natural" terrain that allowed various parts of the universe to loom up on every side. There was also a catoptrical grotto with an abbreviated view of the whole. Describing the profusion of mirrors that broke the site up into "a thousand lovely rooms," William Gilpin (1749) wrote: "The exterior views are also transferred onto the inside walls and the side walls of the room are elegantly decorated with landscapes that surpass Titian's brush with the added advantage that each picture, when one moves about, varies in appearance and shows you something new."[23]

It would be difficult to be more precise in describing all of these landscape evocations. "Such gardens are a very good epitome of the world," Gilpin concluded as he ended his stroll with a friend. In conversation with Saint-Preux in his orchard, M. de Wolmar (Rousseau: *La Nouvelle Héloïse,* 1761) gives his layout the same meaning.[24] The park of Milord Stowe is like a composite of various sites and civilizations; "the master

J. SERLE, ALEXANDER POPE'S GARDEN, TWICKENHAM, 1725.
PHOTO: BIBLIOTHÈQUE NATIONALE.

97

S. BRIDGEMAN, EGYPTIAN PYRAMID AT STOWE, 1739.

98

WILLIAM CHAMBERS, KEW, ALHAMBRA AND PAGODA, 1763.
PHOTO: J. MUSY; COPYRIGHT CNMH SPADEM.

and the creator of this superb solitude has even built in it ruins, temples, antique buildings, and *eras as well as places* are brought together in it with a magnificence that is beyond the human." Not only foreign lands but the eras of the universe are all assembled in the "Garden of Fame."

The creation of a landscape microcosm does not alter its paradisiacal character. "What was once a Desert is now an Eden," Chambers wrote of the garden he created at Kew, in Surrey, for the Princess of Wales,[25] in which, from 1757 to 1762, twenty-one monuments were built, among them a great pagoda, a house of Confucius, and an Alhambra affording a vision of the Orient (fig. 98). Strolling the twisting paths of the Earthly Paradise, one moved from continent to continent, century to century. The Temple of Fame was broken down into its component parts. Rebuilt as separate structures, its façades were strewn over the lawns and in the copses, bringing back the many glories and sights of the planet. Arrangements appropriate to nature, fir trees, druidic oaks surrounding Gothic buildings, palms around the Moslem gazebos, and willows, streams, and rocks around Chinese pavilions, all served to make the picture as real as possible. Collections of items (plate 15), like those of the Halfpennys (1753),[26] provided for this. The universal monument left the print of its theme on the site, which enhanced its irregularity. There was no attempt to orient things or to lay things out according to actual geography. The Gothic north could very well exist between China and Egypt. The Greco-Roman Occident could spring up anywhere in the world. Pyramid and crenelated castle stood side by side (figs. 99, 100). Landscapes were created helter-skelter in the garden, like the oddities piled onto the shelves of a curio cabinet, like some outdoor *Kunst- und Wunderkammer*. It was this very confusion that lent poetry to these compositions recreating legendary worlds. In the history of cosmic representations, they signify the end of the universe that Wren and Dennis still regarded as geometry and architecture.

The system rapidly spread to the continent.[27] In France, according to Laborde (1808),[28] "the first English park" to break with the "sorry regularity" of the classical gardens was Le Raincy (1769–83). Then came Ermenonville (1766–76), Monceau (1773), the Petit Trianon (1774 and 1783), Chanteloup (1775–78), Bagatelle (1777–87), Betz (1780–89), the Folie Saint-James at Neuilly (1784), the Désert de Retz (1785). They are all rural or pastoral universes, universes with many faces. Ermenonville,[29] which belonged to the Marquis de Girardin, who lived in England, harbors the cenotaph of Rousseau, who died on the property in 1778, and has its grove of Clarens, an Arcadian meadow, and a desert. We can see, *inter alia*, a Gothic tower, an obelisk, a Temple of Philosophy, which, like man's own knowledge, was never completed, a hermitage, a brasserie. The different parts of the world are evoked at Betz,[30] created by the Duc d'Harcourt, with an obelisk, a Doric temple, a Chinese kiosk, a druid temple, and the ruins of a Gothic church.

At the Bagatelle, the creation of Bélanger, whose travel diary reflects his perfect knowledge of English landscape gardens, there is a temple to the god Pan, the house of a Chinese sage, a pharaoh's tomb, and a hermit's cell.

An obelisk, a Chinese house, a ruined Gothic church, a real thirteenth-century church, greenhouses, and a pyramidal ice house stand in the Désert de Retz created by R. de Monville (figs. 101–105).[31]

The main building consists of a "destroyed column," the base and a section of a giant Doric shaft (forty-six feet in diameter), which contains a complete house

99

J. G. GROHMANN, LANDSCAPE MICROCOSM: GOTHIC CHAPEL, EGYPTIAN PYRAMID,
AND CHINESE PAVILION IN A PARK, 1799.
PHOTO: BIBLIOTHÈQUE NATIONALE.

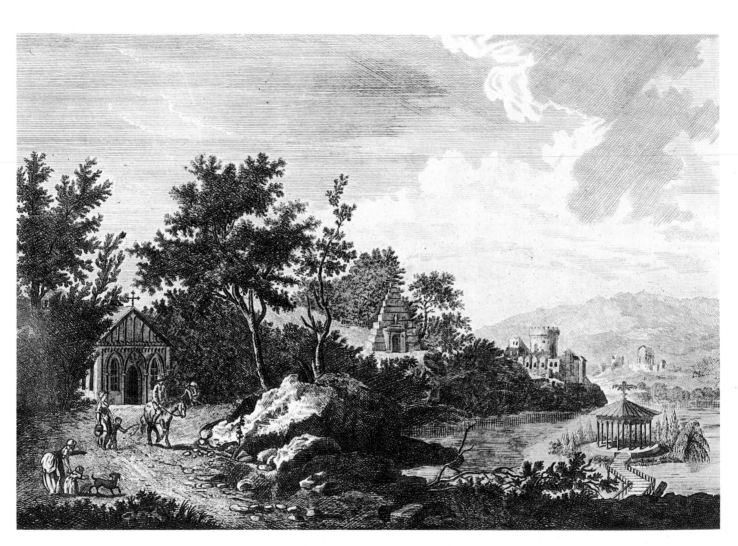

J. G. GROHMANN, LANDSCAPE MICROCOSM: GOTHIC CHAPEL, EGYPTIAN PYRAMID,
AND CHINESE PAVILION IN A PARK, 1799.

100

J. CH. KRAFFT, LANDSCAPE MICROCOSM:
MOORISH, CHINESE, AND GOTHIC PAVILIONS IN PARK, 1809.
PHOTO: BIBLIOTHÈQUE NATIONALE.

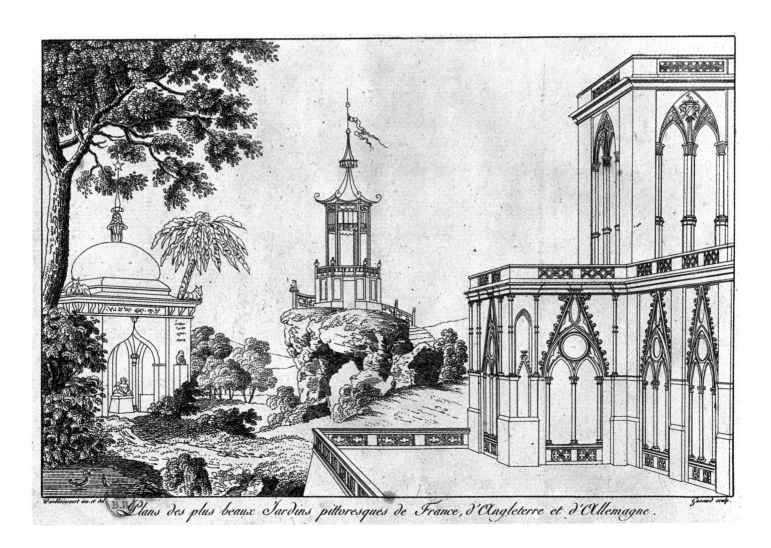

Plans des plus beaux Jardins pittoresques de France, d'Angleterre et d'Allemagne.

101

LE ROUGE, DÉSERT DE RETZ, ICEHOUSE, 1785.
PHOTO: J. MUSY; COPYRIGHT CNMH SPADEM.

Vue de la Glaciere.

DÉSERT DE RETZ, CHINESE HOUSE, PHOTO TAKEN C. 1900.

with basement and four stories and stands at the end of a huge field amid two poplars, a copse of lilac, laburnum, and apple trees, and a grove of larch and green trees. All the landscapes created on the property seem, with the introduction of such fantastic architectural works, to be larger than life, dreamlike. It is a land of illusion in which we are never far from nature, as Carmontelle noted when writing of the garden at Monceau, in which he too mingled odd structures with an Italian vineyard and a grove of exotic trees. "Nature varies according to climate. Let us therefore create different climates in order to forget the one in which we live. Let us change garden scenes as we do the scenery at the Opera, and allow ourselves to view in reality what the cleverest painters might endeavor to show us in decoration, all kinds of weather and every part of the globe."[32]

We owe that poetic outburst to a painter, engraver, and playwright. The philosophy of escape into nature gave rise to a chimerical theater of Elysium and earthly oddities.

In his *L'art d'embellir les paysages* Delille wrote against such abuses—

Bannissez des Jardins tout cet amas confus
D'édifices divers prodigués par la mode,
Obélisque, rotonde et kioskes et pagode,
Ces bâtiments romains, grecs, arabes, chinois,
Chaos d'architecture et sans but et sans choix,
Dont la profusion stérilement féconde
Enferme en un jardin les quatre parts du monde.[33]

[Banish from gardens all this confused profusion/Of different buildings, dictated by fashion,/Obelisk, rotunda, kiosks, and pagodas, /These Roman, Greek, Arabic, and Chinese structures,/ This architectural chaos without either aim or selectivity/ Whose sterilely fecund profusion / Gathers the four corners of the earth together into one garden.]

—while recognizing the reasons underlying them: since the profusion and diversity of the world emerged out of chaos, chaos reflects its underlying order. Nor did things always occur as abrupt breaks with abstractions, especially in countries in which geometrical gardens have been preeminent. In some cases the development was progressive and there were many rigid survivals and juxtapositions. A plan by Molinos shows liberated nature contained in a circle that holds it like a jewel case (fig. 106).[34] The Folie Boutin (1770) has gardens *à la française* and *à l'anglaise* laid out side by side. These are composite monsters, hybrids in spirit and time, in which the "groomed" and the "untamed" enjoy the same space,[35] where "the wild" is also suitably "groomed." Indeed, underground currents were preparing its inevitable spread to and emergence in France.

For some time a nostalgia for nature and experiments in diversity had been rising to the surface on the edges of the mainstream. There were numerous cases prior to 1760 both in literature and in theory and practice.[36] Honoré d'Urfé's pastoral novel *L'Astrée* (1610–25) discovered the calm of the countryside prior to Milton's *Paradise Lost* (1667–74). Charles Dufresnoy (1731) was regarded by French theoreticians (Latapie, 1771, Duchesne, 1775) as a precursor of Kent in the creation of a new style in natural surroundings, in the "Chinese" style. Most of his attempts appear to have been timid and on a small scale. The King quite naturally rejected the plan submitted for Versailles. Nevertheless, we still have the fact that some resistance did exist to Le Nôtre. It was in the Lorraine of Stanislas, the exiled King of Poland, that we find springing up parks with picturesque settings: Polish exoticism with a wooden

106

PLAN FOR A CIRCULAR PARK BY MOLINOS, 1798–99.
PHOTO: J. MUSY; COPYRIGHT CNMH SPADEM.

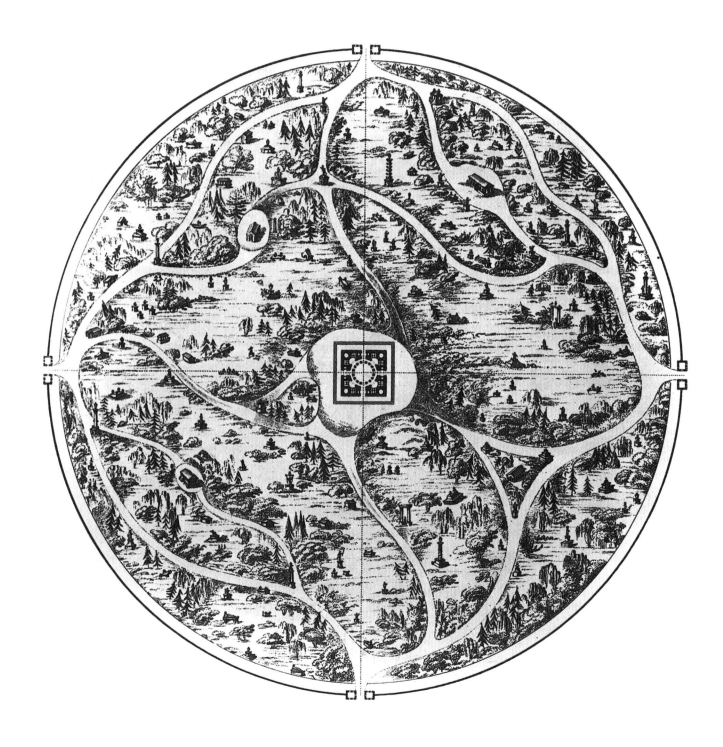

107

THOMAS GAINSBOROUGH, "CLAUDE'S MIRROR," INK DRAWING, C. 1750–55.
LONDON, BRITISH MUSEUM. MUSEUM PHOTO.

retreat, Oriental exoticism with a kiosk mingling China and Turkey and the *Rocher* of Lunéville (1742), artificial boulders set around a courtyard. Eighty-two wooden automatons operate among the cottages and works set up beneath spiked walls amidst sculpted pastoral landscapes. There were rustic settings, scenes of trades, farm animals, as well as monkeys and a hermit in a grotto. The whole thing was clearly contemporary with Stowe, and, in its irregularities and its fictions, it represented an entire program for the future.

The genesis of the landscape garden did not entail a mere intrusion of fields and surrounding woodlands onto another terrain. All of newly discovered nature was to be transfigured and transposed into a domain of vision and symbolism. The rediscovery itself did not happen directly. Foreign factors entered into it from the beginning and strongly influenced its evolution. We have shown that Kent's landscapes were in no way intended to evoke some untamed English site.[37] In 1719 the architect returned from Italy—where he had taken Lord Burlington[38]—dazzled by its scenery and even more by the art of the painters who had depicted it, foremost among whom were Claude Lorrain and Salvator Rosa. The pastoral calm and abrupt grandeur of those two masters were subjects of keen appreciation in England at this very time,[39] and they were the elements he attempted to recreate in his parks. He continued to be obsessed by them until fairly late:

At Blenheim, Croome and Caversham we trace,
Salvator's wildness, Claud's enlivening grace,

reads a poem of 1767 on the progress of taste in the planting of gardens.[40] The painter's picture was now sought in the layout of the site. A special instrument, "Claude's mirror" (fig. 107), was even used to this end. This was a concave, gray-tinted mirror sold to capture the reflected image and attenuate its features. The landscape was viewed as in a *camera oscura* (or a catoptrical grotto) and resembled a work of the artist from Lorraine.[41] Here, in any case, whether mirror reflection or actual garden, we have a reversal of the relationships between the object represented and painting. We are not dealing here with an attempt to reproduce nature in a picture. The picture is projected onto nature. "It appears that this view was copied from some of Ruysdael's pictures, or those of Gaspre Poussin," wrote Laborde of a section of Retz. The relationships that were constantly being created, according to Pope's dictum "All gardening is landscape painting," between the art of gardening and the landscape artists' art of painting meant not only the improvement of natural layout but also the transposition of preconceived models.

The first landscapes attempted in gardens all had foreign origins. In England, it was a vision of Italy; in France, at Raincy, one might have been "in one of the most beautiful locales in England."[42] France also had its own Italy at this period, however, an Italy of monuments and antique ruins, with its own picturesque splendors and mythology. Hubert Robert had brought to life its fascinations and he embodied the ideal figure of a gardener-painter that we encounter at Versailles, at Méréville, at Retz (plate 12).[43] Painting and garden are mutually reflective in every way. At Rambouillet one of the rotundas of Thévenin's *Laiterie* has a vast panoramic picture of Rome set amidst verdure in the foreground.[44] The entire city is represented in the neighboring site, in which we also find a grotto topped by a Chinese pavilion, a hermitage, and a cottage of shells. It is part of the same collection of oddities and areas for escape and repose that spring up spontaneously in any open landscape. However, the very principle of untamed nature was regarded as an

exotic notion. Of the four corners of the earth contained within the garden, one, the Orient, China, began to assume a predominant importance, not only with its monuments but also in hidden ways.

After having praised the regular layouts of his period, in his dissertation written in 1685 and published in 1690, William Temple noted that other types existed that he had heard about from those who had lived among the Chinese:

The Chinese devote their entire minds, which are extremely inventive, to imagining shapes that will be of a great beauty and that will astonish the eye, but which will not be redolent of the order and arrangement that immediately attracts the attention. . . . In fact, if we consider the paintings that appear on Indian canvases or on their most beautiful porcelains, we will find that their beauty is of this sort and that it is in no way regular or orderly.[45]

This beauty is to be preferred to all other. A special name, "Sharawadgi," was given the kinds of disordered combinations that, when we find them striking, we qualify as "fine" or "admirable." The term has been interpreted in three ways—first as disordered grace, from the Chinese *sa-ro-(k)wai-chi;* second, as asymmetrical design, from the Japanese *sorowandji;* third, as an arrangement of large and dispersed compositions, without order, from the Chinese *san-lan-wai-chi*—all of which are more or less in agreement on the basic principle.[46] The geometric shape is countered by disorder, but a disorder that is itself a calculated shape. The passage has often been quoted.

From 1712, deploring the fact that English gardeners were fond of imposing mathematical shapes, cones, globes, and pyramids, on vegetation, Joseph Addison evoked the Chinese method of planting, which, he

states, has a special name and which he identifies with the imitation of nature.[47] The creations of Pope, Bridgeman, and Kent are theoretically overtaken by an Oriental doctrine embodying their principles and always to be associated with new concepts. Horace Walpole (1771), who was against *chinoiserie,* whose fictions he considered to equal, in an opposite sense, French abstractions, agreed that Temple was right when he stated that Chinese gardens are as capriciously irregular as the European are invariably uniform, in which he was precisely reflecting the wishes of his period.[48] G. Mason (1768), who reproduced *in extenso* the text on the *Sharawaddgi,* exclaimed that in writing it Sir William had certainly not been able to imagine that a half century later such Chinese concepts would have become the height of fashion in his own country.[49] In his architectural treatise, published in the same year of 1768, Ware pays a tribute to the Celestials as the creators of the landscape garden.[50] Indeed, it is now China that symbolizes the freeing of nature in every phase of its development, and it is to China that we owe the philosophical content of the notion of irregularity and, at the same time, the notion of artifice reproducing living shapes.

Details on the way in which such arrangements of fictitious nature were conceived in China abounded. Father du Halde (1735) described "artificial rocks and mountains created on every side."[51] The *Galerie du Monde,* also from 1735, even contains the image of "rocks made by art in Pekkinsa village," broken, crumbling, contorted rocks, with numerous outcroppings (fig. 108).[52] In this connection Father Benoît was later to report (1767) that if a Chinese worker spent a great deal of time working stones, "it is only to augment their inegalities and to give them an ever more rural shape. On the mountains, such stones have been polished to form rocks, sometimes as far as the eye can see."[53]

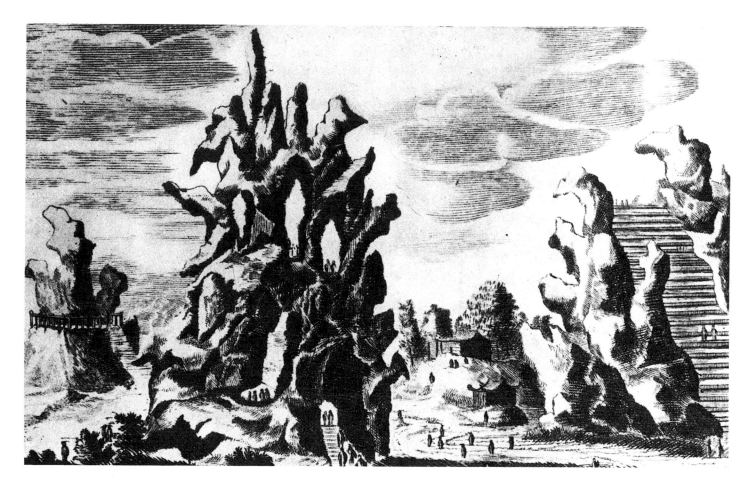

108

"ARTIFICIAL ROCKS IN PEKKINSA VILLAGE," 1735.

109

LE ROUGE, THE ELEVEN DWELLINGS OF THE EMPEROR OF CHINA, 1789.
PHOTO: BIBLIOTHÈQUE NATIONALE.

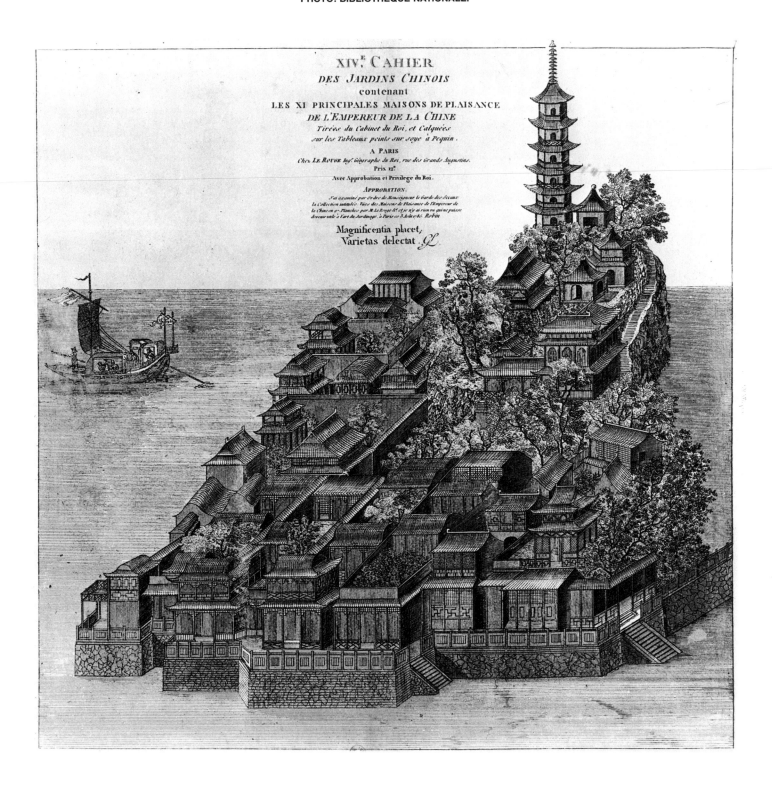

In the meanwhile, however, the detailed description of the *Yuan-ming Yuan,* the Emperor of China's Garden of Gardens, made by Father Attiret, a French missionary at Peking, was published (letter dated November 1, 1743).[54]

Countless tiny mountains of from twenty to fifty or sixty feet were erected "by hand." Canals of fresh water wound at their base and met at several places to form ponds and seas. The mountains were covered with untamed copses and rare trees, the canals were bordered not with cut stones but with irregular boulders, "set with such art that one would think it a work of nature." Everything was infinitely varied. Small palaces and pavilions were also strewn about the garden (fig. 109). There were four hundred of these, but no one was like another: "It is as though each one was created following the notion and model of some foreign land." If in the West Chinese buildings appeared in most of these layouts,[55] according to Father Benôit, the Emperor countered by adding European palaces to his.[56] Without using the term *Sharawadgi,* Attiret admires "the art with which its irregularity is produced," and he defines it in the same way: beautiful disorder and antisymmetry.

"It is a real Earthly Paradise," and it is also a reduced world, in which a whole city, with its churches, stairways, and shops can be reproduced enclosed within walls with four portals at the four cardinal points. "Everything found life-size in the Emperor's capital can be found here in small." The sovereign could thus "see the whole turbulence of a large city in small any time he so wished." We cannot conceive a more complete image of the landscape microcosm. The missionary was deeply conscious of the poetry of the artifice.

He was struck less by the look of the sites that passed before him than he was by their unreality. The deployment of nature was a revelation, its reproduction "by hand," on a reduced scale, a miracle. In its evocative power, its art approaches magic and leads directly to the realm of dreams. The testimony of a Chinese, Liu-Chou, which is included in a missionary collection dated 1782, confirms this illusory concept. "The art of laying out gardens consists in combining viewpoints, variety, and solitude in such a way that the deceived eye will be led to misjudge by their simple, rural atmosphere, and the ear by their silence or whatever disturbs it, and every sense, by the impression of enjoyment and peace. . . ."[57]

The value of such combinations, in which nature and the world are revealed by their fiction, resides in the secret, imperceptible natural manner in which diversity and contrast are employed.

Father Attiret's letter was translated into English in 1761.[58] It is often quoted. The earliest critique of French geometrical style by a Frenchman was based on the images it evokes. It is the gardens of Peking, their antisymmetry, their capricious air, that Father Laugier (1755) contrasts with the methodical regularity of Versailles, which produces first astonishment, then sadness and boredom.[59] This is due to the latter's artificial character. The gardens of the Emperor of China, in which we yearn to wander, are "fictive." Their enchantments are set forth as though by fairies, but they work solely through the simple, the natural. The poetic mechanism of such compositions is perfectly captured in this passage, which ends with the hope that they will be taken as models and that an "ingenious mixture of Chinese ideas with our own" can be achieved.

Fréron gave a similar definition of *chinoiseries* in 1750:

Qui suit la Nature à la piste

Ne sera jamais qu'un copiste

Qu'un malheureux imitateur,

Le Chinois seul est créateur;

Il donne un nouvel ordre aux choses

Fertile en prodiges divers

Ses riantes métamorphoses

Font éclore un autre univers.[60]

[He who follows the path of nature/Will never be anything but a copyist,/ A poor imitator/ Only the Chinaman is a creator;/ He orders things in a new way/ And is fertile with divers feats /His smiling metamorphoses/Open up another world.]

When Rousseau described Chinese gardens in *La Nouvelle Héloïse* "created with such art that their art cannot be discerned," he was periphrasing the same sources. And he directly compares those gardens, in which all the climates of China and Tartary "are assembled and cultivated in the same ground," to the park at Stowe, which also brings together every place and all kinds of weather with an apparent naturalness.

The discovery of nature took a tortuous path. In England it passed through Italy, in France through England and China, and China itself played a part in it with the English parks. Although at Raincy Oriental exoticisms were represented only by the Russian cottage, at Chanteloup, Betz, Cassan, and the Désert de Retz the Orient included the Celestial Empire.[61] Monsieur de Marigny submitted five plans for Chinese belvederes and kiosks for the garden at Ménars (plate 14).[62] The pagoda at Chanteloup arrived in the Loire Valley from Canton, but via Kew Gardens (fig. 110).[63] Le Rouge readily employed the term "Anglo-Chinese gardens" in his *Cahiers*.

William Chambers,[64] creator of Kew Gardens, was a promoter of *chinoiseries* as well as one of the principal theoreticians of landscape gardening. The architect, who was born at Göteborg of Scottish parentage, came to England in 1755 after having made three trips to China, between 1742 and 1749, on boats of the Swedish East India company, and in 1757 he published his findings, one chapter of which was entitled "The Art of Laying Out Gardens According to the Chinese Practice."[65] Augmented, it was the subject of a second edition in 1772.[66]

The author, who claims to have learned not only from his own on-site observations but also from the teachings of a famous painter, Lepqua, whom he had met, places this art on a very high level. It is not a matter of slavish imitation: "A garden must differ from ordinary nature just as an epic poem differs from a prose narrative. Gardeners must give free rein to their imagination, like poets, and even fly beyond the limits of reality."

It is a program for transfiguration, the technique of which is rigorously and painstakingly set forth.

The Chinese do not divide the terrain geometrically, but by scenes, for each of which there must be a viewpoint marked by a seat, a building, or some other object. The spectacles are constantly changing, but in an established order. The garden's perfection consists in their diversity, beauty, and number. The settings can be divided into two categories: life and the drama of nature. "In large gardens the Chinese arrange different settings for the morning, midday, and evening, and they erect to suitable heights edifices proper to the entertainments for each part of the day."

There are also special scenes for each season. For the winter setting there must be pine trees, firs, cedars, and other nondeciduous trees. Greenhouses shaped

110

LE CAMUS DE MÉZIÈRES, THE CHANTELOUP PAGODA, 1778.
PHOTO: GIRAUDON.

like temples, known as "conservatories," are filled with birds that are remarkable for the sweetness of their songs. There, raspberries, cherries, and apricots are ripened. The setting for spring is made up of coniferous trees mixed with lilacs, almond trees, peach trees, and wild rose bushes. Its flowers are the hyacinth, the primula, the snowdrop, and various species of iris. Menageries and bird cages supplement the sparse vegetation of the season. The recommended buildings are decorated dairies and gaming and sports pavilions. The summer setting is the garden's richest and most carefully arranged. Bodies of water are laid out, as are forests (oaks, beeches, plane trees, sycamores, ash, and poplars), there are numerous splendid and spacious pavilions for music, scholarly conversation, and meditation. Everything is of a gentle wildness and a suave luxury. The woods are filled with a thousand melodious birds. Antelopes, chamois, goats, and Tartary horses roam beneath the trees. Every path leads to some ravishing object—a brook, fountain, green glade, or grotto decorated with shells, corals, gems, and crystals. The autumn setting includes trees with long-lasting foliage that turn into sumptuous colors as they age. There are buildings representing hermitages, ruined castles and palaces, deserted churches, tombs, anything that evokes an ending and fills the spirit with melancholy thoughts leading to serious reflection.

The theme of the seasons is mentioned in *Yuan ye,* a treatise on gardens, whose preface dates from 1634, as well as in the essay based on Chinese sources and published in 1782 by the Peking Missionaries, in which it takes a very simple form: peach trees and cherry trees create an amphitheater for spring; acacias, ash and plane trees create bowers of greenery for summer; autumn has weeping willows with their satiny leaves and winter has cedar, cypresses, and pines.[67]

The arrangements are also combined like pure forms that make a direct impression above and beyond the iconography of yearly cycles and cosmic visions. *Yuan ye* notes that "a small hillock can give rise to many effects, a small stone can evoke multiple feelings," and it describes certain layouts: "The paths lead through a bamboo plantation towards a shadowed place where a solitary cottage stands among the pines. There, one can hear the melancholic sound of water. The cranes dance and beat their wings."[68]

One comes to the garden to see it and to participate in a scene. According to Chambers, the Chinese distinguish three kinds of settings, which they call "enchanted," "horrible," and "laughing," which correspond by and large to the settings for summer, autumn, and spring, but in which the fantasy is unrestrained.

The enchanted settings, which could also be called narrative settings, abound in marvels calculated to excite the spectator by a rapid succession of violent, contrasted sensations, paths descending into subterranean caverns in which mysterious glimmers of light illuminate strange groupings (fig. 111), paths that lead through the dimness of tall forests to the edge of a precipice beneath rocks that seem to be suspended in air, into dark valleys or toward sad rivers whose waters slowly wash against banks covered with funerary monuments, beneath the shade of willows, laurels, and trees consecrated to Manchu, the Spirit of Sorrow. Enchanted settings always abound in water works, among which are the Kiao King Palace, with its galleries, arcades, and colonnades of multicolored fountains and cascades. For vegetation the Chinese artists use poplar trees in perpetual motion, Siamese plants, and the most unusual species of trees and flowers; for fauna, there are four-legged animals and monstrous birds brought from distant lands or obtained by

111

LE ROUGE, ENCHANTED SCENE, ROCKS AT THE DÉSERT DE RETZ, 1785.
PHOTO: BIBLIOTHÈQUE NATIONALE.

crossbreeding, watched over by enormous Tibetan dogs, by African giants, and by dwarfs dressed in magicians' robes.

Settings of horror have hanging rocks, dark caves, and rushing streams that plummet down mountainsides. The trees are misshapen and seem to have been broken by violent storms. Some have been uprooted, some alter the course of the streams and appear to have been carried off by the force of the waters. Others, as though struck by lightning, appear to be burned and shattered. Some of the buildings are in ruin, others partly consumed by fire, and a few poor cottages here and there on the hillsides seem to indicate the lives and poverty of their inhabitants

And, to add to the horror and sublimity of such settings, foundries are sometimes hidden in the caves atop the highest mountains, limestone or glass-making ovens that emit great flames and clouds of thick smoke that give the mountains the appearance of volcanoes.

However, such catastrophic visions are only one act of a theatrical work that usually ends on a brighter note.

Such settings are usually followed by laughing ones [plate 13]. The Chinese artists know how strongly the soul is affected by contrasts and they never fail to arrange sudden transitions and striking contrasts in forms, colors, and shadow. Thus, from constricted views they move on to broad prospects, from objects of horror to agreeable settings, and from lakes and rivers to the plains, to the shore, to the woods; from dark, sad colors they go to brilliant ones, and from simple forms to complicated, judiciously distributing the various masses of light and shadow so that the composition seems distinct in its parts and striking as a whole.

The settings and the other parts of the Chinese garden are linked by thoroughfares, paths, bridges, canals, and navigable lakes that are also arranged to show the greatest possible variety.

This strange volume, in which, through an overflowing of fantasy,[69] one can always detect the ring of authenticity, had an enormous influence and aroused varied reactions. In England, there was violent opposition to the author, led by Thomas Gray, Horace Walpole, and William Mason. "I've read Chambers' book," Walpole wrote to Mason, a poet and garden lover, on May 25, 1772. "It is more extravagant than the worst Chinese works."[70] And a satirical poem was aimed at "Oriental Gardening," at first published anonymously but later signed by Mason, and went through three editions from 1773 to 1776.[71] On the continent, Hirschfeld, adviser to the King of Denmark and professor of philosophy and fine arts at the University of Kiel,[72] formulated the greatest number of reservations by casting doubt upon the veracity of the information imparted: Chambers attributes his own concepts to the Chinese in order to arouse interest. According to what Le Comte has told us of China (1697),[73] its gardens are mediocre and its artists generally inept. Attiret greatly exaggerated his descriptions. This is not to say that the whole system is false. There are "the most ingenious pictures and the most astounding fairylike enchantments," and the aberrations of the imagination are accompanied by thoughtful choice and good sense. Chambers has great taste, knowledge, and genius. If his work is not historically valid, "it teaches us a lovely fantasy, one that lacks nothing save, probably, that it will never be realized." And it is the fantasies that cannot be realized, at least not integrally, that have most seduced imaginations.

The theme of the seasons, like that of the continents, was often represented in French gardens, but by allegorical monuments (Vaux-le-Vicomte, 1656–61; Ognon, 1776; the Tuileries, c. 1680). A sketch by Le Brun for Versailles suggested to sculptors a whole four-part cycle including the elements, the parts of the world, the year, the day, and the temperaments. And the return to nature, frequently enough celebrated since Thompson (1727–30) by poems on the seasons,[74] only made life in all its new beginnings more deeply felt. Attempts were made to include it in landscape layouts, and Chambers's scenography inspired the procedures to be followed in that regard. Thomas Whateley, whose work, written in 1765, was the first to give methodical presentation of "modern" gardening theories, dealt with its elements in almost the same terms: "It is through a series of judicious arrangements, and the happy disposal of the objects composing a setting designed for a particular hour of the day, that one can embellish or modify the gaiety of morning, the excess of midday, the evening calm."[75]

Such settings, like those for the seasons, are constantly mentioned in treatises (d'Harcourt, 1774; Girardin, 1775; Hirschfeld, 1783). D'Harcourt gives particularly detailed instructions for them.[76] For the winter garden, flowers are rare, although a few emerge directly through the snow, sturdy plants that come into leaf after heavy frosts, evergreen shrubs and trees. A pantomime—an old man before the fire—can be introduced in a grotto made of minerals, crystals, petrified rocks and trees, stalactites, and cinders, without either shells or corals, reserved, as in Chambers, for the hot seasons. Hothouses and bird cages are also to be set up. In the spring garden, fragile and precocious flowers, rare and seldom cultivated, and open buildings: the roses can be smelled without one's being enclosed. The summer garden should bring together waters, woods, hills, and valleys. The flowers are the usual ones, the trees tall and sturdy, with thick foliage; the style of the buildings and the subject of the composition should be voluptuous, the scenes assembled and decorated as in nature, in a golden tone. Armida's palace surrounding a delightful garden would be a suitable scene for such a theater. In the autumn garden, the flowers should be noble, large, and vivid in color, the plants aromatic, the shrubs should have red fruit. For structures, there should be triumphal arches, columns, and ruins. Crystalline spring, powerful summer with its voluptuousness and its delights, sumptuous, sad autumn . . . the elements, the sense of effects and the choice of words, the poetry of this presentation are replete with Far Eastern refinements. It is a variation that closely follows the arrangements described by Lepqua, while transposing them into the European climate and mythology. By endowing landscape with themes once personified by statues and terms set in geometric verdure, the system is adopting Chinese principles.

It does not appear that the garden at Betz, which d'Harcourt designed with Hubert Robert for the Princesse de Monaco, had any particular arrangements for the Seasons, but there was a Valley of the Tombs, with Scotch pines, black fir trees, and cypresses, as in enchanted settings. The plantation "continued, with a lessening of sadness, up to a broad promenade."[77] Earlier a similar setting, the Woods of the Tombs, had been arranged at Monceau by Carmontelle.[78] Poplars, sycamores, cypresses, plane trees, and Chinese thuyas brought from Italy and the Orient sheltered an Egyptian tomb, two antique tombs, a tomb with a ruined obelisk, a bronze urn on a marble pedestal. A brook ran through the forest, completing the picture as described by Chambers. With its exotic plants, its painted or sculpted trees along the wall, its waterfalls illuminated by candles hung from artificial corals, and its deep, music-filled grotto, the Winter Garden was a

112

MONCEAU GARDEN, GROVE OF THE TOMBS, AFTER CARMONTELLE, 1779.
PHOTO: BIBLIOTHÈQUE NATIONALE.

113

MONCEAU GARDEN, TARTAR TENT, AFTER CARMONTELLE, 1779.
PHOTO: J. MUSY; COPYRIGHT CNMH SPADEM.

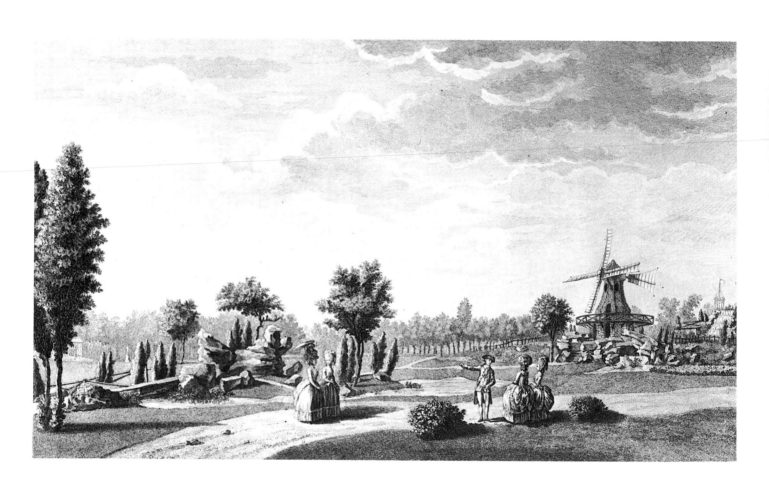

114

MONCEAU GARDEN, ROCKY ISLAND AND DUTCH WINDMILL,
AFTER CARMONTELLE, 1779.
PHOTO: J. MUSY; COPYRIGHT CNMH SPADEM.

fairy tale theater in itself. All its settings (figs. 112–114), the Tartar tent, the dairy, the Turkish tents, the Dutch windmill, the Chinese pavilion for tilting at the ring, the ruined Gothic castle, the minaret, the cliff from which all the waters sprang, had a vantage point designed on the plan. Servants costumed as Tartars and turbaned Hindus exercised African and Asian animals, like the camels that transported visitors. The land of illusion reproduced an Oriental garden not only by repeating its precise contents but also by means of its surprises and its contrasts.

Although the Marquis de Girardin rose up against "this recourse to fairy tale and fable," Ermenonville contained an Elysium and a Desert dominated by a hill covered with arid rocks that repeated the same contrast. The Arcadian Prairie laid out beyond the lake is an Eden for the first men, with a pastoral Obelisk dedicated to the bucolic poets. The desert on the opposite bank is an uncultivated plot of land covered with heather and gorse against a background of sand and stretches of water. There, in the cottage built in the wildest corner of the property, Rousseau would withdraw after his solitary walks to meditate on nature and life (figs. 115–117). All of the provisions contained in the *Dissertation on Oriental Gardening* are to be found in Bettini's plans for the garden of Delphino, the Venetian ambassador to France, reproduced in Le Rouge's Cahier XII (1784), and with the same orchestration. From a "joyful setting" (the temple of Bacchus), we pass on to "The Isle of Tombs, where everything should inspire veneration and sorrow . . . a somber island, without flowers or fruits, covered with green oaks and cypresses creating a thick shade, the better to mask the following setting of an opposite sort: Bridge of Triumphs and Temple of Momus, set in a smiling scene"

From the Garden of Delights, with its Temple of Venus, one moved on to a Fearful Desert. Next came the Elysian Fields, where abundance reigns, which were reached by a covered pathway. There was also a Chinese Garden and a Japanese Isle, surrounded by an impenetrable wall. The descriptions of the subjects give all the details needed to make the settings conform "to the type of emotion they should excite." Thus, there are three categories of funerary monument: "If it is to perpetuate an agreeable memory, the monument should be placed on an elegant column decorated with bunches of roses, jasmine, and vines that will climb and form a shadowy garland. Those whose memories are sad should modestly conceal themselves in a retreat created in the depths of some bosky dell of thick yews, cypresses, weeping willows, philaria. . . . If the memory is of some heroic deed, the monument should be placed amidst a grove of cypress or green oaks and laurels should be planted around it, at the point where all the paths converge. . . ."

The style of this passage recalls Chambers, while the desert literally reflects the English architect's "horrors." "The setting must not only offer a spectacle of sterility, it must not have a hint of habitation, only a few burnt or ruined dwellings, storm-damaged trees, caves inhabited by monsters, entering it must be like entering Nature in mourning: numerous inscriptions will trace the tragic events that so often marked the site. The illusion could be augmented by an artistically constructed volcano, after Vesuvius, that would emit flames produced by charcoal. . . ."

Published at the very moment when the style was about to spread to the continent, Chambers's texts seem to have had a stronger effect there than in England itself, where his activity coincided with the apogee of a long process that had been going on since 1760, of a reaction toward simpler forms.

115

MÉRIGOT, ARCADIAN FIELD, 1788.
PHOTO: J. MUSY; COPYRIGHT CNMH SPADEM.

116

ERMENONVILLE, DESERT HERMITAGE, ANONYMOUS.
PHOTO: J. MUSY; COPYRIGHT CNMH SPADEM.

117

MÉRIGOT, ERMENONVILLE, ISLE OF POPLARS, 1788.
PHOTO: J. MUSY; COPYRIGHT CNMH SPADEM.

It was nature's theatrics, its disposition in accordance with the emotions it inspired, that were returned to with the greatest persistence. Its themes had been developed and augmented prior to the appearance of the second edition of *Oriental Gardening*. Home (1762), who faithfully sums up the doctrine, adds the enchanted, the horrible, and the merry, settings that are majestic, gentle, gay, elegant, wild, and melancholy. "And when they succeed one another, the majestic can be contrasted to the elegant, the regular to the wild, the gay to the melancholy, so that each emotion may be followed by an opposite emotion."[79]

Whateley (1754), who also wrote that "one can compare the terror inspired by a natural setting to that aroused by a dramatic scene," made a thorough analysis of rocks.[80] Terror implies grandeur, but grandeur is also necessary for the majestic, and it is not always a question of size. For example, "a rock that seems to be suspended by some invisible art derives its grandeur from its situation and not from its size." On the other hand, the majesty of a rocky setting is due to the great, linked to the serious, and it excludes sudden transitions. The uniting of different genres in the same place creates a scene of marvels. "The marvelous aspect of the wild category contrasts the most unusual forms and combinations thrown together, thus giving us an idea of nature's inexhaustible variety." It is a theater of pure forms, masses, and agglomerated materials.

In France, in the first work in this series, which also contains the description of the garden of Sseu-ma Kouang dating from 1071, Watelet (1774) stretched the repertory to include the noble, the pleasant, the serious, the sad, the magnificent, the voluptuous, and the terrible.[81] The genre "marvelous" was broken down into the poetic, in which one is transported to distant times and places, and the romantic, which corresponds to the enchanted. Girardin (1775) further distinguished philosophical landscapes to charm the soul and picturesque landscapes to charm the eyes.[82] Hirschfeld, the most scholarly and methodical of these writers, painstakingly defined the properties of each subject.[83] Rocks are suitable for inspiring astonishment, veneration, and fear. The forest, which, in its breadth and height, can be heroic, has gravity and majestic dignity. Peaceful, solitary, deserted, melancholy, gay, pleasant, and serene settings are created by the way the branches and limbs of trees and foliage are disposed and interspersed. The character of open fields is not sublime, but nature can make them peaceful and gentle, as well as welcoming. Bodies of water, which are to the landscape what mirrors are to a dwelling, the eyes in the human visage, provoke sublime emotions when they are deep and broad, elevated feelings close to fear when they foam and roil. Darkness, which is proper to springs or any still water, inspires sadness. There is almost no setting whose effect cannot be augmented or lessened by water, no emotion that it is not able to inspire, stifle, or calm.[84] Gardens, in which one works with these materials, can be classified in five categories: the pleasant, gay, smiling garden; the garden of sweet melancholy; the romantic garden; the majestic garden; the garden made up of all the above. We have a mixture of Home and Chambers. Boitard, who also wrote an almanac of high fashion and French manners, could still speculate in 1825 about terror, both grand and sublime, majesty due entirely to natural nobility, the physiognomy of laughter in tranquil settings with touches of grace and brilliance in the objects decorating them.[85]

There is obviously considerable confusion in such definitions and many literary abuses, but they reveal a state in which nature is surpassed by its scenography and transported into a fabulous realm. Enchanted

scenes are described with particular eloquence. Listing their principal elements, Watelet stresses the powerful effect they can make:

It should be a very wild place where torrents pour down into deep valleys, where rocks and mournful trees and the sound of the water echoed from the walls would fill the soul with a kind of fear, where one could see thick smoke and fire from several forges, some hidden glassworks. . . . These images of a magic desert, of an evocative place, along with the sounds proper to them, would be so full of romance and story that even pantomime would not be necessary. Indeed, the moved imagination would be ready to supplement it for itself; and in the instant the day faded and the shadows of night would spread the sadness proper to them and bring their accompanying illusions, it would be very easy to see Demons, Magicians, and Monsters in such a Desert.

The world is completely transfigured. Morel (1776), who did the preparatory work at Ermenonville, adds:

In the vastness of the subjects he considers, the romantic which includes enchantments, the dreams of fairyland, the feats of magic, in his attempts to realize the most chimerical ideas, the most extravagant inventions, he offers only bizarre elements or events nobody knows anything about. . . . To give the setting a character suitable to such performances, one must find sites of an analogous type: one must have deserts, caverns, abysses; one must have recourse to extraordinary means. . . .[86]

When referring to nature, words such as "magic" and "fairylike" are intended to reveal its deepest essence, its hidden power. Every landscape arrangement is designed to achieve this supernatural effect. When Hirschfeld expressed doubt about Chambers's doctrines, he nevertheless agreed on his genius. His only

fear was that the means available to gardening were insufficient. In order to realize them completely, one would need a Bosch and the limitless powers of painting.

Two phenomena arise out of this development inspired by poets and thinkers: first, the nature rediscovered in gardens is not the country "meadow" behind the house, but an evocation, a dream, an artifice; secondly, this very rediscovery was accomplished through and in the name of the exotic. The universe of surveyors and decorators was succeeded by an irregular universe, one saturated in morphological and theatrical conventions, in an obsession with the marvelous. The dream of the English parks reflects the dream of Italy of the painters of the seventeenth century, but it was China, the true China, the romanticized China, that led to its realization and that was always to be present in the mind throughout the course of its development and propagation, in all its forms, through Europe, both in theory and in practice. Identified with a cosmogony and a higher order, its calculated irregularity produced symbolic and poetic themes in a vertigo of the unreal. Hardly had it been created than the open landscape found itself accompanied by and linked to a visionary landscape.

After the ice age of abstraction and intellect, conditions became propitious for all of the flowerings whose seeds had been planted so long ago. With its contrasted scenes—arid desert, fertile field, Egyptian monuments, rustic hut, sparkling palace—Zahn's hexagonal box enclosed a whole program for the future, down to its specific themes and the actual style of its structures. We cannot estimate the immediate relationship of such an optical toy with the vast natural creations. Nevertheless, it is true that before being

laid out in a garden the lands of illusion had been viewed in the reflections of mirrors set up within the earliest grottoes created by Alexander Pope and William Kent. We also know that Carmontelle had placed views of the Parc Monceau and other Parisian gardens in an optical box, painted on transparent material used in seventeenth-century projectors.

And there were even earlier antecedents. The rediscovery of nature during the Middle Ages had been undertaken in a similar fashion and in virtue of a similar law and a similar course of development. The living universe that reemerges from its schematic images is also fraught with conventions and magic, in which foreign climes flash by and minerals and flora come to life, and it was the Far East that inspired those elements too. Just as in the English parks, since the fifteenth century, we find nature revealing itself in an Edenic atmosphere. In Van Eyck (*The Mystic Lamb*) the entire earth becomes a Paradise in the shape of a landscape garden, with its Fountain of Life.[87] The cosmogonic themes, the Elements and the Seasons, often appear in such depictions. A whole series of northern painters treat even the landscapes of different subjects as "a fragment or reflection" of Elysium (Combe). Jan Breughel carried the theme to the height of paroxysm. With their burgeoning verdure, their glorious pomp, their menageries (elephants, lions, tigers, ostriches) set in sparkling forests, his "terrestrial paradises" (Windsor Castle, The Hague, Musée du Louvre) display the fairyland of wild nature the nostalgia for which would be revived by Milton. And it was again from Italy, as with the Kentish parks, that, to a certain extent, the image of Eden came to be superimposed on the flora of the north.[88]

However, there were more exotic trends in the revival. For one thing, Sterling held that "along with the image of a naturalistic nature, a fantasy landscape con-

tinues to develop,"[89] and, in addition, a whole network of affinities between fifteenth-century European and Chinese landscapes were recognized up until the second quarter of the seventeenth century. We find views with differing settings in an attempt to present as many bits of the universe as possible within the framework of a single picture, and we find many examples of similar settings—those with rocks and water, for example. Man-made mountains with terraces, fallen rocks, both popular in Siena since the fourteenth century, were often erected by artists of the Venetian and Florentine quattrocento. In the work of Leonardo da Vinci, Bouts, Herri met de Blès, and Patinir we find outcroppings of rock, piles of rock, banks of petrified clouds, cliffs, and impossible rocky clefts. They create enchanted settings, horrifying settings. Hirschfeld's text gives a precise description:

The more daring, contorted, unusual, and strange such rocky forms and juxtapositions are, the more they contrast with the neighboring scene and the greater the effect they produce. . . . Peaks, uneven surfaces, misshapen boulders, and rocky bridges, in short, anything that breaks the regularity of the lines or disrupts the natural disposition of shapes, anything that distracts the imagination from the ordinary and transports it to an enchanted world, takes it back to the times of magic and sorcery, has a place here.

Every word directly applies to these compositions, and the latter part of the quotation evokes the magical world of the Flemish masters. Some of their creations—towers, rocky chimneys, mushroom shapes, "vertical labyrinths" (Sterling)—are analogous to China's rocky phantasmagorias (figs. 118, 119), and there were many similar productions. Among these, the curved rock given a singular form by an artist in Ferrara at the end of the fifteenth century appears in

118

FANTASTIC ROCKS: HERRI MET DE BLÈS, *THE GOOD SAMARITAN*.

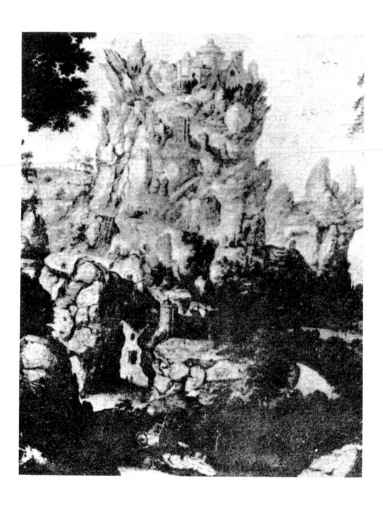

119

ARTIFICIAL ROCKS: CHINESE PAINTING, EIGHTEENTH CENTURY.

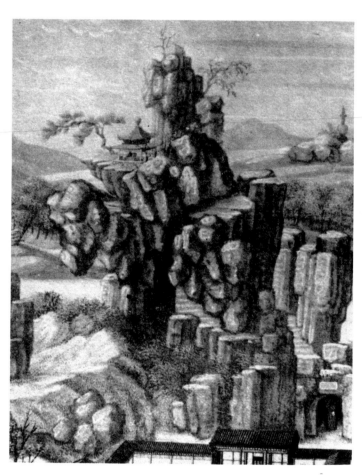

the poem by Sseu-ma Kouang included by Watelet: "A steep cliff with a curved summit hanging like an elephant's trunk," which was in his garden, exactly corresponds to this unique architecture. The suspended rocks and dim caves described by Chambers as resembling a Chinese theater are part of the same visionary world. And the same holds true even for the flaming mountains of Hieronymus Bosch (fig. 120). The description of the waters that, as in China, are constantly associated with rocky mountain in such paintings are also described in these texts as being in harmony with the shapes they assume. "The water must always have the form of an irregular lake or a serpentine stream," William Shenstone wrote in his *Unconnected Thoughts on Gardening* (1764), and Sirén noted its close affinity with *Yuan ye*.[90] "In gardens, it is no small means of reinforcing the grandeur and beauty through surprise. . . . Foaming cascades, gentle waterfalls, swift streams, rivers, calm lakes" (Girardin), water plays a part in filling out the scenic effect by means of intensification or contrast. "It can," Hirschfeld says, "augment the wild atmosphere of rugged rocks and mountains, but it can also spread serenity and make other objects more attractive." Herri met de Blès (*Saint Antoine*, Musée de Grenoble; the *Ascent of Calvary*, Musée de Vienne) and Patinir (*Saint Jerome*, Prado and National Gallery, London) depict majestic scenes of a serious and gentle grandeur, created by the water that stretches behind the frightening rocky scene in the foreground. The same contrast can be seen in Chinese "landscapes with water and mountains" that play with such contrasted notes as in a musical composition (fig. 121).

Themes, forms, methods, even the precise details of such compositions and the trends underlying them are in harmony with the direct arrangements of nature, the evolution of which we have examined. The same rebirth occurred in gardens towards the close of

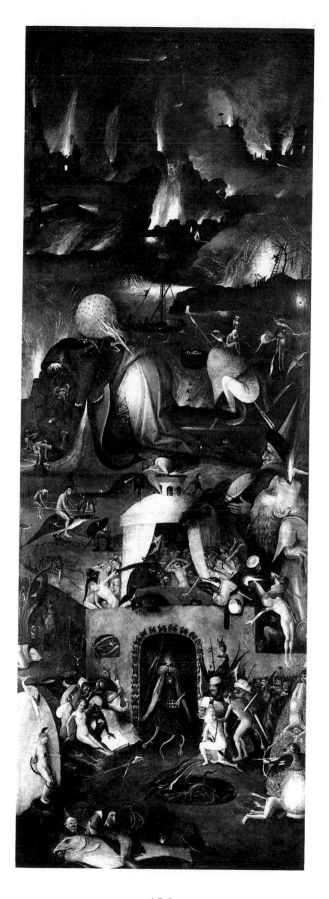

120

HIERONYMUS BOSCH, *HELL*, RIGHT PANEL OF *THE LAST JUDGMENT*, VIENNA, AKADEMIE DER BILDENDE KÜNSTE. MUSEUM PHOTO.

121

"TERRIFYING ROCKS": JOACHIM PATINIR, *SAINT JEROME.*
LONDON, NATIONAL GALLERY. MUSEUM PHOTO.

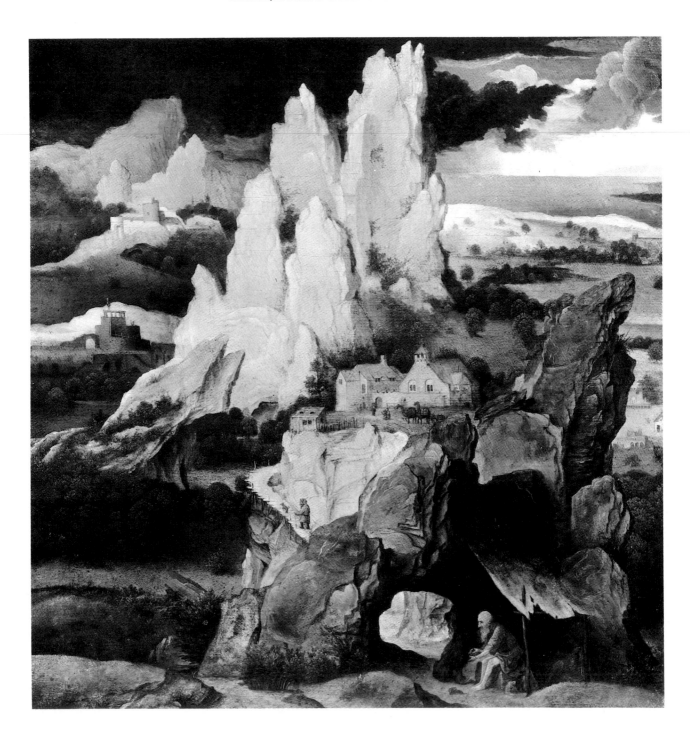

the Middle Ages. It happened very much as it was to do in the eighteenth century. Irregular nature, as in life, and nature transfigured by fantasy replaced structured nature.

Up until the middle of the fifteenth century gardens were enclosed on all sides and compartmentalized. A "house of Dedalus" often reproduced the labyrinth of the Gothic cathedrals. The foliage was trained to form the walls and vaultings of a rural building and to create evenly distributed bowers and shelters. With its "round or square pavilions, or both alternately," at the corners and in the center, and its trellis "topped with crenelations," the garden of Charles V (1337–80), behind the Hôtel Saint Paul at Paris, employed the elements of a fortified castle. There were also "tabernacles" of vegetation topped off, like a steeple, with a large ball, and trellises with lozenges containing *fleurs de lys.* Its description by a *classique*, Henri Sauvel (1724),[91] with its use of builders' and decorators' terms, resembles the nomenclature used by Jacques Boyceau (1638).

Against a background of plantings and architectural layouts resembling chessboards came a flowering that was the harbinger of Kent's Paradise. The peace and prosperity that followed the end of the Hundred Years War (1453) favored its development, one of whose consequences was a vast movement into the countryside.[92] Although ephemeral and geographically confined, especially in the Loire Valley, the phenomenon obeyed a law of evolution. Vergers of Clarens were planted around manor houses; the nobility abandoned their citadels and planted it throughout the countryside. King René himself planted it, in sharp contrast to the rectangular courtyard-like gardens favored by Charles V; they are like the earliest sketches for landscape gardens, and he also created his Angevin Stowe: the garden of La Baumette. Laid out in natural terrain around a rocky outcropping sixty feet in height, which could be described as frightening, it eschewed regular flower beds. However, the choice of site already implied a rejection of geometry and evidenced new aspirations. Two settings were created: a hermitage, the Convent of the Cordeliers, founded in 1451, and a grotto "reproducing the imitation" of the one at Sainte-Baume in Provence. To those settings was added a retreat and an evocation of faraway places, establishing the sign of evasion in the return to nature itself. The vantage point from which the majestic scene of rivers and plain was viewed was equipped with a bower built at the summit of the rock. With its unsettling cliff, its vast calm waters, its chapel, and its cave, Patinir's *Saint Jerome* (c. 1520) contains the same elements. However, the sovereign's garden was also filled with other exoticisms. Rare plants and a whole collection of animals, lions, white monkeys, Barbary goats, ostriches, and an elephant were constant evocations of foreign climes. Men strolled about in Oriental garb. There was a Moor, Falcon, who wore a Saracen robe and was armed with a Turkish dagger, there was a company of dromedaries like the Monceau Tartars.[93] Here too was a land of illusion, a microcosm of an Earthly Paradise, in which nature revealed itself in an atmosphere of fable and the East.

The fantastic landscape follows the natural landscape like its shadow. It evolves in the same sense and the same factors operate with it, many centuries apart, in different areas. It is only in gardens, and in the eighteenth century, however, that we are privileged to have philosophers and experts as our guides. Their evidence is of inestimable value for every period, and for painting as well. In the complex of Western and Oriental civilizations, the imagination is not limitless in its means and its sources. Even "abuses" have constantly taken the same forms.[94]

Notes

Introduction

1. Oscar Wilde, *Intentions* (New York, 1905), p. 263.

Animal Physiognomy

1. *France Dimanche*, no. 189, April 9–15, 1950.

2. C. Barnes, Jr., *Le Zoo du Bureau* (Paris, 1950).

3. R. Foerster, *Scriptores physiogno-monici graeci et latini* (Leipzig, 1893) and *Die Physiognomonik der Griechen* (Kiel, 1884); F. Meier, *De anonymi physiognomonia Apuleio falso adjudicata* (Brussels, 1880); and E. Kelter, *Apulei quoe fertur "Physiognomonia" quando composita sit* (Kiel, 1890).

4. For Arab physiognomies, see Youssef Mourad, *La Physiogno-monie arabe et le Kîtab al-Firâsa de Fakhr al-Din al-Râzi* (Paris, 1939).

5. R. Foerster (*Scriptores physiogno-monici*) gives important lists of me-dieval manuscripts.

6. A. Danieul-Cormier, "Le Specu-lum Physionomiae de Michel Savon-arole et ses sources," in *Positions des thèses de l'École nationale des Chartes* (Paris, 1953).

7. See C. Lenient, *La Satire en France au Moyen Age* (Paris, 1859), chap. VIII, "Le Renart," and J. Hou-doy, *Renart-le-Nouvel* (Paris, 1874).

8. A. Langfors, *Roman de Fauvel par Gervais du Bus* (Société des textes français, 1914–19).

9. Bibliothèque Nationale, Paris, MS. fr. 571.

10. For these concordances and par-allels between the two lists, see F. Neubert, *Die Volkstümlichen An-schauungen über Physiognomonik in Frankreich bis zum Ausgang des Mittelalters* (Erlangen, 1910).

11. Petrus d'Abano, *Liber compila-tionis physionomiae* (Padua, 1474).

12. B. Cocles, *Chyromantiae ac phy-sionomiae anastasis cum approba-tione magistri Alexandri de Achillinis* (Bologna, 1503). The work is included in *Physionomia summi Aristotelis, Physionomia Michaelis Scoti, Physionomia Cocletis cum approbatione Achillini* (Pavia, 1515); two abridged editions were then published at Strasbourg (1533 and 1551) and one at Paris, in French: *Le compendion et brief enseignement de Physiognomie de Barthelemy Co-cles de Bouloigne* (Paris, 1560).

13. The *Physiognomy* of Pseudo-Aristotle was republished in 1527 in Florence, in 1531 at Basel and Frankfurt, in 1538 at Wittenberg; Adamantios was republished in 1540 at Paris, in 1544 at Basel, in 1545 at Rome; Polemon in 1524 and 1545 at Rome.

14. J. d'Indagine (Jean de Hayn), *Physionomia . . .* (Strasbourg, 1529); Michelangelo Blondus (Biondo), *De Cognitione hominis per aspectum* (Rome, 1544); G. Grataroli, *De praedictione morum naturarumque hominum cum ex inspectione par-tium corporis, tum aliis modis* (Basel, 1554). *La Fisionomia del Riz-zacasa* (Carmagnola, 1588) is part of the same group.

15. G. B. della Porta, *De Humana Physiognomia libri III* (Naples 1586).

16. For example, page from the Val-lardi album (now broken up) in the Musée du Louvre. See too the draw-ings published by the Comte de Caylus (*Recueil de testes de carac-tère et de charges dessiné par Léon-ard Florentin et gravé par M. le C. de C.*, n.p., 1730). There is some question as to whether these sketches were not part of the same series of fifty drawings of deformed old men, peasants, and peasant women that Lomazzo mentions as having been in the possession of Au-relio Louino, a bookseller (*Trattato dell'arte della Pittura. . .*, Milan, 1584, p. 360). For da Vinci's text on physiognomy, see his *Traité de la Peinture* published by Péladan (Paris, 1921), pp. 171–72.

17. E. Panofsky, *Hercules am Schei-deweg* (Leipzig, 1930), chap. I, "*Sig-num Triciput*," pp. 1–35, and "Titian's Allegory of Prudence, A Postscript" in *Meaning in the Visual Arts* (London, 1970), pp. 181–205; J. Seznec, *La Survivance des dieux an-tiques* (Paris, 1980), p. 110; J. Baltru-šaitis, *Le Moyen Age fantastique* (Paris, 1981).

18. A. Du Laurens, *Des maladies mélancoliques* (1597 and 1621), p. 24. Quoted from Yvette Conry, "Thomas Willis ou le premier dis-cours en pathologie mentale," *Revue de l'Histoire des Sciences* 31, no. 3 (1978): 191.

19. G. P. Bellori, *Le Vite de'pittori, sculptori e architetti moderni* (Rome, 1672), p. 247. See also J. F. M. Michel, *Histoire de la vie de Rubens* (Brussels, 1771), p. 258, and F. Goler von Ravensburg, *Rubens und die Antike* (Jena, 1887).

20. P. P. Rubens, *Théorie de la Figure humaine, traduit du latin avec XLIV planches gravées par Pierre Aveline* (Paris, 1773).

21. C. Baldi, *In physiognomica Aristotelis commentarii* (Bologna, 1621).

22. *Fisionomia di Polemone, tradotta di greco in latino* (Padua, 1621).

23. *La Physionomie d'Adamantius,* translated from the Greek by H. de Boyvin du Vaurouy (Paris, 1635).

24. J. d'Indagine, *Chiromance et Physiognomie* (Rouen, 1638); Ph. Finella, *Naturali Physionomia planetaria* (Naples, 1649).

25. P. Lomazzo, op. cit., book II. The treatise also contains a short *Physiognomonie astrologique* in a verse translation by H. Pader (*La Peinture parlante,* Toulouse, 1657).

26. N. Coeffeteau, *Tableau des passions humaines, de leurs causes et leurs effets* (Paris, 1620). See also Eustache de Saint-Paul, *Summa philosophiae* (Paris, 1609), III, *De ipsis actionibus humanis, ubi de passionibus,* and Ch. d'Abra de Raconis, *Secunda pars Philosophiae seu Ethica* (Paris, 1617), III, *De passionibus animae.*

27. M. Cureau de La Chambre, *Les Caractères des Passions* (Paris, 1640–62).

28. Descartes, *Les Passions de l'âme* (Paris, 1649).

29. H. Testelin, *Sentiments des plus habiles peintres sur la pratique de la peinture et sculpture mis en table de préceptes* (Paris, 1680 and 1696) and *Conférence de M. Le Brun sur l'expression générale et particulière* (Amsterdam, 1698); Le Brun, *Méthode pour apprendre à deviner les passions* (Amsterdam, 1702); *Conférence de M. Le Brun sur l'expression générale et particulière des passions* (Amsterdam, 1713); S. Le Clerc, *Principe de Dessin, Caractère des Passions, gravés sur les dessins de l'illustre Lebrun* (Paris, n.d.) and *Expression des Passions de l'âme, représentées en plusieurs têtes gravées d'apres les dessins de feu M. Le Brun* (Paris, 1727). Cf. A. Fontaine, *Les doctrines de l'art en France de Poussin à Diderot* (Paris, 1909), pp. 68ff. For the significance of masks of the passions with regard to painting, see W. Sypher, "The Late Baroque Image: Poussin and Racine," *Magazine of Art,* May 1952.

30. H. Testelin, *Sentiments des plus habiles peintres sur la pratique de la peinture et sculpture . . . avec plusieurs discours académiques* (Paris, 1696).

31. Bibliothèque Nationale, Paris, MS. fr. 12987.

32. L. J. M. Morel d'Arleux, *Dissertation sur un traité de Charles Le Brun concernant les rapports de la physionomie humaine avec celle des animaux* (Paris, 1806).

33. H. Jouin, *Charles Le Brun et les arts sous Louis XIV* (Paris, 1889), catalogue of physiognomic drawings, pp. 590–93.

34. Le Brun's physiognomic drawings in the Louvre generally give three stages of the principal subjects: 1. A line drawing of the features accompanied, if necessary, by a geometrical schema; 2. a shadowed drawing without physiognomic geometry; 3. a sketch on squared paper. Some subjects collected by Morel d'Arleux on a single page were originally on separate sheets. The illustration of Morel d'Arleux's collection is reproduced in L. Métivet, *La Physionomie humaine comparée à la physionomie des animaux d'après les dessins de Charles Le Brun* (Paris, 1917). The letters given by Morel d'Arleux for the geometrical schemas do not all appear on the Louvre drawings.

35. A. de Mointaiglon, *Procès-verbaux de l'Académie de Peinture,* vol. I (Paris, 1875), pp. 358–59. According to Jouin (op. cit., p. 303, note 1), the physiognomic drawings now in the Louvre came from the collection of Jabach, who owned them prior to 1670 and did not hand them over to Colbert until 1672 and 1676. Thus they could not have served for the demonstration in question. Whoever owned these sketches, a fourth copy of which Le Brun could have kept for himself, it is certain that these are the drawings shown the Académie in 1671.

36. *Livre de Pourtraiture pour ceux qui commencent à dessiner, inventé et dessiné par Monsieur Le Brun* (n.p., n.d.).

37. C. H. von Heineken, *Dictionnaire des artistes dont nous avons des Estampes,* III (Leipzig, 1789), p. 422.

38. A. Blum, *La Caricature révolutionnaire* (Paris, n.d.), no. 554, pl. p. 180.

39. Bibliothèque Nationale, Paris, coll. Hénin, CXXIX, 11383.

40. J. Grand-Carteret, *Les Moeurs et la Caricature en France* (Paris, 1888), p. 124.

41. P. Camper, *Discours prononcé à l'Académie de dessin sur le moyen de représenter d'une manière sûre les diverses passions . . . et sur l'étonnante conformité qui existe entre les quadrupèdes, les oiseaux, les poissons et l'homme et enfin du beau physique* (Utrecht, 1792).

42. P. Camper, *Dissertation sur les variétés naturelles qui caractérisent la physionomie des hommes de divers climats . . . On y a joint aussi une dissertation du même auteur sur la meilleure forme des souliers* (Utrecht and Paris, 1791 and 1792).

43. P. Camper, *Naturgeschichte des Orang-utangs und einiger anderen Affenarten* (Düsseldorf, 1782).

44. J. C. Lavater, *Physiognomische Fragmente* (Leipzig and Winterthur, 1775–78).

45. J. C. Lavater, *Essai sur la Physiognomonie* (The Hague, 1781–1803).

46. J. C. Lavater, *L'Art de connaître les hommes* (Paris, 1806–9).

47. L. Hirzel, *Goethes Anteil an Lavaters Physiognomik* (N. Reich, 1878), pp. 597–611, and E. von der Hellen, *Goethes anteil an Lavaters Physiognomischen Fragmenten* (Frankfurt, 1888).

48. H. Funk, *Goethe und Lavater*, Schriften der Goethe Gesellschaft, vol. 16 (Weimar, 1901).

49. The chapter on animal skulls is included in *Goethes Werke*, XXXIV, 2, *Naturwissenschaftliche Schriften*, ed. R. Steiner (Berlin, n.d.), pp. 69–72.

50. J. H. Tischbein, *Aus Meinen Leben* (Brunswick, 1861), p. xxi.

51. J. H. Tischbein, *Têtes de différents animaux, dessinées d'après nature pour donner une idée plus exacte de leur caractère* (Naples, 1795), 2 vol. gr. fol.

52. G. Lascaut, *Écrits timides sur le visible* (Paris, 1979), p. 346; see Ovid, *Metamorphoses*, I. 6. 313ff.

53. The passage was included by J. Pommier, *La Mystique de Baudelaire* (Paris, 1932), chap. I, "La Physiognomonie," p. 16.

54. F. J. Gall, *Anatomie et physiologie du système nerveux en général et du cerveau en particulier avec des observations sur la possibilité de reconnaître plusieurs dispositions intellectuelles et morales de l'homme et des animaux par la configuration de leur tête* (Paris, 1818).

55. G. Finsler, *Lavaters Beziehungen zu Paris in den Revolutionsjahren 1789–1795* (Zurich, 1898).

56. *Lettre du comte de Mirabeau à M. . . sur M.M. Cagliostro et Lavater* (Berlin, 1786).

57. T. Thoré, *Dictionnaire de Phrénologie et de Physiognomonie à l'usage des artistes* (Paris, 1836).

58. See F. Baldensperger, *Études d'Histoire littéraire* (Paris, 1910), pp. 51–91, "Les théories de Lavater dans la littérature française"; G. M. Fess, *The Correspondence of Physical and Material Factors with Character in Balzac* (Philadelphia, 1924); J. Lethève, "Balzac et la phrénologie," *Esculape*, March 1951, pp. 55–62. For Lavater's influence on Balzac in general, see A. Prioult, *Balzac avant la Comédie Humaine* (Paris, 1936), and M. Bardèche, *Balzac romancier* (Paris, 1940).

59. Among other publications of *Physiognomies* during this late period, see *Scriptores physiognomoniae veteres* (Altenburg, 1780) and J. B. Porta, *Le Physionomiste ou l'observateur de l'homme avec des rapprochements sur la ressemblance de divers individus avec certains animaux* (Paris, 1808).

60. Henri Lapauze, *Ingres, sa vie et son oeuvre* (Paris, 1911), p. 52. Passage mentioned by J. F. Chevrier.

61. F. Grose, *Rules of Drawing Caricatures* (London, 1788).

62. F. Grose, *Principes de caricature suivis d'un essai sur la peinture comique* (Paris, 1802).

63. Michel Delaporte, *Observations de Lavater sur le système Lebrun* (Paris, 1834).

64. *Le Charivari*, January, February, and March 1839.

65. Under the title *L'Homme, son esprit, ses goûts et ses habitudes, dessins de Grandville* (Paris, 1842).

66. *Le Magasin Pittoresque*, 1843, XIII, p. 108.

67. Ibid., 1844, XII, p. 272.

68. L. Deltcil, *Honoré Daumier* (Paris, 1925), no. 38, face with dog's features, 1832; no. 45, head resembling a monkey, 1832; no. 207, lion head, 1834; no. 565, ornithomorphic head, 1839.

69. E. and J. de Goncourt, *Gavarni* (Paris, 1873), pp. 130, 184.

70. Paul de Saint-Victor in *D'après nature*, by Gavarni (Paris, 1859), p. 8.

71. J. Grandville, *Scènes de la vie privée et publique des animaux* (Paris, 1842); Balzac, *Voyage d'un lion d'Afrique à Paris*, pp. 100, 105.

72. Guy de Maupassant, in *Les Soeurs Rondoli:* "A similarity of gestures, movements, comportment, that seemed to arise out of memory . . ." Passage quoted by F. Baldensperger, op. cit. For the imagery of this latter period, see J. Wechsler, *A Human Comedy: Physiognomy and Caricature in 19th Century Paris* (London, 1982).

73. J. Baltrušaitis, *Aberrations* (1957), fig. 10; *Le Monde*, January 11, 1981, p. xv.

Pictorial Stones

1. A. Chastel, *Léonard de Vinci par lui-même* (Paris, 1952), p. 100. The text appears in Bibliothèque Nationale manuscript 2038, dated 1492.

2. The picture belongs to Jacques Combe, Paris. See J. Combe, "Matieu Dubus," *L'Amour de l'Art*, 1935, pp. 325–26.

3. O. Doering, *Des Augsburger Patriciers Philipp Hainhofer Beziehungen zum Herzog Philipp II von Pommern-Stettin*, Quellenschriften für Kunstgeschichte und Kunsttechnik, vol. 6 (Vienna, 1894), p. 323.

4. J. Lessing and Λ. Brüning, *Der Pommerische Kunstschrank* (Berlin, 1905), pl. XLI. The Pomeranian *cabinet* was in the Museum of Decorative Arts, Berlin.

5. J. Bôttiger, *Ph. Hainhofer und der Kunstschrank Gustav Adolfs in Uppsala* (Stockholm, 1910), II, pl. 24 and 25.

6. Ibid., fig. 57 and pl. 28. Callot's engraving shows the battle between four galleys of the Grand Duke of Tuscany against Turkish vessels. According to Baldinucci, the battle occurred off Corsica.

7. O. Doering, *Des Augsburger Patriciers Philipp Hainhofer Reisen nach Innsbruck und Dresden*, Quellenschriften für Kunstgeschichte und Kunsttechnik, vol. 10 (Vienna, 1901), pp. 44, 116, 161.

8. J. Le Brun and P. Sutermeisters, *L'Apogée du baroque* (Lausanne, 1966), p. 186.

9. M. Misson, *Nouveau voyage d'Italie* (The Hague, 1691), p. 98, letter dated Innsbruck, December 7, 1687.

10. O. Worm, *Museum Wormianum* (Leyden, 1655), p. 44.

11. F. Imperato, *Dell'Historia naturale libri XXVII* (Naples, 1599), p. 662.

12. O. Jacobaeus, *Museum regium . . .* (Copenhagen, 1696), p. 46, pl. XI, fig. 1.

13. In the second edition of the catalogue (Copenhagen, 1710), pt. II, 1, pp. 56–59.

14. E. Brackenhoffer, *Museum Brackenhofferianum Argentinense* (Strasbourg, 1677), p. 78.

15. J. D. Major, *Museum Cimbricum oder so genannte Kunstkammer* (Ploen, 1688), p. 2.

16. G. E. Rumphius, *D'Amboinsche Rariteitkammer* (Amsterdam, 1705), p. lvi.

17. M. B. Valentini, *Historia simplicium reformata sub Musei Museorum titulo* (Frankfurt, 1704), p. 42.

18. E. Holländer, *Wunder, Wundergeburt und Wundergestallt* (Stuttgart, 1921), fig. 109.

19. Among others at Rome (Qualdi Museum and Kircher Museum), at Verona (Calzolari Museum), at Milan (Settala Museum) at Bologna (Aldrovandi Museum and Cospi Museum). See Ph. Buonanni, *Museum Kircherianum* (Rome, 1709), p. 208; F. Calzolari, *Museum Calceolarium Veronese* (Verona, 1622), p. 419.

20. P. M. Terzago, *Museum Septalianum . . .* (Tortone, 1664), pp. 41, 142.

21. L. Legati, *Museo Cospiano . . .* (Bologna, 1677), pp. 172ff.

22. Stones with polygonal fortresses are reproduced in Rumphius, op. cit., pl. lvi. figs. A, B, C, and D.

23. See the catalogue for the Carracci exhibition at Bologna (*Mostra dei Carracci*, Bologna, 1956, no. 113, pp. 247–48), which notes in this connection that, according to Malvasia, the same artist had painted an Andromeda on alabaster for Cardinal Orsini. André Chastel has indicated such examples.

24. A. Kircher, *Mundus subterraneus* (Amsterdam, 1664).

25. C. J. Solin, *Polyhistor* (Paris, 1847), p. 101.

26. F. de Mély, *Les Lapidaires de l'Antiquité et du Moyen Age*, vol. 3 (Paris, 1902), pp. liv, 30, 31.

27. Marbode's *Le Lapidaire* is published in Migne, *Patr. lat.*, CLXXI. For French versions see L. Pannier, *Les Lapidaires français du Moyen Age, des xii, xiii et xiv siècles* (Paris, 1882).

28. J. de Mandeville, *Le Lapidaire du xiv siècle* (Vienna, 1862), p. 23; for the chronology of this treatise, see L. Pannier, op. cit., p. 191.

29. For the spread of antique glyptics in the Middle Ages, see F. de Mély, "Du rôle des pierres gravées au Moyen Age," *Revue de l'Art chrétien*, 1893, and J. Baltrušaitis, *Le Moyen Age fantastique, Antiquités et Exotismes dans l'Art gothique* (Paris, 1981), pp. 25–30.

30. The excerpts from Gethel's book are from the *Lapidaries* of Hugues Ragot, Conrad von Megenberg (Tethel), and Mandeville (Techef). See F. de Mély, "Du rôle des pierres gravées," p. 198; J. de Mandeville, op. cit., p. 122; C. von Megenberg, *Das Buch der Natur* (Greiswald, 1897), p. 402.

31. Albertus Magnus, *De Mineralibus et rebus metallicis*. Cf. ed. of Venice, 1542, Book II, chap. I, p. 209, and chap. II, pp. 211ff.

32. Ibid., Book I, chap. IX, p. 154.

33. L. Dolce, *Libri tre nei quali si tratta delle diverse sorti delle gemme che produce la natura* (Venice, 1566).

34. P. Pomponazzi, *De naturalium effectum admirandorum causis* (Basel, 1556).

35. G. Cardan, *De Subtilitate . . .* (Nuremberg, 1550) and *De la subtilité et subtiles inventions, ensemble les causes occultes et raisons d'icelles* (Paris, 1556), pp. 137ff.

36. R. Belleau, *Amours et nouveaux échanges des pierres précieuses* (Paris, 1576), p. 40.

37. I. Habert, *Les Trois Livres des météores* (Paris, 1585), p. 58.

38. The legend of Pyrrhus's agate is recounted in its classic version in several texts, *inter alia*, F. Rueus, *De gemmis . . .* (Paris, 1547), G. Merula, *Memorabilium* (Lyons, 1556), p. 292, and A. Bacci, *De gemmis et lapidibus* (Frankfurt, 1603), p. 88.

39. The text to which Cardan is referring is found in *De re aedificatoria*, L. B. Alberti (c. 1450). See Strasbourg edition, 1541, fo. 29v.

40. J. C. Scaliger, *Exotericarum Exercitationum liber. . .* (Lubeck, 1557), p. 180.

41. G. Agricola, *De re metallica, de ortu et causis subterraneorum. . .* (Basel, 1546), p. 309.

42. C. Gesner, *De omni rerum fossilium, lapidum et gemmarum maxime, figuris et similitudinibus liber* (Zurich, 1565), pp. 141ff.

43. J. Gaffarel, *Curiositez inouyes sur la sculpture talismanique des Persans* (Paris, 1629), pp. 156ff., 167ff.

44. The story is drawn from J. Nyder, *Formincarium* (Douai, 1602), p. 293.

45. F. S. de Brives, *Relation des voyages* (Paris, 1629).

46. J. Lieure, *Jacques Callot* (Paris, 1927), no. 314 of catalogue, pl. 7.

47. O. Croll, *Traicté des signatures ou vraye et vive anatomie du grand et petit monde*, in *Royale Chymie* (Rouen, 1634), p. 11.

48. U. Aldrovandi, *Museum metallicum* (Bologna, 1648), published by B. Ambrosini.

49. E.g., in the paving stones in San Miniato and the baptistry at Florence.

50. A. Boèce de Boot, *Gemmarum et lapidum historia* (Hanover, 1609) and *Le parfait Joaillier ou Histoire des pierreries* (Lyons, 1644), p. 326.

51. Ibid., p. 629. "The marble hardens and accretes by means of exhalations. . . . The exhalation paints colors therein. . . . For the generation of marble, not only is heat needed but also often subterranean cold. . . ."

52. E. Luidus, *Lithophilacii Britannici Ichnographia* (Oxford, 1698); G. E. Rumphius, *Thesaurus Cochlearum et Mineralium* (Amsterdam, 1705); J. J. Baier, *Oryctographia norica* (Nuremberg, 1719); J. Woodward, *Attempt Towards Natural History of the Fossils of England* (London, 1729); A. J. Dézallier d'Argenville, *L'Histoire naturelle éclaircie dans une de ses parties principales, l'Oryctologie qui traite des terres, des pierres, des métaux, des minéraux et autres fossiles* (Paris, 1755); R. Brookes, *Natural History*, vol. 5 (London, 1763), *inter alia*.

53. L. N. Lange, *Historia lapidum figuratorum Helvetiae* (Venice, 1708).

54. J. B. R. Robinet, *De la Nature*, vol. IV (Amsterdam, 1766), pp. 7ff.; *Traité de l'animalité; considérations philosophiques de la graduation naturelle des Formes des Êtres ou les essais de la Nature qui apprend l'homme* (Paris, 1768).

55. Leibnitz, letter to Hermann and Appel; see J. B. R. Robinet, *De la Nature*, p. 7.

56. J. B. R. Robinet, *De la Nature*, pp. 197ff.

57. Ibid., p. 212.

58. J. B. R. Robinet, *Considérations philosophiques*, pp. 19–37.

59. Ch. L. Richard, *La Nature en contraste avec la Religion et la Raison en l'ouvrage qui a pour titre: De la Nature* (Paris, 1773).

60. J. E. E. Walch and G. W. Knorr, *Recueil des monuments des catastrophes que le globe terrestre a essuyées* (Nuremberg, 1777), vol. I, 1, pp. 116–117 and vol. I, 2, p. 5; cf. R. Caillois, "Les Traces," *Preuves*, July 1961, pp. 21–22.

61. E. M. L. Patrin, *Histoire naturelle des minéraux* (Paris, 1801–2), III, pp. 280ff. Continuation of *l'Histoire naturelle* of Buffon and Déterville.

62. J. V. Monbarlet, *Le Secret des pierres* (Paris, 1892), and *Les Pierres et l'Histoire, Le Druidisme et son oeuvre* (Paris, 1896).

63. André Breton, "Langue des Pierres," *Le Surréalisme même*, no. 3 (Autumn 1957), reproduced in *Perspective cavalière*, text established by Marguerite Bonnet (1970), pp. 147–55.

64. R. Caillois, *Méduse et Cie* (Paris, 1960), pp. 54ff., "*Natura pictrix,* Notes sur la peinture figurative et non figurative dans la peinture et dans l'art"; "Les Traces," in *Preuves*, 1961, pp. 21ff.; "Images, images. . ." in *L'Oeil*, no. 137 (May 1966), pp. 20–27; *Pierres* (Paris, 1966); *L'Ecriture des pierres* (Paris: Skira, 1970, and Flammarion, 1981).

65. A. J. Dézallier d'Argenville, op. cit., p. 168, pl. 4c.

66. Claude Boullé generously made his collections available to us for the specimens in this latter series.

The Romance of Gothic Architecture

1. Goethe, *Von deutscher Baukunst* (1772), in *Werke*, Hamburg Edition, vol. XI. The text is quoted by N. Pevsner (*An Account of European Architecture*, London, n. d., p. 198), based on the article by Geoffrey Grigson in *Architectural Review* 99 (1946). The notion of the Gothic forest was also put forward in 1775 by J. G. Sulzer, *Tagebuch einer von Berlin nach den mittaglichen Ländern von Europa in der Jahren 1775 und 1776 gethanen Reise und Rückreise* (Leipzig, 1780), pp. 290-92.

2. Chateaubriand, *Le Génie du Christianisme* (Paris, 1802), III, chap. VIII.

3. F. von Schlegel, *Sämmtliche Werke*, VI (Vienna, 1823), chap. "Grundzüge der gothischer Baukunst," pp. 260ff.

4. S. T. Coleridge, *The Philosophical Lectures*, ed. Kathleen Coburn (London, 1949), pp. 256ff.

5. G. W. F. Hegel, *Esthétique*, French translation (Paris, 1944), p. 86. This and the preceding passage are quoted from J. Rykwert, *La maison d'Adam au paradis* (Paris, 1976), pp. 105ff.

6. *Les Fleurs du Mal*, in Baudelaire, *Oeuvres complètes* (Paris: Bibliothèque de la Pléiade, 1975), pp. 11, 75, and notes of Claude Pichois, pp. 839ff. Cf. J. Pommier, *La mystique de Baudelaire* (Paris, 1932), p. 20, and F. W. Leakey, *Baudelaire and Nature* (Manchester, 1969), p. 115.

7. J. K. Huysmans, *La Cathédrale* (Paris, 1898), p. 64.

8. Père M. A. Laugier, *Observations sur l'architecture* (Paris, 1765), pp. 116ff.

9. J. F. Félibien, *Dissertation touchant l'architecture antique et l'architecture gothique*, published with *Les plans et les descriptions des plus belles maisons de campagne de Pline le Consul* (Paris, 1699), pp. 173–75, 185.

10. H. Le Blanc, *Architecture des églises anciennes et nouvelles* (Paris, 1733).

11. G. Boffrand, *Livre d'architecture* (Paris, 1745), pp. 6ff.

12. J. F. Blondel, *Architecture française ou recueil des plans, élévations, coupes et profils*, vol. I (Paris, 1752), chap. I, p. 14.

13. Florent le Comte, *Cabinet des singularités d'architecture, peinture et gravure* (Paris, 1699), p. 111.

14. Fénelon, *Dialogue sur l'éloquence avec une lettre écrite à l'Académie française* (Paris, 1718), pp. 405ff.

15. J. F. Sobry, *De l'Architecture* (Amsterdam, 1776), pp. 20, 27.

16. A. N. Dézallier d'Argenville, *Vie des fameux architectes*, vol. I (Paris, 1787), pp. xxix ff.

17. A. Millin, *Antiquités Nationales*, vol. II (Paris, 1791), *Notre-Dame de Mantes*, pp. 7–11.

18. *The Works of Alexander Pope ... with the Commentaries and Notes of Mr. Warburton* (London, 1751). The text of Warburton is reproduced in F. Grose, *The Antiquities of England and Wales* (London, 1773), p. 76, and *Essays on Gothic Architecture* (London, 1800), pp. 120–22.

19. Warburton usually uses the terms "antique Gothic" and "modern Gothic," the former referring to Roman and pre-Roman buildings, as in Félibien.

20. J. Evelyn and R. Fréart, *A Parallel of Architecture, Being an Account of Ten Famous Architects with a Discourse of the Terms and a Treatise of Statues* (London, 1664), p. 9.

21. J. Evelyn, *Sylva or a Discourse of Forest-Trees* (London, 1664).

22. Ch. Wren, *Parentalia or Memoirs of the Family of the Wrens* (London, 1750), pp. 298, 306.

23. M. Dellaway, *Anecdotes of the Art in England* (London, 1800) and *Les Beaux-Arts en Angleterre*, with notes by A. Millin (Paris, 1807), vol. I, p. 14.

24. J. Hall, *On the Origin and Principles of Gothic Architecture*, Transactions of the Royal Society of Edinburgh, IV, 1798. Cf. Hall, *Essay on the Origin, History and Principles of Gothic Architecture* (London, 1813). For the garden in Milan, see D. Leonardi, *Le Delizie della Villa Castellazzo* (Milan, 1743).

25. P. Decker, *Gothic Architecture* (London, 1759), fig. 2.

26. Ch. Over, *Ornamental Architecture in the Gothic, Chinese and Modern Taste* (London, 1758), figs. 16, 27.

27. Le Rouge, *Jardins anglo-chinois* (Paris, 1776), book 4, pl. 3, and book 7, pl. 16; J. G. Grohmann, *Ideenmagazin für Liebhaber von Gärten, englischen Anlagen und für Besitzer von Landgütern* (Leipzig, 1797), book 1, pl. VI.

28. H. Home, *Elements of Criticism* (Edinburgh, 1762 and 1765), vol. II, p. 461.

29. For all these quotations see E. S. de Beer, "Gothic: Origin and Diffusion of the Term, The Idea of Style in Architecture," *Journal of the Warburg and Courtauld Institutes* 11 (1948): 152–62. Cf. also E. Panofsky, "Das erste Blatt aus dem Libro Giorgio Vasari's," *Städel-Jahrbuch* 6 (1930): 36.

30. A. Venturi, "La lettera di Raffaello a Leone X," *L'Arte* 21 (1919): 57–65, and *Storia dell'arte italiana* 9, no. 2 (Milan, 1926): 55. See also E. S. de Beer, op. cit., and Raphael, *Tutti gli scritti*, ed. Camesasca (Milan, 1956), p. 56; cf. J. Rykwert, op. cit., p. 120.

31. London, National Gallery; see G. Mandel, *Tout l'oeuvre peint de Botticelli* (Paris, 1967). The picture was purchased at Rome around 1800 by W. Y. Ottley. Resold several times in England, it was bought by the National Gallery in 1878. J. F. Chevrier drew our attention to it.

32. J. Baltrušaitis, *Le Moyen Age fantastique, Antiquités et exotismes dans l'art gothique* (Paris, 1981), p. 86.

33. R. Bernheimer, "Gothic Survival and Revival in Bologna," *Art Bulletin* 36 (1954): 271.

34. G. Dehio, *Geschichte der deutschen Kunst* (Berlin, 1921), vol. II, p. 163, and *Handbuch der deutschen Kunstdenkmäler*, vol. I, *Mitteldeutschland* (Berlin, 1905), pp. 55, 252, 341.

35. G. Dehio, *Geschichte der deutschen Kunst*, vol. II of plates, fig. 42.

36. R. Hofmann, *Geschichte der Kirche St. Marien in Pirna* (Berlin, 1890). See also *Wasmuths Lexikon der Baukunst*, vol. IV (Berlin, 1932), p. 70.

37. Philibert de l'Orme, *Le Premier Tome de l'Architecture* (Paris, 1567), p. 217.

38. L. Brion-Guerry, *Philibert de l'Orme* (Paris, 1955).

39. Chateaubriand, op. cit., p. 25.

40. J. N. L. Durand, *Recueil et parallèle des édifices de tout genre avec un text extrait de l'Histoire générale de l'architecture* (Paris, 1800); Legrand's *L'Essai sur l'Histoire générale de l'architecture* was published separately in 1809.

41. *Essays on Gothic Architecture* (London, 1800 and 1802).

42. The study is extracted from F. Grose, *The Antiquities of England and Wales* (London, 1773), vol. I.

43. M. Dellaway, op. cit., pp. 15, 20, 21 of the French edition.

44. A. Lenoir, *Musée impérial des monuments français, Histoire des Arts en France et description chronologique...* (Paris, 1810), pp. 34–39.

45. For the arrangement of the room, see G. Huard, "La Salle du xiiie siècle au musée des Monuments français à L'École des Beaux-Arts," *Revue de l'Art ancien et moderne* 47 (1925): 113–26.

46. C. Le Brun, *Voyage par la Moscovie en Perse et aux Indes orientales* (Amsterdam, 1718).

47. A. de Laborde, *Voyage pittoresque en Espagne* (Paris, 1806).

48. G. D. Whittington, *An Historical Survey of the Ecclesiastical Antiquities of France with a View to Illustrate the Rise and Progress of Gothic Architecture in Europe* (London, 1809).

49. J. Haggitt, *Two Letters on the Subject of Gothic Architecture* (Cambridge, 1813).

50. Ch. L. Stieglitz, *Von altdeutscher Baukunst* (Leipzig, 1820), p. 63, §47.

51. J. Murphy, *Plans, Elevations, Sections and Views of the Church of Batalab* (London, 1795).

52. Ch. Dupuis, *Origine de tous les cultes* (Paris, 1795), vol. III, pp. 48ff. J. Baltrušaitis, *La Quête d'Isis, Introduction à l'égyptomanie* (Paris, 1967), pp. 30ff.

53. The term "hieroglyphic and Egyptian figures" had already been applied to medieval sculpture (at Chelles and Notre Dame de Paris) by J. Lebeuf, *Histoire de la ville et de tout le diocèse de Paris* (Paris, 1754–55), vol. I, p. 11, and vol. VI, p. 39. The reference was supplied by Jacques Vanuxem, to whom we owe various items of information on this subject.

54. The mention of Isis as the tutelary goddess of the Parisians occurs in A. Duchesne, *Les Antiquités et recherches des villes, châteaux et places plus remarquables de toute la France* (Paris, 1609), p. 84. J. Baltrušaitis, *La Quête d'Isis*, chap. I.

55. A. Lenoir, op. cit., p. 54.

56. A. Lenoir, *Nouvelle Explication des hiéroglyphes ou les anciennes allégories sacrées des Égyptiens* (Paris, 1808), pp. 128–29. J. Baltrušaitis, *La Quête d'Isis*, p. 43.

57. The fanciful attributions of certain monuments of the Middle Ages, for the most part Roman or transitional, to classical antiquity was based solely on historical legends without any consideration of style or structural elements, the Gothic being *par excellence* "anti-antique."

58. H. Le Blanc, op. cit., p. 13.

59. Père L. Le Comte, *Nouveaux Mémoires sur l'état présent de la Chine* (Paris, 1696), vol. I, pp. 341ff.

60. J. Ruskin, *Lectures on Art* (London, 1870), par. 186, reference of L. Grodecki in *Vitraux de France* (Paris, 1953), p. 13.

61. J. Le Gentil de la Galaisière, "Mémoire sur l'origine du Zodiaque," in *Mémoires de l'Académie Royale des Sciences* (Paris, 1785), p. 19.

62. L. F. Delatour, *Essai sur l'architecture des Chinois* (Paris, 1803), p. 184.

63. A. Lenoir, *Histoire des Arts en France* (1810), pp. 35, 36, and "Notice sur l'origine de l'architecture appelée improprement gothique," in *Mémoires de l'Académie celtique* 3 (1809): 351.

64. F. W. Schelling, *Textes esthétiques*, trans. A. Pernet, intro. by X. Tilliette (Paris, 1978), pp. 117ff.

65. To be compared with the contemporary text of Schlegel.

66. P. Toynbee, *The Letters of Horace Walpole* (Oxford, 1903), vol. III, p. 4.

67. A. O. Lovejoy, "The First Gothic Revival and the Return to Nature," *Modern Language Notes* 47, no. 7 (1932): 419–46.

68. W. and J. Halfpenny, *New Designs of Chinese Gates, Palisades, Staircases, Garden Seats, Chairs, Temples*, vol. IV, (London, 1752), pl. 54, and *Rural Decorative Architecture in the Augustine, Gothic and Chinese Taste* (London, 1753), pl. 12, 13, 14.

69. Ch. Over, op. cit., pl. 23, 24, 25, 32, 35.

70. J. Ch. Krafft, *Recueil d'architecture civile* (Paris, 1812), pl. 119–120, no. 11.

71. For the "Gothic Revival," see C. Eastlake, *History of Gothic Revival* (London, 1872); H. Tietze, *Das Fortleben der Gotik durch die Neuzeit*, *Mitteilungen der K. K. Zentral-Kommission für Denkmalpflege*, XIII, 1914; H. Lützeler, *Die Deutung der Gotik bei den Romantikern, Wallraf-Richartz Jarhbuch*, II, 1925; Kenneth Clark, *The Gothic Revival* (London, 1928); A. Neumeyer, "Die Erweckung der Gotik in der deutschen Kunst des späten 18. Jahrh.," *Repertorium für Kunstwissenschaft* 49 (1928); P. Yvon, *Le Gothique et la Renaissance gothique en Angleterre* (Paris, 1931); A. Addison, *Romanticism and the Gothic Revival* (New York, 1938); G. Germann, *Gothic Revival in Europe and Britain* (Cambridge, Mass., 1972) (with an important chapter on the legend of the Gothic forest); J. Macaulay, *The Gothic Revival* (Glasgow and London, 1975).

72. See M. Aubert, "Le Romantisme et le Moyen Age," in the collection *Le Romantisme et l'art* (Paris, 1928).

73. E. Lambin, *La Cathédrale et la Forêt* (Paris, 1899). In this connection the author refers to a text by Saint Bernard: *Amplius invenies in sylvis quam in libris.*

74. L. M(ay) (le Père Avril), *Temples anciens et modernes ou observations historiques et critiques sur les plus célèbres monuments d'architecture grecque et gothique* (London, 1774).

75. J. Milner, "Essay on the Rise and Progress of the Pointed Arch," in *History of the Antiquities of Winchester* (Winchester, 1798) reproduced in *Essays on Gothic Architecture* (London, 1800).

76. On the first page of A. de Caumont, "Essai sur l'architecture du Moyen Age," *Mémoires de la Société des Antiquaires de Normandie* 1 (1824): 585ff., and J. J. Bourassé, *Archéologie chrétienne ou Précis de l'Histoire des Monuments religieux du Moyen Age* (Tours, 1841), pp. 28ff.

77. The elements of the question with an extensive bibliography are summarized by E. Lambert, "La Croisée d'ogive dans l'architecture islamique," in the collection published by the International Institute of Intellectual Cooperation, *Recherches*, no. 1, *Le Problème de l'Ogive* (Paris, 1939).

78. For the Chinese contribution to Gothic architecture, see J. Baltrušaitis, *Le Moyen Age fantastique*, chap. VII, "L'Arc en accolade oriental"; J. Bony, *The English Decorated Style, Gothic Architecture Transformed (1250–1350)*, (Oxford, 1979), p. 78.

Gardens and Lands of Illusion

1. J. Zahn, *Oculus artificialis* (Erfurt, 1685), pp. 729ff. See J. Baltrušaitis, *Le miroir, révélations, science-fiction et fallacies* (Paris, 1978), pp. 30ff.

2. E. de Ganay, *Traité de la Décoration des dehors des jardins et des parcs par Mgr le duc d'Harcourt* (Paris, 1919), p. 100. This is the first publication of the treatise, written c. 1774.

3. R. L. Gérardin (Marquis de Girardin), *De la composition des paysages ou des moyens d'embellir la nature autour des habitations en joignant l'agréable à l'utile* (Geneva, 1775), p. 4. Republished under the same title by Éditions du Champ Urbain, with an afterword by Michel H. Conan (Paris, 1979).

4. J. Boyceau de La Barauderie, *Traité du jardinage selon la raison de la nature et de l'art* (Paris, 1638).

5. A. J. Dézallier d'Argenville, *La Théorie et la Pratique du jardinage* (Paris, 1709, 1713, 1722, and 1747).

6. See L. Carpechot, *Les Jardins de l'Intelligence* (Paris, 1912). W. H. Adams, *The French Gardens (1500–1800)* (New York, 1979), pp. 75–161.

7. Ch. Wren, *Parentalia or Memoirs of the Family of the Wrens* (London, 1750), p. 351.

8. J. Dennis, *The Grounds of Criticism in Poetry* (London, 1704), cited by A. O. Lovejoy, "Chinese Origin of a Romanticism," *Journal of English and Germanic Philology* 32 (1933): 1.

9. S. Switzer, *Iconographia Rustica* (London, 1715).

10. B. Langley, *New Principles of the Gardening . . . after a more grand and rural Manner than has been done before* (London, 1728), p. xi.

11. H. Home, *Elements of Criticism*, II (Edinburgh, 1762 and 1765), p. 439.

12. P. Grimal, *Les Jardins romains à la fin de la République et aux deux premiers siècles de l'Empire* (Paris, 1943), pp. 320ff.

13. A. Blunt, "The Hypnerotomachia Poliphili in 17th-Century France," *Journal of the Warburg Institute*, 1 (London, 1937–38).

14. H. Walpole, "William Kent," in *Anecdotes of Painting in England*, IV (Strawberry-Hill, 1771), p. 111.

15. See M. Jourdain, *The Work of William Kent* (London, 1948).

16. P. Willis, *Charles Bridgeman and the English Garden* (London, 1978). For English gardens in general, see E. Hyams, *The English Garden* (London, 1964); C. E. C. Hussey, *English Gardens and Landscape, 1700–1750* (London, 1967); M. Hadfield, *The British Landscape Gardens* (London, 1977); D. Jarrett, *The English Landscape Gardens* (London, 1978); and two collections of texts with introductions, J. D. Hunt and P. Willis, *The Genesis of Place, The English Landscape Garden* (London, 1975ff.), and M. M. Martinet, *Art et Nature en Grande-Bretagne au xviiie siècle* (Paris, 1980).

17. H. F. Clark, "Eighteenth Century Elyseums," in *England and the Mediterranean tradition, Journal of the Warburg and Courtauld Institutes* (London, 1945), pp. 154–78.

18. J. J. Rousseau, *Julie ou la Nouvelle Héloïse* (Amsterdam, 1761), p. 340.

19. J. Serle, *A Plan of Pope's Garden* (London, 1745).

20. A. Pope, *Works*, vol. V (London, 1739), p. 69; M. M. Martinet, op. cit., p. 9. See also H. R. Brownell, *Alexander Pope and the Arts of Georgian England* (Oxford, 1978).

21. L. Lange, "La grotte de Thétis et le premier Versailles de Louis XIV," *Art de France* 1 (1961): 133–40.

22. S. Bridgeman, *A General Plan of the Woods, Parks and Gardens of Stowe* (London, 1739), and J. Seeley, *Stowe, a Description of the House and Gardens* (London, 1797). The engraving with the Chinese house is reproduced in O. Sirén, *China and Gardens of Europe of the Eighteenth Century* (New York, 1950), fig. p. 30. See also G. Clark, "The Gardens of Stowe," *Apollo* 97 (1973): 558–71.

23. W. Gilpin, *A Dialogue upon the Gardens at Stowe* (London, 1745–49); M. M. Martinet, op. cit., pp. 123, 129.

24. Cf. P. Willis, "Rousseau, Stowe and 'le jardin anglais,'" *Studies on Voltaire and the Eighteenth Century* 90 (1972): 179. For workshops in general, see E. de Ganay, "Fabriques aux jardins du xviiie siècle," *Gazette des Beaux-Arts* 45 (1955): 287–98.

25. W. Chambers, *Plans, Elevations, Sections and Perspective Views of the Gardens and Buildings at Kew in Surrey* (London, 1763). R. King, *The World of Kew* (London, 1976). See also W. Blunt, *A Prospect of Kew Gardens* (London, 1978).

26. W. and J. Halfpenny, *Rural Decorative Architecture in the Augustine, Gothick and Chinese Taste* (London, 1753).

27. For general documentation, see the notebooks by Le Rouge, *Jardins anglo-chinois* (Paris, 1776–89); J. G. Grohmann, *Ideenmagazin für Liebhaber von Gärten, Englischen Anlagen und für Besitzer von Landgütern*

(Leipzig, 1796–1811); J. C. Krafft, *Plans des plus beaux jardins pittoresques de France, d'Angleterre et d'Allemagne* (Paris, 1809–10); as well as works by M. Charageat, *L'Art des Jardins* (Paris, 1930); E. de Ganay, *Les Jardins de France et leur décor* (Paris, 1949); A. Perraux and M. Plaisant, *Jardins et paysages. Le style anglais* (Lille, 1977); D. W. Wiebenson, *The Picturesque Garden in France* (Princeton, 1978).

28. A. de Laborde, *Description des nouveaux jardins de la France et de ses anciens châteaux* (Paris, 1808), p. 135.

29. Mérigot, *Promenade ou itinéraire des jardins d'Ermenonville* (Paris, 1788), see the 1979 Girardin edition, pp. 123ff.

30. J. A. J. Cerutti, *Les Jardins de Betz, poème* (Paris, 1742); *Les Jardins de Betz, description inédite*, published by G. Macon (Senlis, 1908).

31. L. Eugène Lefèvre, *Le Jardin et la singulière habitation du Désert de Retz*, Bulletin de la Commission des Antiquités et des Arts de Seine-et-Oise, 1917; O. Sirén, "Le Désert de Retz," *Architectural Review* 106:327–32; O. Choppin de Janvry, "Le Désert de Retz," *Bulletin de la Société de l'Histoire de l'Art Français*, 1970, pp. 125–53. For general Gothic ruins, see E. de Ganay, "Le Goût du Moyen Age et des ruines dans les jardins du xviiie siècle," *Gazette des Beaux-Arts* 8 (1932): 183–97.

32. L. Carmontelle, *Jardin de Monceau près de Paris* (Paris, 1779), p. 4; D. Wiebenson, "Le Parc Monceau et ses fabriques," *Les Monuments historiques de la France*, no. 5 (1976), pp. 16–19; *Grandes et petites heures du Parc Monceau, Catalogue de l'exposition au Musée Carnavalet* (Paris, 1981).

33. J. Delille, *Les Jardins ou l'Art d'embellir les paysages* (Paris, 1782).

34. *Jardins en France, 1760–1820, Pays d'illusion, terre d'expérience*, Catalogue de l'exposition, 1977, no. 14 (2).

35. Term used by Voltaire in his letter to Chambers (1772), ibid., p. 49.

36. D. Wiebenson, op. cit., chap. I, "The French Picturesque Garden before 1760," pp. 3ff. For the Lunéville kiosk, see F. Baldensperger, *Le Kiosque de Stanislas, décor et suggestions d'Orient*; for the *Rocher*, Ostrowski, "Théâtre des automates," *Le Pays lorrain* 3 (1972): 175–85.

37. M. Jourdain, op. cit., p. 75.

38. R. Wittkower, "Lord Burlington and William Kent," *Archaeological Journal* 102 (1947).

39. E. W. Manwaring, *Italian Landscape in Eighteenth Century England, A Study of the Influence of Claude Lorrain and Salvator Rosa on English Taste, 1700–1800* (New York, 1925); I. W. U. Chase, *Horace Walpole Gardenist* (Princeton, 1943), chap. I, "The Beauty of Irregularity and Italian Landscape Painting."

40. *The Rise and Progress of the Present Taste of Planting* (London, 1767), quoted from Chase, op. cit., p. 144.

41. Arthur Young quote in *Monthly Review* 38 (March 1768): 222, and Thomas West, *A Guide to the Lakes* (London, 1778); see M. M. Martinet, op. cit., pp. 23, 229. Noted by J. F. Chevrier.

42. A. de Laborde, op. cit., p. 135.

43. J. de Cayeux, "Hubert Robert dessinateur de jardins et sa collaboration au parc de Méréville," *Bulletin de la Société de l'Histoire de l'Art Français*, 1968, pp. 123–33; O. Choppin de Janvry, "Méréville," *L'Oeil*, December 1969, pp. 39ff.; S. de Lassus, "Quelques détails inédits sur Méréville," *Bulletin de la Société de l'Histoire de l'Art Français*, 1978, pp. 273–87.

44. *Jardins de France, 1760–1820, Catalogue de l'exposition*, 1977, no. 54.

45. W. Temple, "Upon the Gardens of Epicurus," in *Miscellanea*, II (London, 1690) and *Works*, vol. 3 (London, 1757), pp. 229–30; *Les Oeuvres mêlées de M. le Chevalier Temple*, II (Utrecht, 1693), pp. 83–95.

46. For sources of W. Temple's Chinese background, see S. Lang and N. Pevsner, "Sir William Temple and Sharawaggi," *Architectural Review*, December 1949.

47. In *The Spectator*, vol. 6, no. 414, 1712. See A. O. Lovejoy, op. cit., and H. F. Clark, op. cit., p. 155.

48. H. Walpole, "On Modern Gardening," in *Anecdotes*, IV, and *Essai sur l'art des jardins modernes* (Strawberry-Hill, 1775), p. 46.

49. G. Mason, *An Essay on Design in Gardening* (London, 1768), p. 26.

50. I. Ware, *A Complete Body of Architecture* (London, 1768), pp. 645–46.

51. Père du Halde, *Description géographique, historique . . . de la Chine*, II (Paris, 1735), p. 85.

52. *La Galerie du Monde*, II (Leyden, 1735), pl. 40.

53. *Lettres édifiantes et curieuses écrites des Missions étrangères par quelques missionnaires de la Compagnie de Jésus*, XXIII (Paris, 1781), letter of Père Benoît to M. Papillon d'Auteroche, November 16, 1767, p. 537.

54. Ibid., XXVII, letter of Père Attiret to M. d'Assaut, November 1, 1743, pp. 8ff. For Peking gardens and Chinese gardens in general, see E. H. Wilson, *China, Mother of Gardens* (New York, 1971); C. B. Malone, *History of the Peking Summer Palaces under the Ch'ing Dynasty* (Urbana, Ill., 1934); and O. Sirén, *Gardens of China* (New York, 1949). In his notebooks XIV–XVII, Le Rouge reproduced prospects extant today in the Cabinet des Estampes, Bibliothèque Nationale, Paris. Concordances between the originals and Le Rouge's reproductions were established in 1946 by Mme R. Guignard. See also M. Keswick, *The Chinese Garden* (London, 1978).

55. For a listing of Chinese buildings in Europe, see E. von Erdberg, *Chinese Influence on European Garden Structures* (Cambridge, Mass., 1936).

56. Some of these European palaces are reproduced in O. Sirén, *Gardens of China*, pl. 189–92. See collection Oe 18 of the Cabinet des Estampes at the Bibliothèque Nationale, Paris.

57. Père P. M. Cibot, *Mémoires concernant l'histoire des sciences, les moeurs, les usages des Chinois par les Missionnaires de Pékin*, VIII (Paris, 1782), p. 318.

58. Joseph Spence under the pseudonym of Sir Harry Beaumont, "A Particular Account of the Emperor of China's Gardens, near Pekin," in R. Dodsley's *Fugitive Pieces*, I (London, 1761), pp. 61ff.

59. Père M. A. Laugier, *Essai sur l'architecture* (Paris, 1755), pp. 241ff.

60. Published in *Quelques écrits de notre temps* (1752), III, p. 41. Quoted from D. Wiebenson, op. cit., p. 20.

61. For Chinese constructions in the West, see H. Cordier, *La Chine en France au xviiie siècle* (Paris, 1910), and E. van Erdberg, op cit.; O. Sirén, *China and Gardens of Europe in the Eighteenth Century* (New York, 1930); H. Honour, *Chinoiseries. The Vision of Cathay* (London, 1961); R. Wittkower, "England, Palladianism. The Landscape Garden, China and the Enlightenment," *L'Arte* 40 (1969): 13–25.

62. M. Mosser, "Monsieur de Marigny et les jardins; projets de fabriques pour Ménars," *Bulletin de la Société de l'Histoire de l'Art Français*, 1972, pp. 285ff., figs. 12–17.

63. R. Édouard-André, "Documents inédits sur l'histoire du château et des jardins de Chanteloup," *Bulletin de la Société de l'Histoire de l'Art Français*, 1933, pp. 21–39.

64. J. Harris, *Sir William Chambers, Knight of the Polar Star* (London, 1970).

65. W. Chambers, *Designs of Chinese Buildings, Furniture, Dresses, Machines and Utensils* (with a French text) (London, 1757), chap. "Art of Laying out Gardens," pp. 15ff., reprinted in Th. Percy, *Miscellaneous Pieces Relating to the Chinese*, II (London, 1762).

66. Chambers, *A Dissertation on Oriental Gardening* (London, 1772), and *Dissertation sur le Jardinage de l'Orient* (London, 1772).

67. Père P. M. Cibot, op. cit., VIII, p. 321.

68. Quote from O. Sirén, *Gardens of China*, p. 14.

69. For O. Sirén (*China and Gardens of Europe*), fantasy elements are included only in the second, 1772, version of Chambers's text, written as a polemic against Brown.

70. I. W. U. Chase, "William Mason and Sir William Chambers' Dissertation on Oriental Gardening," *Journal of English and Germanic Philology* 25 (1936): 190.

71. *An Heroic Epistle to Sir William Chambers* (London, 1773). See I. W. U. Chase, op. cit., pp. 517ff.

72. Ch. C. L. Hirschfeld, *Théorie de l'Art des Jardins*, I (Leipzig, 1779),

pp. 111ff. See W. Schepers, *Hirschfelds Theorie der Gartenkunst, Grüne Reihe,* vol. 2 (Worms, 1980).

73. Père le Comte, *Nouveaux Mémoires sur l'état présent de la Chine,* I (Paris, 1697).

74. Cardinal de Bernis, *Les Quatre Saisons ou la Géographie française* (Paris, 1763); A. Le Bret, *Les Quatre Saisons* (Paris, 1763); Saint-Lambert, *Les Saisons* (Paris, 1764).

75. Th. Whateley, *Observations on Modern Gardening* (London, 1770).

76. Duc d'Harcourt, op. cit., chaps. IX-XIII.

77. G. Macon, op. cit., p. 17. The anonymous description of Betz was written c. 1789–90.

78. L. Carmontelle, op. cit.

79. H. Home, op. cit., I, p. 286.

80. Thomas Whateley, *Observations on Modern Gardening* (London, 1770); see also M. M. Martinet, op. cit., pp. 188ff.

81. Cl. H. Watelet, *Essai sur les jardins* (Paris, 1774), pp. 80ff.

82. The Marquis of Girardin, op. cit., p. 137.

83. Ch. C. L. Hirschfeld, op. cit., I, pp. 221ff.

84. For the subject see E. de Ganay, "Les Rochers et les Eaux dans les jardins à l'anglaise," *Revue de l'Art ancien et moderne* 66 (1934): 63–80, and M. Keswick, op. cit., ch. 7, "Rocks and Water," pp. 155–73.

85. P. Boitard, *Traité de la composition et de l'ornement des jardins* (Paris, 1825), pp. 14ff.

86. J. M. Morel, *Théorie des Jardins, ou l'Art des Jardins de la Nature* (Paris, 1776), p. 388.

87. Ch. de Tolnay, *Le Maître de Flémalle et les Frères van Eyck* (Brussels, 1937), chap., "La Terre vue comme Paradis."

88. J. Combe, "Au Paradis terrestre," *L'Oeil,* January 1956.

89. Ch. Sterling, "Le Paysage dans l'art européen de la Renaissance et dans l'art chinois," *L'Amour de l'Art,* January and March 1931. For the Far Eastern influences on medieval landscapes, see J. Baltrušaitis, *Le Moyen Age fantastique,* pp. 211–20.

90. W. Shenstone, *Unconnected Thoughts on Gardening,* in *The Work in Verse and Prose,* II (London, 1764); cf. L. Carpechot, op. cit., pp. 18–23. See O. Sirén, *China and Gardens of Europe,* pp. 38ff.

91. H. Sauvel, *Histoire et Recherches des antiquités de la Ville de Paris,* II (Paris, 1724), p. 283.

92. A. Lecoy de la Marche, *Le Roi René,* II (Paris, 1875), p. 29.

93. Ibid., p. 151. See also E. de Ganay, *Les jardins de France,* pp. 15–21.

94. An early version of this study appeared in *Magazine of Art,* April 1962, under the title "Eighteenth Century Gardens and Fanciful Landscapes." It was reprinted in slightly different form in *Traverses,* 1977, pp. 94–112. Another version served as preface to the catalogue for the exhibition *Jardins en France 1760–1820, Pays d'illusion, Terre d'expérience,* May-September 1977, Hôtel de Sully, Paris, of which an abridged bilingual edition (French-English) appeared in 1978. The 1977 exhibition contained an outstanding collection with several new acquisitions that shed new light on the subject. Lastly, it was printed in a bilingual (Italian-English) text in *Lotus International* 2 (1981): 51–69.